WENDELL MINOR

Art for the Written Word

WENDELL MINOR

Art for the Written Word

TWENTY-FIVE YEARS OF BOOK COVER ART

INTRODUCTION BY DAVID McCULLOUGH

HARCOURT BRACE & COMPANY

NEW YORK SAN DIEGO LONDON

To Florence

Who stands with me all the way

Library of Congress Cataloging-in-Publication Data
Minor, Wendell.
Wendell Minor: art for the written word/Wendell Minor, Florence Friedmann Minor, editor.
p. cm.
Includes index.
ISBN 0-15-195614-6.
ISBN 0-15-600212-4 (pbk.)
1. Minor, Wendell—Themes, motives. 2. Book jackets—United States—Design.
I. Minor, Florence Friedmann. II. Title. III. Title: Art for the written word.
NC1883.3.M56M57 1995
741.6'4'092—dc20 94-37166

Text set in Centaur
Designed by Vaughn Andrews
Production supervision by Warren Wallerstein and David Hough
Printed in Singapore

First edition
A B C D E

ARTIST'S STATEMENT

I BELIEVE STRONGLY in the picture as narrative: an image frozen in time that sets the stage for the action that follows; a picture that invites the viewer into it and offers up a sense of mystery.

Ever since man began telling stories, the mind has conjured up images to accompany them. I certainly found this to be true when I was told stories or read to as a child.

Today, the art of storytelling has all but disappeared, and the act of reading has been relegated to the smallest corners of our daily lives. The video is all powerful. Yet nothing, to my mind, can ever match the vivid pictures imagined while reading a book.

I will be forever grateful to my sixth grade teacher for introducing and reading aloud so many stories by our classic American writers: Lardner, London, Poe, and Twain, to name a few. In retrospect, that experience helped forge my future as an illustrator for the written word. I find it truly ironic that so many years later, I have had the opportunity to create illustrations for stories by all of the aforementioned authors.

The paintings in this book represent only a small portion of the book covers I have designed and illustrated these past twenty-five years. Nevertheless, they do represent the basic tenets that I feel are essential for a good narrative picture: 1) style should not exceed concept for the sake of trends; 2) elements in the composition should be kept to a minimum; 3) the visual message should be ambiguous enough to allow the reader to participate with his or her own imagination; 4) the image should honor the story, honor the written word!

A good picture, like a good story, is timeless.

The cover art in this book is not presented in chronological order. Instead, it is arranged to create the most pleasing visual order. This, I believe, makes for a better book, and that has been, and always will be, my first priority.

—*Wendell Minor*

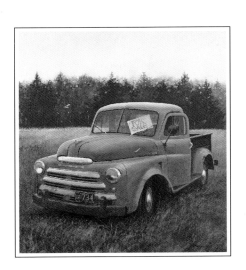

THE TIMES AND PLACES OF WENDELL MINOR

by David McCullough

I LIKE OLD TRUCKS," Wendell said with emphasis.

It was a summer afternoon and in two Adirondack chairs pulled up in the shade of an elm tree, we were sitting talking about the jacket he'd done for a book called *Truck* by John Jerome.

"They remind me of 'Lovesick Blues' and Hank Williams in 1949," he said. "And of my grandfather. Grandfather Roy Sebby was a farmer who lost his farm in the Depression and bought a Phillips 66 station on Route 66 in 1943. . . ."

The truck in the painting stands alone in a grassy field. It's a 1950 faded blue Dodge, all details—broken door handle, For Sale sign in the windshield, New Hampshire license plate, Ram's head hood ornament—lovingly rendered. In the background is a thick stand of dark spruce and fir trees, defining the boundary of the field and giving the picture, as is often the case in Wendell's work, a certain edge of mystery.

"I used to sit on the step of that gas station drinking Grapette and RC Cola and watch all the Chevys and Fords go by. And I knew the make and model of every car up 'til 1960. This

was in Plainfield, Illinois, a rural town of about fifteen hundred. I loved it. But it's gone."

"It's gone?" I asked.

"Well, it's not a rural town anymore."

We are old friends. We have known and worked with one another since Wendell did the cover for my book *The Great Bridge* back in 1972. He is fifty now, a spare, tidy, gentle, good-natured man of medium height with deep-set gray-green eyes which, in combination with the high dome of his bald head, give him something of the look of an intensely watchful high priest or bird of prey. It might be a face from El Greco, I've sometimes thought, except that he smiles so easily, and the voice, deep and resonant like a radio announcer's, is so pleasantly middle-American. "Yup," he'll say in agreement.

Mainly Wendell looks like his paintings. There's no fat, nothing sloppy or superfluous or out of place. The whole arrangement is crisp, clearly stated. The clothes look as if just back from the cleaners; the brown hair, worn long about the ears, falls exactly so; the beard and mustache, also brown but with

touches of gray, are always neatly trimmed. It's a look not of vanity, but of an old-fashioned kind of middle-American self-respect that you see often in old photographs.

"I have a wonderful photograph of that gas station from the forties," he said, his back straight in the chair, his gray-green eyes seeming to focus on the tips of a nearby picket fence. "And a picture of my grandfather standing with his uniform and a smile at Sebby's Super Service on Route 66!"

Wendell Minor is an exceptionally gifted, almost unimaginably prolific American artist—painter, illustrator, graphic designer—whose best work echoes themes to be found in Winslow Homer, N. C. Wyeth, Edward Hopper, and Georgia O'Keeffe, not to say a touch of René Magritte and numerous authors whose books he has worked on. He has been called a traditionalist and a romantic, terms he doesn't dispute. Few artists of any era have seen their efforts reproduced in such quantity or enjoyed by so many people. In the world of publishing there is no one quite like him. Indeed, his value to the

whole world of books, to publishers, editors, authors, booksellers, and to millions of readers who care about books, can hardly be overstated.

In the past twenty-five years, since first arriving in New York, he has produced more than fifteen hundred book jackets, which on average is more than one a week, and they include covers for many of the most popular books of the day: ten by James Michener, seven by Larry McMurtry, the best-selling thriller by Mary Higgins Clark, *Where Are the Children?*, Judith Rossner's

Looking for Mr. Goodbar, Pat Conroy's *The Great Santini* and *The Prince of Tides*. He has created covers for a shelf of classic American literature, including works by Willa Cather, Conrad Richter, Jessamyn West, Wallace Stegner, and John Hersey. Toni Morrison's *Sula* and Louise Erdrich's *The Beet Queen* have the common hallmark of a Wendell Minor painting on the cover. So do books by Ray Bradbury, Mary Renault, Ernest J. Gaines, M. F. K. Fisher, Garrison Keillor, and Ivan Doig.

There are Wendell Minor covers for Georges Simenon's detective novels, the C. S. Forester *Hornblower* series, for Sigurd Olson's essays, for a Bennett Cerf collection of famous ghost stories, for histories, biographies, books on sports, cookbooks, and such distinguished works of nonfiction as Tracy Kidder's *House* and Paul Theroux's *The Old Patagonian Express*.

Thanks to Simon & Schuster, four more of my own books since *The Great Bridge* have also been published with Wendell's covers, including *Truman*, for which I am ever grateful.

He has besides documented spaceflight for NASA, painted a U.S. postage stamp celebrating North Dakota's one hundred years of statehood, and illustrated seven widely acclaimed children's books: *The Seashore Book* by Charlotte Zolotow; *Mojave*, *Sierra*, and *Heartland* by Diane Siebert; *Red Fox Running* by Eve Bunting; and *The Moon of the Owls* and *Everglades* by Jean Craighead George.

Yet for all this his name is not widely known. His work, despite its immense reach, remains largely anonymous, since the modest "W. Minor" signature is rendered small (and often all but hidden in the composition) and few readers ever bother to check a cover credit on a jacket.

But no matter. In his white-walled studio in Connecticut he is at work from morning until well into the night, ten, twelve hours a day, usually seven days a week. Often he's on the phone as he works, a radio playing classical music. He knows fine art, and of American painters especially he will talk at length. John Singer Sargent, Thomas Moran, Homer, Hopper, and Fairfield

Porter are his heroes. The watercolors of Sargent and Homer he admires above all.

He knows history, architecture, automobiles, antique toys, gardening. For twelve years he taught at New York's School of Visual Arts and has decided views on teaching. He is passionately interested in nature, a bird-watcher, though he seems uneasy with the term, and loves recounting his field studies in the wild. On an expedition for the children's book *Sierra*, he hiked to the 11,516-foot summit of Vogelsang Peak, the highest point on the high Sierra loop trail in Yosemite National Park, "to see the view." For *Everglades* he assembled some forty volumes of South Florida history, South Florida flora and fauna, "for background," and spent days in the Everglades wilderness filling sketchbooks and taking more than a thousand photographs. "I could do five books on the Everglades and still not have it all," he says, as though this is exactly what he would like to do.

At times he appears driven by his work. "Does anybody ever tell you that's not good for you?" I asked when he told me the hours he puts in. "*Everybody!*" he said with a laugh.

"My grandfather—Norwegian stock—worked fourteen hours a day from age nine and never said a word. My father—from German extraction—ah! *Perfectionism:* 'That's good, but you can do better. You'll do it better next time.' My mother—'This is the day the Lord has made. Let us rejoice and be glad in it.'"

Born in Aurora, Illinois, in 1944, the first child of Gordon and Marjorie Sebby Minor, Wendell grew up in a four-room white clapboard house on the edge of town, two blocks from cornfields and barns. For reading matter at home the choice was *Field & Stream* or the Bible.

Gordon Minor was a farmer's son and World War II veteran who for forty years worked as a precision machinist for a power tool manufacturer and for forty years, for all his skill, hated every day of it, living only to be in the out-of-doors. Wendell de-

scribes him admiringly as the most avid hunter and fisherman he ever knew.

"The summer I worked at my father's plant, between my second and third years in art school, we would check in every morning at 6:59 on the dot. Same parking spot, same place. Lunch buzzer would ring at 12:00. At 12:29 the lunch buzzer would ring again. At 3:28, everybody'd line up at the time clock, punch the clock, and make a beeline for the park-

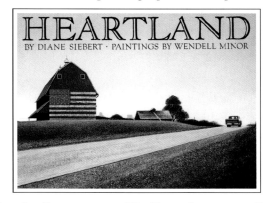

ing lot so you could be the first one out. You'd get home, scarf down dinner, and you'd be gone. You'd be out fishing until dark.

"On weekends my father was gone every Saturday and Sunday, out in the woods. He'd sit in the woods all day long by himself. . . . And it didn't really matter whether he got anything or not. He was like an Indian.

"I remember him getting angry with me once. I said, 'Pa, you're so good at this, why don't you start your own repair shop for rods and reels and guns?' And he said, 'You don't understand. I have to earn a living.'"

Built on an island in the Fox River, Aurora was then "like a miniature Manhattan," with the Leland Hotel as "our Empire State Building." Wendell remembers it as a wonderful time and place, with streets overarched with trees, before the devastation of Dutch elm disease. "Oh, you know, burning leaves on fall afternoons and football games and high school homecoming floats." Plainfield and his grandfather Sebby's gas station were fifteen miles down the road. Until he was eleven, when his younger brother, Kent, was born, Wendell remained an only child.

"Of course, you can't separate the place from the time. It's

totally different now. Aurora, like many towns in the heartland, has lost its identity to the shopping mall."

Diagnosed early in childhood as having a heart murmur, he was supposed, on doctor's orders, never to exert himself physically. Sports were out. Consequently, he turned to drawing. Slow to read, because of dyslexia, he was put in special reading classes and felt, in all, "very stupid." But when in fourth grade a classmate accused him of having traced a buffalo's head that he had drawn freehand, Wendell sensed he had something others did not. He began doing sets for school plays and knew—*"I just knew"*—he was destined to leave Illinois.

In sixth grade, a favorite teacher, LaVerne Gilkey, would have the class put their heads on their desks every afternoon for forty-five minutes while he read aloud from Mark Twain, Edgar Allan Poe, or Jack London. "'To Build a Fire' is engraved in my mind forever—and seeing, just imagining the cold and winter landscape. And that was the beginning of recognizing that I had this need to put pictures and words together."

Once, when he brought home a report card with four A's and a B, he was lectured about the B, told it should have been an A.

In high school the pressures grew worse. The memory still haunts him. "Someone asked recently, 'What is your life like?' I said, 'It's like walking into a classroom and the teacher says, "Put everything under your desk. We're having a pop quiz."'" He saw himself surrounded by others naturally smarter and more talented than he. "My longtime nemesis, James Groniger, was an all-letter man, straight A's, perfect, did everything perfectly, and it always bugged the hell out of me. . . . I remember once we had to write an essay about another person in our class, and much to my surprise, Jim wrote about me. And you had to guess who the person was. And I remember—all I can remember—was 'His clothes are always neatly pressed and his shoes are always shined.'

"And it was about *me!* I was so flattered that he, out of the entire class, picked me to write about. 'Cause you know we all looked up to Jim . . . 'cause we all wanted Jim's approval, and that becomes projected on everything you do in life. Even though my father's gone, I'm still looking for my father's approval."

After high school, he went to work in a slaughterhouse, "doing everything nasty" and saving money while living at home. His father knew his plan and disapproved.

"When I had money enough saved to go away to my first year at art school, he took me down to the Chevy dealership and let me try out a brand-new '64 Chevy convertible on the pretext that he was going to buy one. Then he said, 'Why don't you buy this, Wendell? Don't you think you'd like that? Wouldn't you like to stay home and maybe get a job at the factory and buy this new car? You don't want to go away.'"

"I said, 'Pa, you don't understand, I gotta do this.' And I think then he understood how much it meant to me, because I could turn down a Chevy convertible."

My father too, I told Wendell, had offered me a car if I would stay home in Pittsburgh and go to college there.

"Same thing! Same thing!" Wendell exclaimed. "But you know those ghosts are the fuel that drives the wheels that make the motion."

"Yes, sure," I said. "But you love what you do. You're on vacation every day."

His face lit up. "You think that shows?"

The appeal of the Ringling School of Art and Design in Sarasota was threefold, he remembers: Florida was warm, far from home, and cheap—$1,500 a year, supplies and housing included. "We had this little old school bus that would take us out to De Soto Lakes. And so my earliest impressions of painting were in natural light. Study nature!"

Instruction was under a cantankerous former New York magazine illustrator and landscape and portrait painter named Loran Wilford. "He'd say, 'God dammit, you're not doing it right.

Gimme that brush.' And he would just lay it in and say, 'Now look! Look at the horizon.' And, 'You've got to get this right!' And then he would make us paint portraits with a three-inch brush. He'd say, 'Forget the details, look at the planes.'

"There is not a day goes by that I don't think of him."

At the start of his second year at art school, at age twenty, Wendell underwent surgery due to complications related to his heart murmur, an operation he barely survived. The experience profoundly changed his whole outlook. "I think I saw then that life is short, and that if you have a direction and more ideas than you know you can fulfill in a lifetime, you tend to be very careful about how you spend your time."

From movies he had seen, books he'd read, he also knew he "belonged" in New York, and arriving in the city in late summer 1968, with one suitcase, a portfolio, and a new sportcoat, he felt he had come home. Hired by designer Paul Bacon to do book jacket designs, he soon saw that the quantity of work he could get would be limited only by how quickly and efficiently he could read the manuscripts. So the former dyslexic taught himself to speed-read.

"Paul is the father of modern book cover design. He taught me respect for the written word. 'Read the damn book. Give it a sense of time. Give it a sense of place.'"

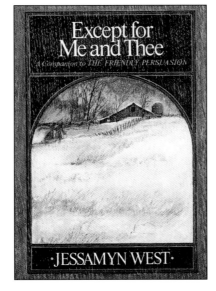

His first illustrated cover, done over Thanksgiving weekend, 1968, for Jessamyn West's *Except for Me and Thee*, remains a favorite and contains many of the narrative qualities and design elements to be found in much of his work.

Written as a companion to Jessamyn West's earlier novel, *The Friendly Persuasion,* the story is of a struggling Indiana Quaker family of the last century, and any of several strong characters or dramatic turning points could have served for the cover. Instead, in Wendell's hands, the image becomes what he calls a mental snapshot of the essence of the book.

Painted in a brown, blue, and black monochrome, with touches of yellow, and composed of only a few elements, its strength is largely in its simplicity, in how much is left out, left to the imagination.

A nighttime, rural winter landscape deep in snow is framed by a plain Victorian window. We are inside looking out from the warmth and security of a farmhouse presumably. Two tiny figures, a man and a woman, are dimly seen in silhouette making their way through driving snow to a lone barn on the horizon. The long coat and bonnet on the woman, the length of her scarf trailing in the wind, suggest a time distant from our own. There is a half-buried snow fence. A wooden silo and a few bare trees also mark the horizon. The rest, as much as three-quarters of the scene, is empty, snow-covered foreground, without a footprint nor trace of man nor beast. It would be a prospect of almost unrelieved bleakness, if it weren't for the lighted lantern in the man's hand and a still stronger, warmer light in a window of the barn.

Wendell, who is but one generation removed from struggling middle-western farmers on both sides of his family, talks of the "primal instinct to check your livestock, to make it to the barn in the blinding snowstorm." Life and light move through cold and darkness drawn by life and light.

"A good cover *has* to have a sense of time and place, a sense of the atmosphere of the book," he continues. "I think of it as a picture puzzle with one or two pieces missing. Only by reading the book will they be found. There needs to be enough ambiguity so people project their own feelings into the image. It shouldn't rob us of our own imagination the way television does."

The appeal of homely, foursquare buildings, the vernacular architecture of America, and of the rural heartland especially, is an extended refrain through all his work. Farmhouses, barns, roadside cafés, gas stations, Main Street storefronts, and grain elevators appear repeatedly. Nearly always they are of an earlier time and rendered always as the clear, unhesitating statement of someone who knows exactly how such structures sit on the landscape, how they were built, when, and by whom.

The window is an important, repeating element, a kind of proscenium arch. Sometimes, as in the cover for *Except for Me and Thee,* we are inside looking out—the scene for Larry McMurtry's *Terms of Endearment* is also a vivid example. In others, we are outsiders, as in the painting for *The Year the Lights Came On,* a novel by Terry Kay set in the days when rural electrification was changing much of the country. A boy in checked shirt and blue jeans, his back to us, stands looking into the bare kitchen window of an almost painfully stark frame house. In the window a single light bulb hanging from a cord blazes above a plain kitchen chair and table. It is a stage set bare of its actors, one of whom, surely, is the boy and he, we know, understands as we do not, all that has happened there, on the other side of the thin clapboard walls. But because his face is turned from us, we must compensate with imagination.

The novel is largely autobiographical. But so also is the painting. "Exactly like you," the author's wife told her husband when she first saw the dust jacket, remembering how he had looked in his youth. And clearly it could be Wendell Minor, too, coming of age in Illinois.

There is a dreamlike, surrealistic quality here and in others of the paintings. Some are outright scary, as intended. In the paintings for Mary Higgins Clark's *Where Are the Children?* and *The Auctioneer* by Joan Samson, the focal point—a Cape Cod house in one, a Maine barn and auctioneer's truck in the other—is lit as bright as day, incongruously, unnaturally, against a sky as black

as night. For a collection of stories by Michael Rogers titled *Do Not Worry About the Bear,* the effect comes from a giant full moon rising over a mountain lake—a sorcerer's moon, the ultimate moon on the ultimate crystal night—in juxtaposition to its reflection in the water, where we see the face and beady red eyes of a great bear.

A compelling silence reigns in all three of these scenes. But then an air of quiet, of perfect stillness, is characteristic of so many of the paintings and a considerable part of their pull, and increasingly so in a market where so much of what is published visually shouts for attention. A Wendell Minor cover for a reissue paperback edition of Harper Lee's *To Kill a Mockingbird,* as elegant, still, and haunting as any he has done, is said to have

increased sales of the book by 75,000 copies.

His love and respect for nature are manifest in nearly everything he paints. Long prairie horizons reach to huge prairie skies,

the whole panorama sometimes wrapping around the book from front to back. Winter storms build. Morning mists hang over upcountry Minnesota. The spectacular profile of a bighorn sheep is seen so close up and exactly that it is as if we could count each hair. The human figure in nature is nearly always small in scale, thereby enlarging both the grandeur of the landscape and the effect on the human spirit.

But it is perhaps in his handling of the simplest of everyday objects that Wendell is at his best. He invests them with interest, with story, in a way few artists can. He makes an event of the commonplace. It is one of his greatest gifts.

In a small audience survey of my own, I asked some of my family to look through forty-odd prints of Wendell's book jackets and tell me which especially appealed to them. Among the unanimous choices was *The Great Santini* by Pat Conroy, where the single design element is a worn Marine Corps flight jacket on a wire coat hanger. "It's a coat of action, the coat has a story," said one of my sons. "I think there's great heart in it," his wife added. "The way the elbow bends you can almost see the arm that was in it."

And then there are the paintings in which the object, the icon at the center of the composition, is a machine of one kind or other set alone in a landscape. It is perhaps the strongest theme of all, and invariably the machine is painted with the same care, the same obvious affection given the natural setting.

There is the sumptuous Packard parked on a beach in the cover for Anton Myrer's *The Last Convertible;* a stately old upright typewriter set incongruously on a beach with blue ocean behind for Garrison Keillor's *We Are Still Married;* a prefabricated windmill on the Nebraska plains for Willa Cather's *O Pioneers!;* a Russian factory ship in an Arctic sea for Martin Cruz Smith's *Polar Star;* and others: tractors, cars, airplanes, and trucks, many trucks, including most eloquently the faded blue 1950 Dodge sitting in the grassy field.

The son of the machinist who loved nature paints the machine in nature again and again.

For a considerable time he felt down about his work, discouraged that it was leading nowhere. "I went through a number of years thinking what I was doing was insignificant, of no consequence, and that I should be doing serious painting. And then I think painting in New Mexico several summers made me realize that it was me and only me that was restricting. And I just decided that I was going to make what I do for book covers the best kind of art form I could make it be.

"Oh, I used to be very traumatized and upset about not getting into a certain competition and I would sulk around for weeks at a time. I remember before I could ever get into the Society of Illustrators' Annual National Exhibition—it took me four years of entering before my first piece was accepted—and I would go to the show and I'd look at all this wonderful work and I'd go home and be depressed and I'd say, 'Well, damn it, get to work and get better!' "

After years in New York, Wendell and his wife, Florence, have resettled in rural Washington, Connecticut, where they turned an undistinguished matchbox of a house into a home of exceptional charm. They are serious collectors of antiques. His drawings and paintings, plus a few others by friends, fill the walls. Two prized cats have the run of the place.

His studio, a single, spacious white-walled room, is over the garage, and as in the house, everything is in perfect order. Custom-built cabinets, storage units, work surfaces are arranged for utmost efficiency, while at the center, like the focal point of one of his paintings, is a vintage oak drawing board, perhaps a hundred years old, with side drawers and a heavy cast-iron base. Looking up from his work, through windows on three sides, he sees only woods.

Preliminary sketches are done in pencil (sometimes colored pencil) or watercolor. The finished work is in acrylic, more often than not, though he uses oil on occasion and enjoys watercolor above all. Whichever the medium, he works extremely fast.

The computer, too, has become a mainstay, and he will describe the changes it has brought with the ardor of a convert.

"I can scan a preliminary watercolor sketch into the computer and see immediately how it will work with type. I can toy with the color, magnify or reduce the sketch as I wish, call up any of three thousand different typefaces. Instantly!"

He has become proficient, as well, in the latest digital technology for design and printing. For it is not just that he does the illustrations for his covers, but the entire scheme—typography, design, mechanicals—and the use of type is never an afterthought, always an integral part of the composition.

Very little about any part of the work, however technical or mundane, is bypassed or left to anyone else, other than his wife. Wendell attends to it all and to the smallest detail, as if wary that anything less might lead to a breakdown in the system. He has no agent, preferring to negotiate assignments himself ("I enjoy dealing with people in that regard"). With a completed piece ready to be sent to the publisher, he packs, wraps, and tapes the package, expertly, perfectly, without a wasted motion, his hands flying. The label on the package is of his own design.

Until a few years ago, when he became president of the Society of Illustrators, Wendell had time, too, to read all the books assigned, but now about half are read for him by his wife, Florence, who does a detailed written report and marks those passages she thinks essential for him to read. A former film editor, she is particularly skilled at seeing the visual possibilities in a manuscript and he has come to depend on their discussions of each cover before beginning work.

"She has an acute sense of the importance of the cover to the marketing of the book," he says, "and that's all become such a big part of it. Used to be the editor and the art director decided. Now everybody has a say—the marketing division, the subsidiary rights people who show the cover to the book clubs, the advertising division, the author, the author's agent, maybe the agent's wife. And then it goes to the sales conference where the salespeople can take a crack. . . .

"There's nothing that goes out of my studio that Florence doesn't approve."

She was Florence Friedmann before they were married in 1978. With her thick curly black hair, her lithe good looks, she could be a model. Possibly, she is even more efficient and orderly than he. "The best organizer I know," he insists. "If I ever stopped moving, I think she'd put a label on me."

Over the years Wendell has received more than two hundred professional awards. He has had several one-man shows. His work can be found in the permanent collections of the Illinois State Museum, the Muskegon Museum of Art, NASA, the Air Force, the Museum of American Illustration, the Library of Congress, as well as many private collections, including those of a number of authors whose books he has worked on.

But it is the work itself that matters above all. Of his financial success or money in general, he says little. "Money doesn't buy class. Money doesn't buy creativity and it doesn't buy intelligence," he observes, but then acknowledges what he calls his blue-collar need for a feeling of financial security.

"Most of my pleasures are internal—walking to the town green to pick up the mail in the morning and noticing a spiderweb that has been built the night before . . . the shell of a locust under a leaf . . . the sound of nature. Sitting down with watercolors in the weeds and recording a passing moment."

While lecturing in Italy for a week last year, he found time to do seven superb watercolors. This summer he will go on a pack trip in the Big Horn Mountains of Wyoming, again taking his watercolors.

"I feel like the perpetual student. I feel I'm just getting started all the time. Nothing has ever been boring for me. Every time you pick up a watercolor brush, it's like being a novice all over again."

His time best spent, he also says, is still his time at the drawing board. "To me my drawing board is my universe. And a universe I can control. I can create a sense of peace within myself. . . . And let's face it, as creatures of nature, we have damn little chance to have a sense of peace. I'm trying to find it for myself, and in doing so, maybe give a split second of peace to someone else. . . . I don't know how many people have said, 'That's my grandfather in that painting.' They project into the paintings the same kinds of feelings that I felt. And to me there is no award that can match the ultimate sense of communication. . . .

"Doing the North Dakota stamp was probably the most anonymous piece of art I've ever done, but everybody in the United States got to enjoy it."

"And you enjoyed that?" I asked.

"And I enjoyed it. Yup!"

The North Dakota stamp appeared in 1989. The year following, in Illinois, Gordon Minor died at age seventy-four, and Wendell learned that for years his father had been boasting about him and his success.

"It was after his funeral. My mother said, 'You know, your father always bragged about you to everybody, but he could never tell you.'"

In our conversation under the elm tree, I asked Wendell what he knows now that he didn't know in art school.

"That simpler is better. And having the intelligence and the confidence to do it simpler takes a lifetime."

At fifty, he feels different about himself than in times past. "For years I struggled against what I really was, and this is basically a pretty simple person with very simple tastes and a very simple perspective. And I finally decided, what the hell's wrong with that!"

As an artist he is at the top of his form, and the publication of so much of his work in this book, all in one place for the first time, is a major event, both a handsome tribute and recognition of a kind long overdue. With certainty, there is more to come.

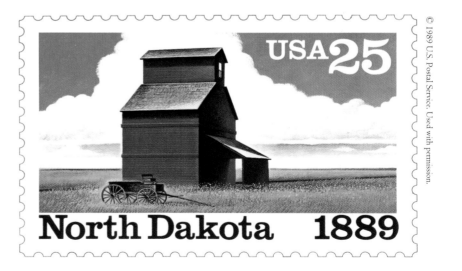

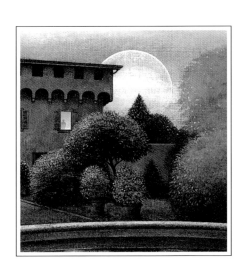

A CONVERSATION WITH PAUL BACON

WM: Paul, when did you design your first trade book cover, and who did you do it for?

PB: It isn't easy to remember because it was 1950, but it was done for E. P. Dutton and it was a book called *Chimp on My Shoulder* by a friend whose name was Bill Westley. Bill knew I was an artist and he said, "Would you like to illustrate my book?" I had never done anything like that before, and I said, "Hell, yeah. I would." I did the illustrations, which were black-and-whites, and Bill liked them and said, "I can't promise anything, but why don't you do a jacket and let's see what happens." So I did a couple of sketches for the jacket, and they didn't pick my favorite, but they did pick one.

That was the beginning of it. I didn't realize at the time that it was the beginning of a new career.

What I was really interested in back then—and doing a lot of—was album covers. I thought of myself, if anything, as a jazz-oriented person. I was writing and reviewing jazz records for *Record Changer* magazine. Then, when Riverside Records was start-

ed by the same guys that ran the *Record Changer,* I sort of automatically started doing the album covers which, of course, were ten-inch LPs then. Stuff like Sidney Bechet, Louis Armstrong, the classics.

WM: And your love of music and practice of music persists to this day, and has probably been your alter ego all these years?

PB: Right. And I think, as I have said before, that it has probably kept me sane.

Bill Grauer and Orrin Keepnews were co-owners of Riverside Records. They came up with a plan to make a package of records for which I did a dummy cover. Now Orrin also happened to be an editor at Simon & Schuster. This is where the real connection was. Tom Bevans, who was the art director at Simon & Schuster, saw my work and said to Orrin, "Who is the guy that did that cover?" and Orrin said, "He's a pal of ours, Paul Bacon." Tom said, "Tell him to come see me." I did, and he had no idea what I could do; neither did I. This was by now around

1952. I had not done a book jacket in a couple of years, and I would never have said I was a book jacket designer.

WM: At this point, you thought of yourself as a graphic designer, not a book jacket designer. Did you think of yourself as an illustrator?

PB: No. I didn't think of myself as an illustrator at all. I thought of myself as a Swiss-influenced designer, thanks to my former employer, Hal Zamboni, who was a Bauhaus man.

WM: In a way, my walking into your studio having notions of being a designer and not an illustrator was very much a repetition of your experience.

PB: Very close. When I went with Hal Zamboni it was 1946. I was right out of the Marine Corps and I didn't know a goddamn thing about anything. I could barely find my way around the streets of New York, let alone through an art studio. I started totally from scratch, never having been to an art school, just an excellent high school, which was not so unusual in the forties.

WM: Wasn't the apprentice system still pretty much intact back then?

PB: Yes. You got a job for very little money, but you got a job with somebody that you thought was good, and then you started learning.

We were a three-man studio with Hal and his brother and me, and I liked that setup. I was making thirty or forty dollars a week, which was standard at the time. I learned a lot under the gun that I would never have learned if I had gone with a big agency.

WM: When you matured and went into business for yourself as Paul Bacon Studio, you maintained that tradition of one or two designers and a skeletal staff, as it were, didn't you?

PB: Yes. By the time I became a studio, which was 1955, I knew that what I really was was a book jacket guy who still did album covers, instead of the other way around.

WM: Were you hand-lettering your jackets at that time, as well?

PB: Yes, except I was hand-lettering to simulate type. It had not occurred to me then that I would become a letterer who would invent alphabets.

WM: I see. Everything at that time was cold type, correct?

PB: That's right. Either linotype, monotype, or hand-set metal. And if you could afford it, which we mostly couldn't, you could get photolettering.

WM: And you still do a lot of hand-lettering, don't you?

PB: Yes, I still do. Over the years, I have probably in a half-baked way designed around two or three hundred typefaces, although I seldom go beyond eighteen or nineteen characters. I have always been tempted to develop one or two of them, but never have.

I have worked for just about everybody, as you know. I think I have not missed very many publishers over the course of my forty-odd-year career. With Simon & Schuster alone, I've worked for one company for forty-two years.

WM: That is amazing. And as a matter of fact, I consider it amazing that I have worked for S&S for twenty-four years.

PB: That is no can of corn, either.

WM: I don't think that will ever happen again.

PB: I don't think so either. It's the kind of thing like with Robin Yount, the wonderful ballplayer who retired from Milwaukee and never played for another ball club. He had a Hall of Fame career for one team. That kind of thing is not going to happen again either.

WM: What is your opinion of typography today since it has been digitized and all the rules have been broken—or at least it seems that way?

PB: It irritates the hell out of me. Let me rephrase that. I see many, many things that I think are gorgeous. I have seen jackets today all over the place that I realize in the 1950s would have looked like the Sistine Chapel. So beautifully done, such a level of illustration and printing—the whole attitude. I would love to be able to say, "It's not like it was when I was a boy." But it ain't true. There's a lot of brilliant stuff out there.

But by my hard-nosed Chicago standards—which were taught to me by the Zamboni brothers—a lot of the type is awful. People don't know what the hell letter space is or air space is.

I have seen titles and authors' names on books that fifteen minutes' work by somebody who knows what character spacing is would have improved immeasurably; somebody who says, "What you have to do is move the *A* about an eighth of an inch to the right and the whole balance of the word will be much better." That kind of stuff is now considered nitpicking.

WM: Do you think that that kind of discipline and that kind of "classical quality," if you want to call it that, is forever lost, or do you think it will be recycled?

PB: I think it is forever lost, and I will tell you why. When you and I started out, if you couldn't letter ten or twelve typefaces from memory pretty accurately, if you had to consult a type book in order to letter Futura or Garamond or Bodoni, you wouldn't be considered a lettering person at all.

Today, it's almost like saying to somebody, "Why don't you get those steel radial tires off your car and put on these nice old single-weight tires." They ain't going to do it.

WM: How does one achieve a classical sense of typography without some historical reference point?

PB: I don't know. I wonder what kids are reading today. The Bible for me was *Gebrausch Grafik.* That magazine introduced me to my first heroes in the graphic arts. The monthly issue of *Gebrausch Grafik* would come in, and here would be Hans Erni in Switzerland and John Minton in England and all these guys that became the giants. They were the Babe Ruths, as far as I was concerned.

That was a liberal education. Without some kind of indoctrination into what the possibilities are, if you don't know the world record, you can't be a world-class broad jumper. If you want to be an illustrator, if you think you can be just as good as Stevan Dohanos—who was an admirable illustrator, no doubt about it—it's not going to work today. You have to know what the boundaries are now.

WM: I know we are probably getting off on a tangent here, but when I came to New York in 1968, I got many comments (you were one of the few exceptions) to the effect of, "You do too many things, Wendell Minor. You do graphic design, you do a little illustration, you do lettering. You have to be known for one thing." In fact, I found the opposite to be true.

And I am finding that today, things have come full circle. It

seems to me that the more multifaceted you are, the better your survival skills and your survival will be.

PB: I think so, too.

WM: Let's get back to your development as, in my opinion, the first and foremost book jacket designer of modern times. How do you feel about your career? How it has developed? And which of your covers stand out most in your mind?

PB: I think the turning point, if there was one, was certainly *Compulsion* by Meyer Levin, which was published by Simon & Schuster in 1956. It was a hell of a good book, and they knew it, and I knew it, and I was very pleased and sort of honored that they would entrust me with this thing because I knew it was a biggy.

WM: Was it a best-seller at the time?

PB: Yes, it became a best-seller.

WM: That was your first big success?

PB: Yes. And it was a hard process, that jacket. I slaved over it. I did a couple of things that were god-awful. I was really getting nowhere when suddenly, in sort of a burst of despair, in fact as a reaction against all the careful lettering that I was doing, I just wrote out the

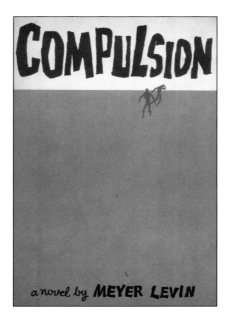

word "compulsion" with a big brush. Then I touched it up and said to myself, "I think I've got something here."

When I sent it over, I thought the phone would ring and the art director would say, "What the hell is this? This doesn't look like your work." But the response was very positive.

WM: That was your transformation into the world of fiction?

PB: That book made me a guy who could do fiction and could deal with a "big book."

WM: It has been stated in some circles that you are the father of the best-seller look, and I know that is a label you do not appreciate. Could you clarify how that makes you feel and how you see yourself?

PB: I see myself with a considerable range. Look, people have said, "I can always pick out your jackets." But I always secretly think that I have a few I could show you and I guarantee you wouldn't know they were mine.

I don't like the idea of being typecast, but what people associate me with—and God knows I'm not the only perpetrator of this by any stretch—is the idea of very powerful typography with a small and evocative image. Not an illustration, but a kind of synthesis of design and illustration, a thing that can be used as a logo for the book.

WM: A graphic art piece?

PB: It is in some way a logo. On *Compulsion* it was the two little guys that went with the big word.

WM: Some of your jackets I remember distinctly are *Confessions of Nat Turner* [by William Styron], *We Bombed in New Haven* and

Catch-22 [by Joseph Heller]. . . . *Compulsion* is obviously cemented in your mind in much the same way my first successful book jacket, *Except for Me and Thee,* by Jessamyn West, is cemented in mine. What other jackets do you remember that speak of personal triumphs?

PB: I did a lot of my best work for Harris Lewine, who worked at Macmillan, Harcourt, Holt Rinehart and Winston, and Warner. He was a wonderful and very demanding and marvelous art director to work for because if he really liked the thing, he would fight tooth and nail for it, which cost him a few jobs. But that is beside the point.

Frank Metz at Simon & Schuster is another wonderful art director. He has always been satisfying to work for because basically, he is a serious man, and you always feel that you are being entrusted with something—things like *The Secret of Santa Vittoria* by Robert Crichton, who was Michael's cousin.

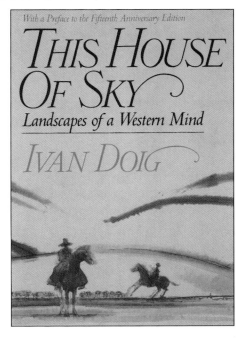

WM: And of course, *The Andromeda Strain* by Michael. That was a big one.

PB: Right. I did all the early Crichtons.

WM: And what about *Sophie's Choice* [by William Styron]?

PB: I was going to say that the one project that probably changed the direction for me personally in some ways was *Sophie's Choice* because it was the first big book I had ever done, I think, that had no illustration on it whatsoever.

WM: Strictly typography—and that was hand-lettered, wasn't it?

PB: All hand-lettered. It was an eye-opener because it dawned on me that I could make something that looked important and was very satisfying as far as I am personally concerned without having to worry about any image. Only the title and the author. That was kind of a lovely discovery for me.

WM: This is interesting because this is where you and I kind of departed. You, as the Swiss designer, gravitated toward more of a graphic solution; I took more of a pictorial direction, and my typography took a secondary importance.

PB: True, but your typography always seems to be very, very carefully chosen and done to exactly complement the illustration, which makes nothing but good sense to me.

WM: Before I go on further, are there any other jackets that you feel were especially important to you?

PB: The one that I really have a soft spot in my heart for is *This House of Sky* by Ivan Doig. That got me into the Society of Illustrators annual exhibition.

WM: I remember that. A beautiful watercolor-washed sky and there were some silhouettes on a horizon?

PB: Yes. A father and son, both on horseback. And it was a wraparound, and it's really still a pretty nice jacket. I still like to look at that one.

WM: I distinctly remember *Confessions of Nat Turner* as being a beautifully constructed jacket of typography.

PB: It is all hand-lettered, but it is hand-lettered to look like wood type, which made perfect sense, and it has just got the one image of the black avenging angel. I forget where that came from—I may have stolen it partly from William Blake—but it seemed appropriate.

WM: What about *Catch-22?*

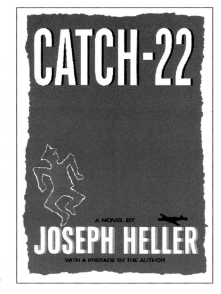

PB: Well, *Catch-22* is a special case, sort of independent of me. I think I did twelve comps for that jacket. I might do different lettering today, but they're reissuing the book just as it was, and I still like it, thank God.

WM: That sounds familiar, doesn't it, Paul? Do it over until you get it right?

PB: Oh, man. Bob Gottlieb was, and still is, the most brilliant editor I have ever met. Exasperating, and great fun to work for.

WM: And I remember my days of meeting Bob Gottlieb and working with him and he would say, "Well, you know, it's not there yet." He would always tell you when it wasn't right. He

wouldn't necessarily give you any clues, but you knew you had to go back and rethink it.

In that same vein, I remember doing nine sketches on a Michener and twelve sketches on a McMurtry because you feel that no matter how much you may have failed on a given image, you know you have got to come up with another one.

I think that is basically the quality one must have to be a creative cover designer. You can never say there is not another image.

PB: If you wanted to give up, you could. But I never did. I was always a bulldog about it. And you have a strong strain of bulldog in you, too.

WM: Philosophically speaking, you are a man of many parts. You were a teacher and a mentor of mine, and you are probably one of the most intelligent, sophisticated people I have ever met. I recall sitting in your studio—was it 2 West 45th Street?

PB: 2 West 45th, you betcha.

WM: We would listen to Karl Haas on the radio and talk about opera or historical events or events of the day or wine or food.

PB: One of the things that always charmed me about our place was that we were doing good work, but we were also listening to country music and Louis Armstrong. There was a streak of earthiness and vulgarity and joy about it. There were a lot of different appetites, is what I am trying to say. I think we all fed on that. I never heard anybody really be pompous about anything.

It was a great place to work, wasn't it? There were a lot of different kinds of people there.

WM: I will never forget the experience.

And I must tell you that it was working for you and in pub-

lishing that gave me an education that I never got formally. If you recall, Ringling School of Art and Design wasn't even accredited in those days, so I got a three-year commercial design certificate. I had had trouble reading all through school with a slight dyslexia problem, and it wasn't until I got into publishing and learned how to speed-read, and got into the environment that you had at that time, that every subject was open for discussion for me. I would say, "Paul, what do you remember back in World War II about such and such?" or, "What was going on at this specific point in time?" and we would talk about it. You would be a sounding board—literally a walking encyclopedia—and that was the greatest of educations.

PB: Do you remember the comps we used to do, those beautiful hand-done comps with all the stuff lettered in poster paint on acetate?

WM: Absolutely. I would spend hours doing them.

PB: Right. That was the kind of thing that I suppose would be considered a mere frippery today.

WM: I think what I carried away from you is your tradition, the love of reading, the love of being faithful to what you are reading. I remember you saying if an author is going to take six months or three years to write a book, you better damn well read it.

Since this book is called *Wendell Minor: Art for the Written Word*, it is basically about how visuals honor that written tradition and about being faithful to it.

PB: Right on the money. You know, I just don't remember—how did you come to see me in the first place?

WM: Well, I worked with Brad Holland at Hallmark Cards in Kansas City in 1966. Brad came to New York in 1967, and encouraged me to do the same. I always wanted to come East, but his having already made the trek and offering me a place to stay temporarily was just the impetus and the encouragement that I needed.

I remember arriving Labor Day of 1968, with my trunk and portfolio in hand, and fifteen hundred dollars cash in the bank after having sold my brand-new 1968 Volkswagen. And I started looking for corporate design work. I was interested in annual reports, having had a little agency experience and knowing that I really didn't want to go the advertising route.

At the time Brad had been doing some work for Alex Gotfryd at Doubleday, and Alex said to Brad, "Do you know how to do a comp?" and Brad said, "Of course." When Brad showed up with pieces of tracing paper taped together, Alex said, "Let me show you what a comp looks like." He handed Brad a Paul Bacon sketch and just about blew Brad's mind with all this beautiful hand-lettering, just like a printed piece.

So Brad came home that night and said, "You know, you ought to put Paul Bacon Studio on your list." I said, "Oh yeah? Who is Paul Bacon?" and he said, "He's a jacket designer and his work is fantastic."

So I immediately went to a bookstore and started flipping books over to the back flap of the jacket—a habit I have to this very day—and I was amazed to see how many jackets had a Paul Bacon or Paul Bacon Studio credit line.

PB: Yes, we were doing a lot of them.

WM: When I came to see you, you had just lost a designer; you were looking for someone. And I had a mixed-bag portfolio: a little bit of Hallmark, a little bit of small-town agency. It

showed my interest in a lot of different things, and you said, "I see you can comp letter," and I said, "Yes, I can."

However, I spent the first six months at Paul Bacon Studio tracing out of a type book at night. Needless to say, I got the job done.

PB: That was the essential thing. Whatever it is you didn't know, I knew instantly when I looked at your portfolio that you would make a good jacket designer. I never had the slightest doubt.

WM: Well, I think sometimes serendipity plays a large part in how we develop. I will never forget that first Monday morning. You said, "I think I have a manuscript for you." And you threw *Man's Past, Man's Future* [by Stephen Raushenbush] at me. And I remember learning how to speed-read that day. I think before the day was over, I had a comp.

PB: This is where I felt that, "Bacon, always trust your instincts." You proved almost within a matter of hours that you were exactly what I thought you were.

WM: I think my second jacket was *The Liar* by Thomas Savage, which was a parody of the Arrow collar man with a stickpin running through the image. Then there was *Except for Me and Thee*, which I did over the Thanksgiving holiday on a piece of wood the same size as the book jacket. I worked all weekend on that. I think I showed it to you on Monday, and it was accepted immediately.

PB: With a shower of sparks. Obviously, if I needed any corroboration of my brilliance, that was it.

WM: So I began to think, "Maybe I can paint pictures and make a living at it!"

That was the first glimmer of hope. I may have mentioned this to you in the past, but I used to put in between eighty and ninety hours a week for you, even though I was getting paid for forty, because it took me that long to do things sometimes.

PB: To be honest with you, I didn't know that. All I knew was that the work was good.

WM: In a sense I was doing it for myself, because I knew I had to improve.

I worked for you officially until early fall of 1970, and I distinctly remember October 5, 1970, as the launching of my freelance career.

PB: Right. Totally on your own.

WM: At that time, you dissolved the studio. But then I thought maybe you would want a studio mate.

PB: Right. We shared the place.

WM: And that lasted until 1973. I moved to Greenwich Village in May of 1973, and that is when I finally got my own work space.

What I especially recall in sharing the studio with you was having you to bounce ideas off of, and saying, "Paul, what do you think of this?" My biggest fear was working by myself for the first time and not having anyone but my cat to give me criticism.

It was a tremendous adjustment for me, and of course, I was still single in those days, from 1973 until I met Florence in 1976. During that period of isolation, I started to paint in New Mexico in the summer. The summer of 1974 was a quantum leap forward in terms of my illustration because I remember taking an assessment of my work. Beginning in 1972, I was doing about 150 book jacket designs each year, and I suddenly realized

that I wasn't getting enough of my personality into the graphics. I wanted more of a personal commentary. Even though I had been doing some illustration, I had not made a total commitment to it. So I went out to Santa Fe and painted thirty landscapes that summer, and came back with a renewed vigor about making a serious commitment to illustration.

PB: That is the line of demarcation?

WM: Right. At that time, I did Toni Morrison's *Sula,* and Judith Rossner's *Looking for Mr. Goodbar* . . .

PB: That was a powerful jacket.

WM: . . . and *The Auctioneer* [by Joan Samson]. I was still doing graphic things. I did *All the President's Men* [by Carl Bernstein and Bob Woodward] in 1975 as well, and that was a collage. For a long time I did a combination of graphics, collage, montage, and sort of quasi-primitive illustration, which I still do occasionally. It was basically just a slow evolution of experimentation.

PB: I always thought that the pencil drawings you did of Eleanor Roosevelt were pivotal in your career.

WM: Yes. That was a children's book written by Jane Goodsell and published in 1970 by T. Y. Crowell. My very first fully illustrated book. I did twenty-two illustrations plus a color cover.

PB: They were really good. I could see something was happening there. You were finding something that was going to be very valuable.

WM: It's interesting because I wanted to illustrate children's books at that time, but the mathematics did not work out. That whole book paid very little, and I was working around the clock.

I remember when I was working for you, I would work twelve hours a day, and then go home and work another six hours. Those were the years that I literally put in eighteen- or twenty-hour days as a matter of course.

PB: In some ways, I think we are like opera singers. You get hired to sing in a specific opera because they think you have got the kind of voice that can handle it, and you are physically not too bad for the part, and as long as you can still sing, you are going to do your performance and you are going to work.

In a sense we are performers, and we have to do our best performance under the same kind of time limits. The curtain goes up as soon as you sit down at your drawing board.

WM: As you know, too, a lot of times we get involved with so many assignments at once, we are under pressure in a collective sense. Sometimes the pressure is so overwhelming it almost cancels itself out. I have often likened it to getting yourself caught in a maze, and the building is on fire, and you had damn well better find the way out.

PB: The big clock is ticking, baby.

WM: I currently have enough assignments that will probably take three times the amount of time I think they will and if I really dwell on it, I'll break out in a cold sweat.

You get up one day at a time, you give it your all every day, and the image I liken it to—it may not be very romantic—is that of a plow horse. You put the blinders on and you do your job. And at the end of the day you realize, "Gee, I plowed quite a few furrows."

I'll bet you've probably done over three thousand covers in your career.

PB: Try eight thousand.

WM: Eight thousand? You blow my mind, my friend, because I have never done an accurate count, but I know I've done between fifteen hundred and two thousand, somewhere in that vicinity. . . .

PB: Remember that in that count is a lot of stuff that was not done unaided.

WM: Okay. But I meant things that have come through the studio?

PB: Yes, I think we are at something like eighty-seven hundred.

WM: That is an incredible legacy, I would say.

PB: It's a small town library.

WM: It certainly is!

PB: There's a lot of stuff that I hope they don't trace back to me, but there's lots of good stuff too. I think that in terms of sheer output, it is kind of a frightening number, but what it represents is forty-odd years, and some of those years I worked like a damn fiend, same as you do.

WM: Sure. You were an incredibly bad influence on that score, or a tremendously good one, because you worked as hard as anyone I had ever met, and I knew that I should do the same.

PB: Didn't it seem to you that there was no other way to do it?

WM: No, there wasn't, because I think the one finite thing about creativity is that it's a void that can't be filled by any one person, or any one event, or any one thought, or any one physical act. It has an insatiable appetite. No matter how much you do in a given day, you can convince yourself that you have done absolutely nothing.

PB: Yes.

WM: And it is hard to explain—Florence has lived with me for nearly twenty years and now that she has been working in the studio with me for the last four years, she has a much better understanding of the craziness that I go through. But at the same time, I don't think anyone who is not living with it or close to it can ever understand the complexities and the anxiety, the angst, the frustration that goes into something that looks so simple. And I suppose that is true in any creative art form. I think there is a certain amount of flagellation and punishment that creative people inflict on themselves.

PB: Regardless of how masochistic you are in the first place.

WM: Exactly. And I think that particular trait is very common in all the creative arts.

PB: Don't you think that in one week you can do a brilliant jacket almost by accident and a mediocre jacket by incredibly hard work?

WM: Sure, and it's a testament to the subliminal thought patterns of the mind and the very self-conscious, conscious thoughts that we have that get in the way of the true primal creative instinct.

PB: Amen and double amen. I thank God that it does prevail. The only bad thing is that if you are in a sour groove regardless,

people say, "Wow, you have done all these jackets, it must be wonderful."

I just say, "Look, if I'm not doing a good one now, it doesn't matter how many I have done."

WM: I think it is the craftsman aspect of one's creativity that is the conduit, the continuance of being able to get up and do it every day and suffer the bad ideas so you can get to the good ones.

PB: Exactly. Again, I hate sports analogies although I use them all the time, but it's like being a ballplayer. If you boot one and go to the locker room and cry, you are not going to hang around very long. You simply have to be able to deal with failure because we are all going to get it.

The thing that I thought I saw in you instantaneously and realized in a sort of continuum after that—the word "solid" is what comes to mind. Even the stuff that you did when you were a relative neophyte as a book jacket designer had a quality of intelligence and solidity. Talent is wonderful stuff but you have to combine it with other things in order to deal with the specific thing that we do. We do a thing that requires the ability to comprehend, to assimilate, and then do the work.

WM: I think if one has an open mind and adheres to the principles we just talked about, there should be no end to creativity in anyone's lifetime.

PB: I think that's true.

WM: I remember a very poignant cartoon sequence that Norman Rockwell had drawn. It was in one of the volumes published on his work and it was called "Cradle to the Grave." It showed a little baby drawing a very primitive picture and the last

drawing was a hand coming out of a coffin doing a rather abstract painting.

Obviously Frank Sinatra doesn't quite always sing in tune anymore, and Rockwell's last few paintings weren't his best, but the fact is that Rockwell literally went from almost cradle to grave doing what he loved the most.

To me, success is the process of doing, not the ultimate destination, which is what most of us call success. I think that you should always have the proverbial carrot in front of your nose, something that is just slightly out of reach.

PB: Absolutely. Complacency is what gets your sentries shot and your town sacked.

WM: I always liken it to trying to outrace a prairie fire.

PB: Yes, you've got that midwestern soul. I wouldn't have thought of that, but that's great.

WM: Of course, I think having come to New York and having had the chance to work with you initially set me on a course that I would never ever have imagined.

PB: I just think that the idea of doing this book is wonderful.

WM: What I am hoping is that this collection of paintings will be bigger than the sum of its parts.

PB: I am sure of it, and it will reinforce everything, Wendell. The most surprised guy of all will be you.

A CONVERSATION WITH FRANK METZ

Gary Gunderson

WM: Without a doubt, Frank, you have had one of the longest and most distinguished careers of any art director in book publishing. When did you start art directing trade books?

FM: I came to the children's books imprint at Simon & Schuster in 1950, first as a production assistant and then as an art director, and I joined the adult trade division as an art director in 1957.

WM: You have probably had the longest working relationship that anyone in the industry has had with Paul Bacon. Isn't that true?

FM: Probably so. My friendship with Paul was one of the first that I formed in trade publishing, in the latter days of 1957. At that time, Paul was working on several jacket designs that had originated with my predecessor. Almost from day one, I'd heard what a wonderful designer Paul was, and after we met, our relationship seemed to be a natural.

WM: Could you say something about what special things you think Paul brings to the art of the book jacket?

FM: I think the paramount quality that Paul brought and still brings to this business is his incredible appetite for reading. After all, it seems to me that this is the prerequisite for anybody doing book jackets and paperback covers.

WM: As you know, Paul hired me in September of 1968, and I think you were aware that I was doing some work for Simon & Schuster sometime in 1969. I was working on *The Nashville Sound* [by Paul Hemphill], and I remember you calling the studio and specifically saying, "Paul, you didn't do this jacket, did you?" Then Paul mentioned my name to you.

You and I have had a special working relationship since then which has basically spanned my entire professional career. That kind of thing may never repeat itself in publishing history, because the development of a career over a long period of time seems to be a thing of the past. Things happen so quickly now.

When we started working together, what was your perception of my work, and can you say how it has developed over the years?

FM: I think one thing you brought to the profession from your own training and background, as well as from Paul's influence, was a sense of order and a sense of purpose about doing jackets in which typographic lettering and design could become totally integrated with illustrative elements.

Another thing was that you always could find ways of using your reference in a very, very telling way so that it became uniquely involved with the total look of the jacket design. I remember this was very apparent when you designed the jacket for David McCullough's *The Great Bridge* back in the early 70s.

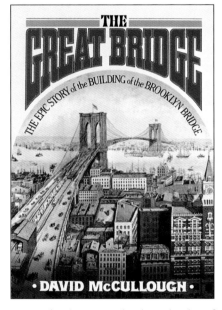

I am sitting in your studio now, looking at the hundreds of books you have done, and we have just spent an hour or more looking at material for the new Larry McMurtry book that utilizes your telling eye about where and how to look for reference. I think this is a distinctive trait that a lot of people nowadays simply do not possess. Perhaps it comes with time, perhaps it will come with experience for them, and perhaps it won't—I really don't know.

I think your illustrations have grown a great deal. I think they have a lot more depth to them now than they did in the early days. Fifteen or twenty years ago, you had a preoccupation, and a natural one at that, with surface technique. You now have a

greater insight into taking that virtuosity you always had and making it count. At their very best, your illustrations have a great degree of warmth and involvement.

WM: Thank you, I appreciate that. Frank, do you feel that being a fine artist gives you a special perspective on being an art director?

FM: I think that insights I have from my career as a painter have helped designers and illustrators who have worked with me over the years.

WM: I think it goes without saying that you and I have worked together very well over the years and I probably have produced some of my best work for Simon & Schuster. I certainly attribute that to your view as an art director and a painter.

Your career in adult trade books has spanned a period of thirty-seven years, and from my perspective, you have always been able to grow and change. You constantly evolve and you are just as contemporary in 1994 as you were in 1957. To what do you attribute your success?

FM: Well, I think being receptive, being open-minded and fairly objective is a part of it. Also, at Simon & Schuster, there is a regard between myself and my colleagues for each other's abilities and acumen about the work of the book jacket and the whole publishing process. With many different people who I have worked with and worked for, and despite the great revolutionary upheavals in the publishing business, I think that this is the criterion that has remained the same.

WM: I recall early on, when we were working on McMurtry's *Terms of Endearment*, having a meeting with Michael Korda in his office. We had agreed on a concept for the jacket, and it pretty

much went forward from that point on. There didn't seem to be any obstructions beyond that.

FM: Right. There were no committees, and there had not yet been the fragmenting within a publishing house of advertising and marketing and publicity and editorial, so that how a book jacket was ultimately chosen was a decision that emanated from a very, very few people.

There was never any large number of editors, either. Michael Korda would have been around, and still is. Bob Gottlieb possessed the same kind of one-on-one intimacy. You respected them because they were involved with the author, they were involved with the book, they were committed to the whole publishing process from beginning to end. We all know this is simply not possible now. Time does not permit it. The workload of editors is extreme, and this reflects the monumental changes in the whole process.

WM: You were talking about marketing. It seems to me that the importance of the book jacket has grown, even though this may not be acknowledged in the industry as much as we might like it to be. Do you feel it is used much more as a marketing tool than it ever has been in the past?

FM: I think there is a kind of gray area there. The book jacket is the lightning rod. It will attract the ire and contempt of the author's agent, the editor, et cetera. It has a short shelf life, and it must make a statement.

In designing jackets, we are trying for an effect, we are trying for a quick response. All of the painstaking involvement between an art director and the designer/illustrator goes on simply because those two people find it necessary. But whether the book has a huge first printing and is displayed in every window of every chain and superstore in the United States, or it is a smaller book that is sold through independent stores, the pursuit of excellence is always the priority.

There is an old cliché in publishing, which is that a best-seller will sell with a mediocre jacket, but you never hear that an excellent book jacket has helped to sell the book.

I look at the way a book jacket performs by going into Rizzoli's, by walking into Brentano's, by looking in the windows of Books & Company, in the same way I used to decide about buying a particular bottle of wine by looking at the labels.

Today, the point of sale has been taken over in large part by the superstores, which has made packaging a very different priority than it had been before. The attention that is given to the book jacket from the publisher down to the many layers of people who work on the book is far, far greater than it was twenty years ago.

When I used to walk down Fifth Avenue in the late 1950s and early 60s, one of my favorite stores was the old Brentano's because I would see salespeople hand-selling books. You had the feeling that books were sold for their tactile value. You went downstairs to the basement of Brentano's and there was a woman who sold all of the trade paperbacks, which in the fifties and sixties had one of the most distinguished periods of their entire history in terms of packaging. Each publisher's trade paperback books would be sold in their own section, so you could very easily compare what your books looked like next to Vintage's or next to Anchor's.

WM: Who do you think of in terms of influences in the world of book jacket design and illustration over the years?

FM: Certainly Paul Bacon and Larry Ratzkin. And Pushpin Studio, who I believe for many years spun off an enormous influence on packaging—that was John Alcorn, Seymour Chwast, and Paul Davis, among others. Also, the art department

at Columbia Records which had, at one time, some of the best talent in the country: Carin Goldberg, Paula Scher, Henrietta Condak, and John Berg, to name a few.

WM: You mentioned earlier the old adage: If it sells well, it's a great book, and if it doesn't sell, it's a bad book jacket.

This brings to mind our mutual friend David McCullough and his book *Truman,* which was an interesting case in point. A book of such an historical nature generally gets relegated to the biography section in the bookstore. Do you feel that the decision not to go with one of those great Yousuf Karsh photographs, but rather to go with a painting, was one of those exceptions where maybe the book got a little more display because of the jacket's narrative quality, or doesn't it make any difference?

FM: I think in the long run it made a lot of difference. *Truman* was one of those exquisite amalgamations of ideas, not the least of which was the idea that David McCullough had in the first place to write the book. But there was such a groundswell of deep internal enthusiasm for this book at Simon & Schuster that it created a great feeling of confidence and an affirmation that we didn't and shouldn't have to resort to the kind of package that ordinarily would have been done.

You and I both know David very well. So we had something else going for us from the very beginning, which was David's regard for you and for me. And when you have this kind of bonding at the very beginning, you go into a project with far more confidence than if you are working with an author you have never met before. David McCullough is one of the real giants for me and my colleagues in all my years at Simon & Schuster. I think it was a blending of a lot of these things, and it was wonderful to hear from so many people how well the jacket met the needs of the book, and the book reflected the jacket.

It also illustrates the policy that I think some publishers still

have, which is that they depend on getting their marketing people or the sales department to tell them what the jacket should look like. With *Truman,* the sales department was not involved in telling us what this book should look like.

WM: Did the sales department have any view on this jacket at all, at that point?

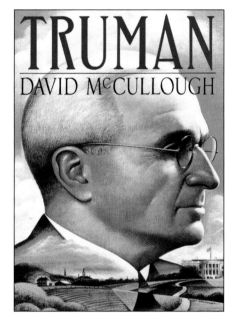

FM: No. When we sent down this jacket design, the first person who saw it was Michael Korda, the editor, the second person who saw it was David McCullough, and it turned out to be a triumph all the way around.

WM: It's interesting that I probably have received more personal compliments on that jacket than on any of the others I've done in a long, long time. And because of that, I thought it would do well in the national exhibitions. It was published in the *Print* Regional Design Annual, but otherwise it was overlooked.

FM: It seems to me that there is a message out there regarding the jurying standards for selections for national exhibitions.

WM: Prior to *Truman,* you and I worked with David on *The Path Between the Seas.*

The story of the building of the Panama Canal has many complex elements to it, and if you recall my first sketch for the

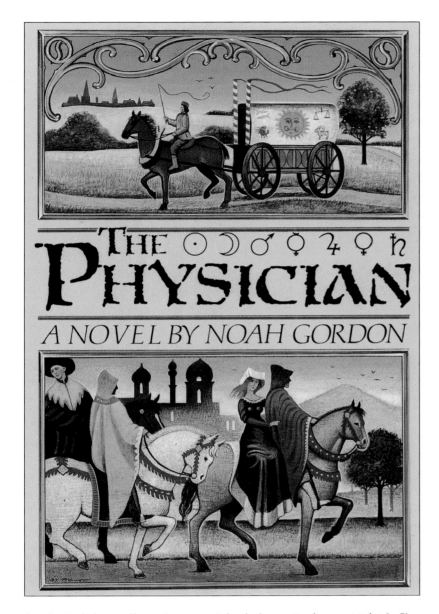

I wonder if I can mention some of the other books we've done together to see if anything comes to mind. There was *Where Are the Children?* by Mary Higgins Clark; *The Hawkline Monster*, Richard Brautigan; *The Physician*, Noah Gordon; *The Snowblind Moon*, John Byrne Cooke; *Looking for Mr. Goodbar*, Judith Rossner. . . .

FM: Well, one of the first book jackets we both rose to the fore on was *Looking for Mr. Goodbar.*

WM: Yes. I believe that was published in 1975. It's almost twenty years ago now.

FM: Well, there's a long story to that one. Yet I think what I remember most now after so many years is that it's the first instance I can recall where a designer/illustrator's imagination caught fire and opened up the eyes of the publisher. In this case it was Dick Snyder, and he had to be sold on it. Judith Rossner also had to be sold on it.

I think it was one of those breakthrough jackets that signaled a direction in which risks could be taken regarding how specific one could be, and how to visually handle what was essentially a horrific crime. The cover boiled down to one central illustration, and I think if we've learned anything over the years, it's that you need to end up with a focus for an image rather than a complex cornucopia of many things that don't really add up to anything, don't really send out a strong signal.

I think one of the best jackets you ever created was *City of the Dead* [by Herbert Lieberman]. In many ways, there was an honest feeling with that book that perhaps it should have been a best-seller. It certainly had all the qualities of one. I remember that the finished illustration was extraordinary, especially given the subject matter.

WM: I'll never forget my day at the morgue!

book, I did a collage, because I had done *Freedom at Midnight* [by Larry Collins and Dominique LaPierre] that way, and we were thinking along those lines. But David wanted something simpler—a strong central image. The cover that finally won everyone's approval was not one that depicted the building of the Canal, but an image that showed the result of the long years of human struggle: the first ship to sail through all the locks from sea to sea.

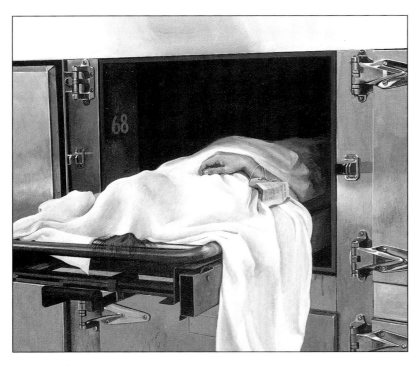

FM: Another jacket I'm remembering is *The Feast of Santa Fe* [by Huntley Dent]. You're probably not generally known as an illustrator who would be given or yearns for a cookbook assignment, but that was one of those extraordinary book jackets that really helped sell the book, and the book is still selling. We adapted your illustration for the trade paperback, and it looked very very good. Here is another one of the qualities that I think you excel in. You took your eternal interest in landscape and your love of the landscape of the Southwest, and you turned it into a brilliant selling book jacket.

WM: *The Auctioneer* [by Joan Samson] was another very significant painting for me. Do you remember the barn with the red truck backed up to it, and the snow? It's a wraparound painting. That is when I was painting larger images on canvas, when there was time to do that.

Like the writer who feels that a certain novel seems to have written itself, I almost felt that this particular painting painted itself. The image goes back to 1974, but to this day, it remains one of my favorites.

FM: You have been very fortunate—but it has also been well earned—that you have been able to retain your identity. You have been able to grow, your work grows and matures. But it is also due in large part to having a great support system out there—art directors and publishers and authors who realize that what you give to a book has a very special quality. Booksellers and everyone involved in publishing, I think, become aware of this. This is a great asset. And I suppose the reality of it is something that we talked about earlier on: What shows about your work is that you read what you work on.

I find so often when I go into a bookstore and I look at illustrative jackets that the illustration bears testimony to the fact that the art director and the artist in question illustrated something that was probably on page ten of the manuscript. Now sometimes that works by dumb luck, but a lot of times it doesn't. The ongoing criterion I have abided by over the years is that you are in publishing, which happens to be involved with books, and you can't do your job unless you read them.

WM: Exactly. And I think that the part of our relationship I have enjoyed most is your across-the-board understanding of any period of time, historically and culturally. I think my philosophy in terms of what I paint is that when the style exceeds the content of what you are doing, you are doing something wrong. If you are working on a book about the Southwest or about New York in the 1940s, you have to absorb yourself in that place or that period. I do it, and you do it. We dig out wonderful photographs and paintings from the period, and find out what was going on culturally back then to try and immerse ourselves in what that time was like. And then you take a little piece of that and transform it through your per-

sonality to make a statement that gives some hint to that understanding.

Let me ask you, Frank, what do you see at this point for the future?

FM: I think the future is now more than ever less certain for those people who are actually working in the trenches. And I think it is less certain for those people who aspire to careers in either editing or design or production or illustration of books, primarily because of the economic pressures of publishing itself. Yet there is still a proliferation of photographers and illustrators and designers who want nothing more than to do book jackets and paperback covers because it offers the opportunity to amalgamate so many of the nuances of design.

As far as trends are concerned, I couldn't begin to make a prediction. Illustration and design have always been in transition, always been in flux. One only has to open copies of the Society of Illustrators annuals or The Art Directors Club annuals from fifteen, twenty, thirty years ago, as well as the magazines of the forties and fifties, to realize how tastes have changed. And yet as creative people with open minds, we still find that we look to the past and derive from it elements that can be transposed forty years into our time, and we can use them to our advantage.

What seems to be a trend now, I don't believe for one minute will not go through transition and change five years from now. But being in design, being in illustration, there is a life force there. One has to possess an appetite for learning, for looking, for moving ahead—constantly evolving, shifting, risk taking.

WM: I agree. Even after all the years I have spent in publishing, I still find each assignment a new and exciting challenge.

FM: I've got to run. But speaking of assignments, Wendell, when can I expect revised sketches on the McMurtry?

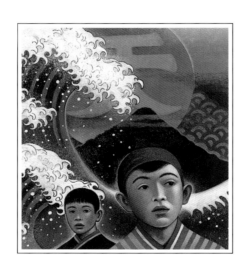

They say you must never judge a book by its cover, but I do, and so do most people, and so thank goodness Wendell Minor did both my covers. I am particularly convinced that art and the written word must complement and convey the same mood and message and style of the book. In both my books, place, period, and style were captured by Wendell, and as a matter of fact, people have begun to identify my books by Wendell's covers. However, it has occurred to me that Wendell gets to read the story and then create the cover. Next time, I think I'll have Wendell do the cover first, and then I'll write the book. Fair is fair!

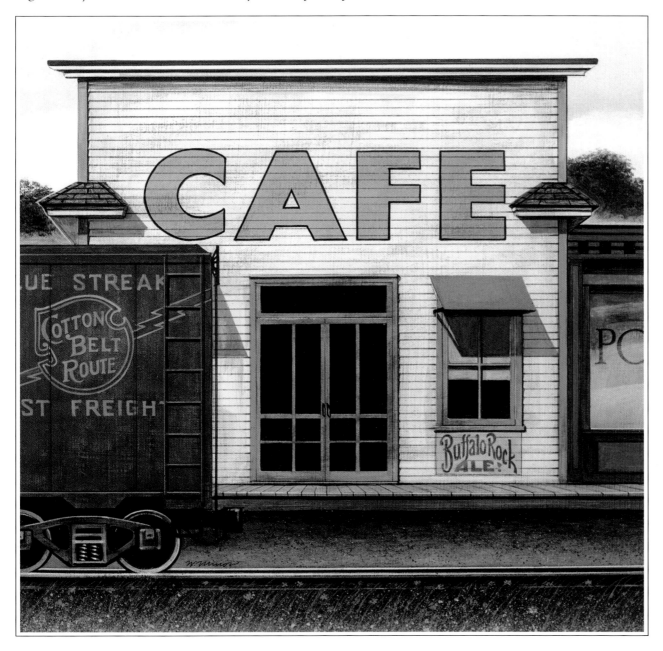

FALSE PREMISES *by Winthrop Knowlton*

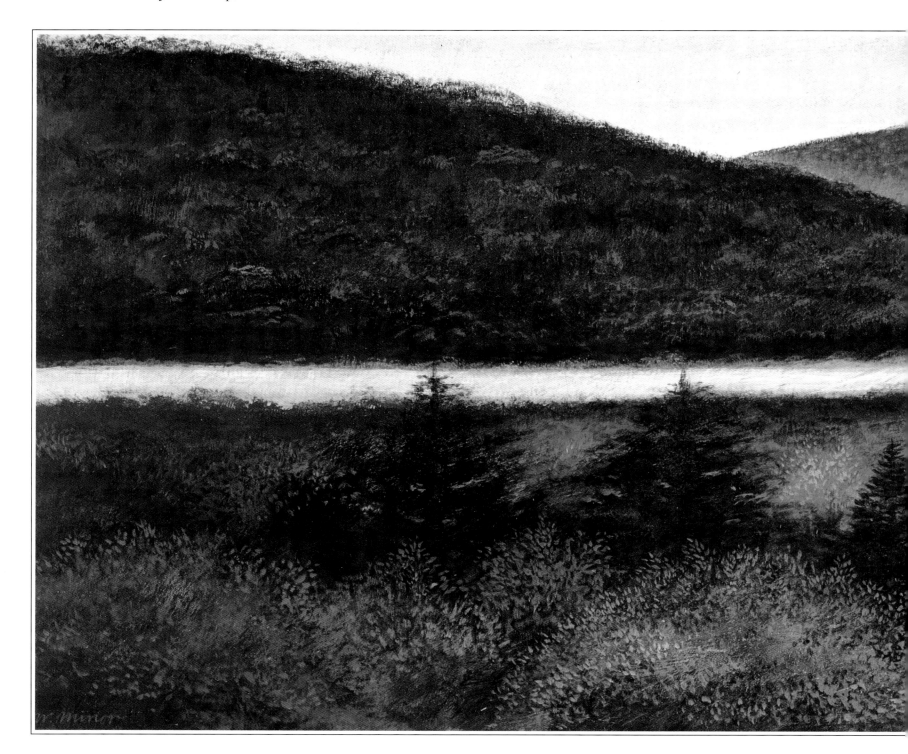

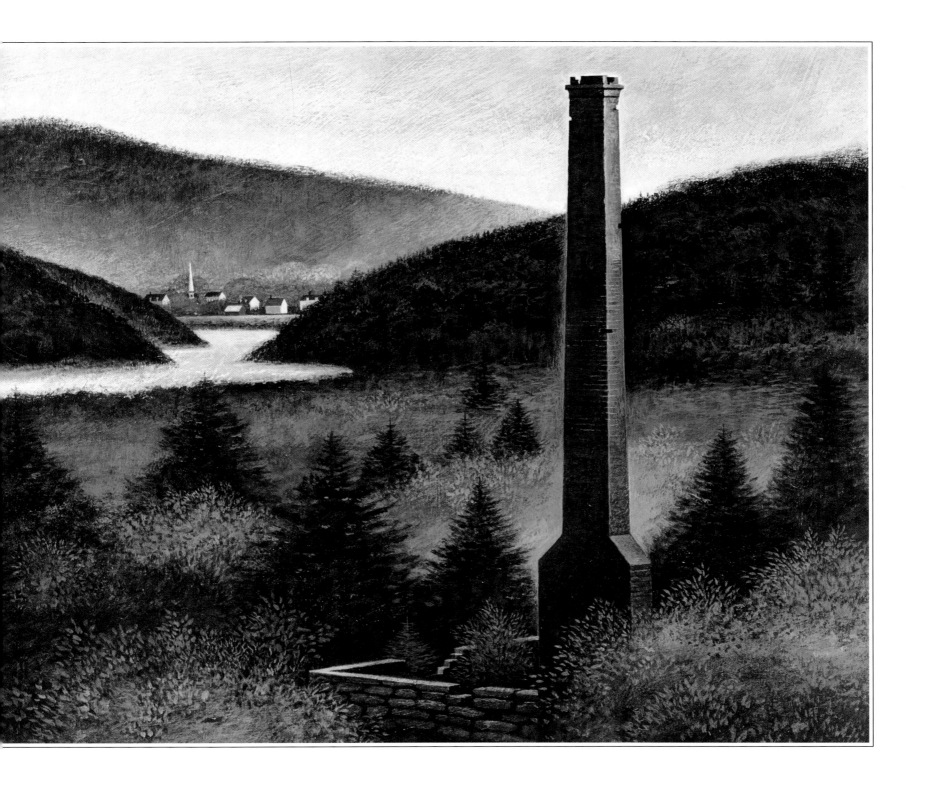

October 27, 1983

Dear Wendell,

Here's a little story right out of O. Henry.

Once upon a time, a young high-school English teacher named Kim McClish was wandering in a small-town library in Arkansas looking for something to read. She was attracted by a book jacket showing a red Porsche at dusk in the autumn woods. She read the novel and loved it.

Several years later she wanted to find the novel and read it again, but she couldn't remember the title or the author, only that red Porsche on the cover. By looking and looking all over the library, she happened to find it again, read it once more, and write the author a fan letter, which found its way to him in the spring of 1977. It was his first fan letter from his native Arkansas, and he was so moved he arranged to take her out to dinner in October of that year.

Six Octobers later, he married her.

First moral of this story: If you're a reader, write a letter to a novelist you love. Second moral of this story: If you're a novelist, always get Wendell Minor to do your covers.

Best regards,
Don

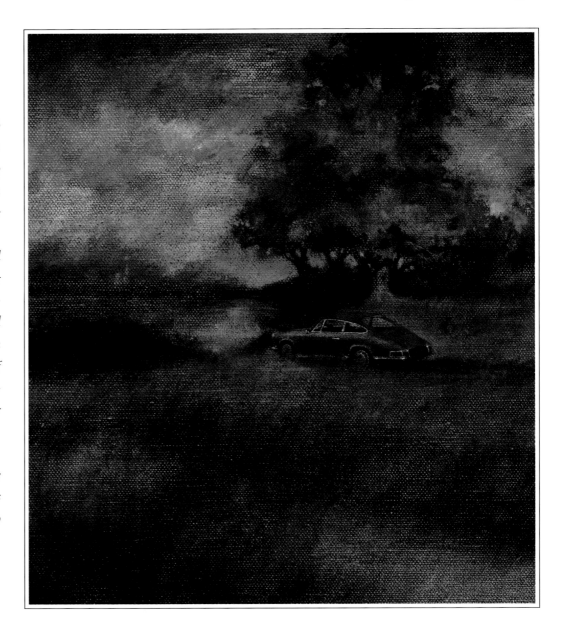

THE BUFFALO BOOK *by David A. Dary*

Since selling books is essential for the survival of any book publisher, the importance of good cover art is more important than ever. In a highly competitive marketplace, trade publishers know that the cover art of their books must attract attention and invite potential buyers to inspect the book. Publishers know that books with good cover art are more likely to sell than those with poor cover art.

It has been my experience that sometimes highly attractive covers are not truly representative of the material found between the book's two covers. This is unfortunate. There have even been times when the cover art has been the most endearing feature of a truly bad book.

As a nonfiction writer, I have never had much say as to the cover art used on my books. I have, however, been fortunate to have wise publishers with integrity who have made certain the cover art was attractive and representative of the books' contents.

When Avon reprinted *The Buffalo Book,* I was impressed with the simple but effective and very accurate illustration of a buffalo bull (bison) standing on a prairie mound with other buffalo in the distance. Even to the animal's erect tail, a sign of alarm, Wendell Minor captured the principal subject of my book in all its glory. There is no question in my mind that his cover art not only contributed to increased sales, but was in part responsible for attracting readers to the often tragic saga of an American symbol.

TIKAL *by Daniel Peters*

It's been my experience, through four novels, that the cover art comes down to me late in the game, not for my approval so much as to catch any egregious misrepresentations that might've slipped past my editor and the production people. The last three have been historical novels about pre-Columbian cultures, and ever since I was shown some sample jacket copy that spoke of leopards rather than jaguars (in Mexico), I've lived with a certain dread of what might slip through someday. I spend a considerable amount of effort on getting my facts straight in the text, so it would bother me enormously to get a cover with images borrowed from the wrong culture or historical period. A confusion of Tenochtitlán with Teotihuacán, for example, or a Nazca weaving presented as Inca cloth. Those leopards. A little knowledge here could have dangerous results.

The cover for *Tikal*, my novel about the Maya of the Late Classic Period (circa A.D. 800), was perhaps most vulnerable to visual malapropism. Given the long history of the Maya and the many phases and regional variations in their art and iconography, it would've been easy to rip off one of their magnificent stone sculptures or polychrome pots, and just as easy to choose one from the wrong place or time.

Wendell Minor chose instead to create a kind of generic stone face, and to make it the dominant feature of a carefully balanced composition. Wearing the title like a headdress, the face seems to loom out of the mist and foliage, enormous and unchanging, its blank gaze contrasting with the lively eyes of the toucan and macaw in the foreground. This tableau simultaneously evokes the lushness of the rain forest in which these Maya lived, the brooding power of the gods they worshipped, and the sheer vitality that let them raise great cities in the heart of the jungle. The cover thus provides a visual introduction to the world of the novel within, without giving away any of its specific secrets.

Wendell Minor has done two covers for me now, and they've both been strikingly attractive and above scholarly reproach.

What impresses me most in retrospect, though, is the way they *serve* the books for which they were designed. That can only be the result of a full and sensitive reading of the text, coupled with a desire to capture something of the spirit of the book, distilled into images and colors. An author could hardly ask for more than that. So far, having Wendell as my cover artist has been dumb luck on my part, but I'll know enough to ask for him in the future. I know I'll like what I finally get to see, and I won't have to worry about any of those insidious leopards slipping through.

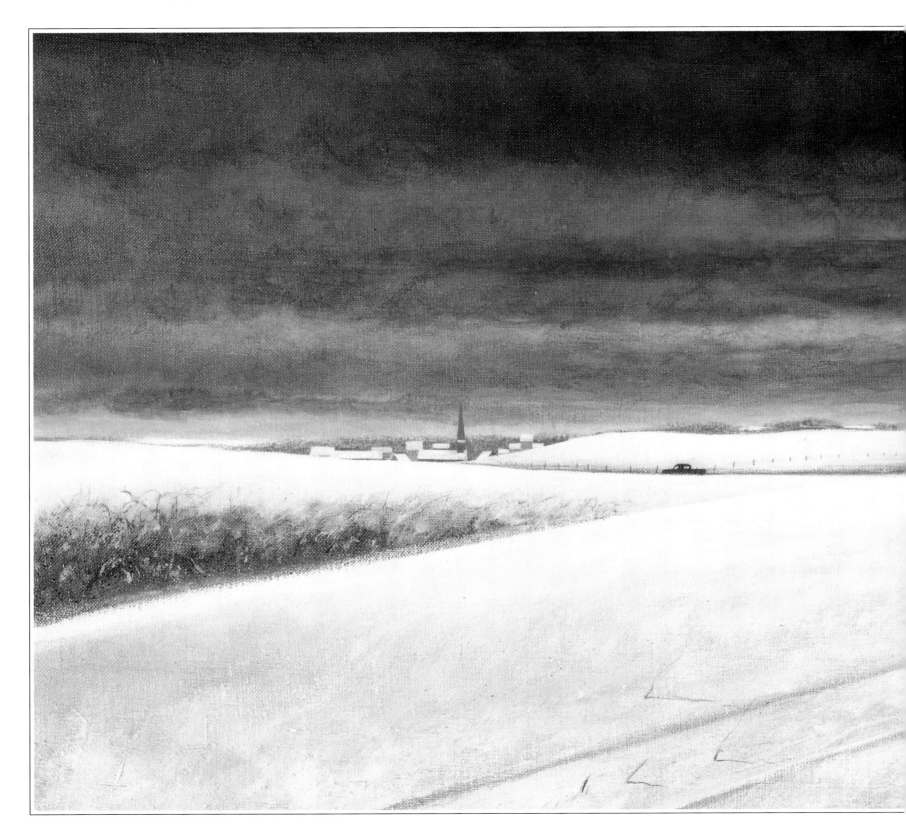

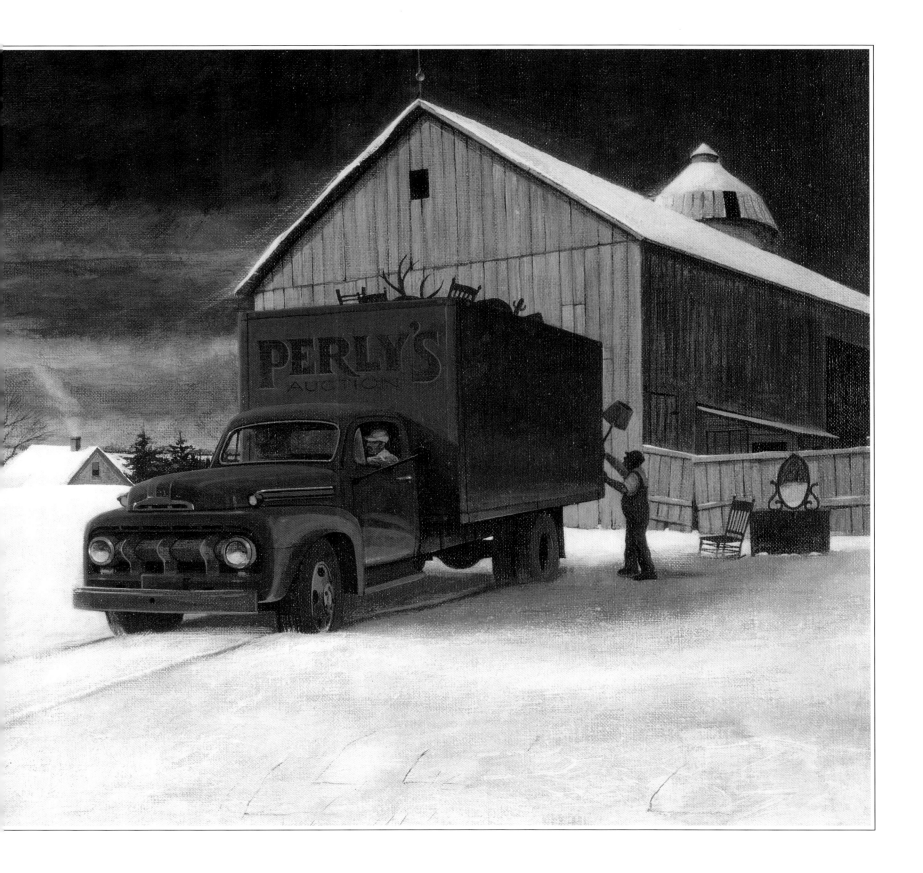

WORDS BY HEART *by Ouida Sebestyen*

When my first book was published, only thirty-five years after I vowed to become a writer, no artist in the world could have created a flawless jacket for it. The shoes weren't right! She didn't even own white stockings! It just wasn't what I had seen in the private movie that had rolled through my head as I wrote.

Now, fourteen years later, when I glimpse *Words by Heart* in a bookstore or library, I see the rich stillness extending around to the back of the book, and the hope suggested by the rising smoke and the coming morning. I delight in the turned head that lets each reader decide what the hidden face looks like.

It must be daunting to have first crack at drawing readers to a new book, to have to please so many people beyond yourself, to try to establish a mood, time, and place at one glance. So never mind the wrong shoes. The important thing is that certain artists are willing to risk being the gate that entices in the garden wall, the carnival barker, the curtain that silences us as it opens on magic.

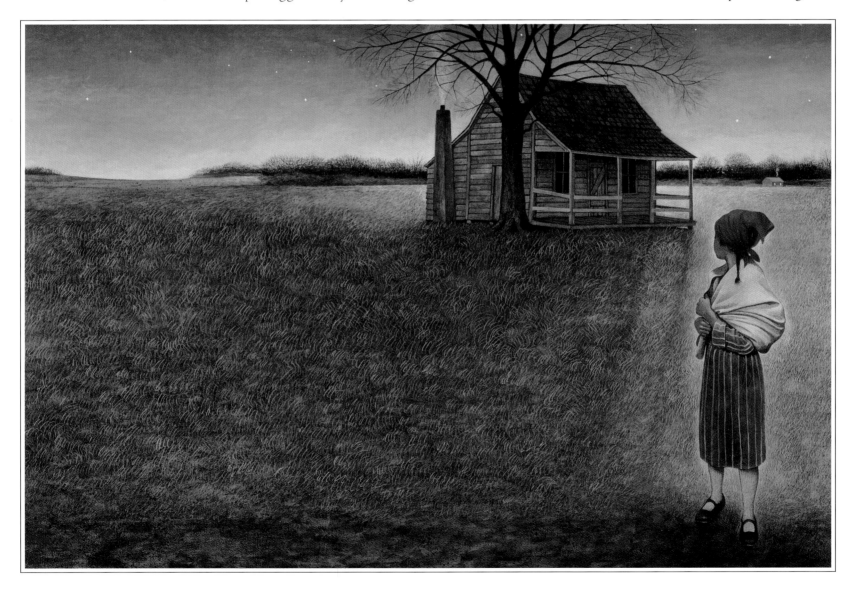

BAILEY'S CAFE *by Gloria Naylor*

Jacket illustrations for my novels have always posed a challenge to artists because I write about mythical places that must simultaneously be nowhere yet identifiable everywhere. I attempt in my art to give a mailing address to a hope, or to a dream, or to your worst nightmare. Since I'm seeking to find words for the wordless, my book jackets have demanded that the artist find images for what is not. With *Bailey's Cafe*, Wendell Minor matched me stroke for stroke:

There is nothing in the back of this cafe . . . the place sits right on the margin between the edge of the world and infinite possibility.

You know *exactly* where this cafe that he's painted sits because you've seen those red checkered curtains, that time-worn

wooden storefront, those homey curlicue letters, tucked just around the corner in some bittersweet memory, why, only the other day . . . and yet . . . and yet . . . there's something deep in those recesses just a little bit mysterious, a menu that might contain foods you would find strange, a clientele that's perhaps hostile, perhaps not. But it's inviting enough for you to give it a try—especially if you're awfully tired and need a place to rest.

It wouldn't surprise you that a place like this is open twenty-four hours a day. And it wouldn't surprise you if some people are seen entering that front door and never coming back out. With my art, I created a doorway to infinity. With his art, Wendell lets you know that you've arrived.

February 12, 1993

Dear Wendell Minor:

Thank you for your assistance in bringing my various books to the attention of the public. Whenever I see one of my novels in the hands of a reader who has bought it from a secondhand bookstore, the cover long since gone, I am startled by its barren look. Covers help establish a book during its first assault on an indifferent public, and effective covers perform a most valuable task in opening the way. I take them seriously, as part of the compact parcel—colorful jacket, inside blurb, back-cover photograph—and if the first is poorly done, it sounds a negative note that can be hurtful.

Of course, I realize fully that in the years to come, the book sans cover in its drab cloth binding is the one that will remain on library shelves and will be, in a sense, the real book. But just as a girl of nineteen can use a bit of facial makeup to aid her in those perilous years of finding a husband, so even a good book can profit from a bit of coloring too.

May 1993 prove to be a banner year for you.

Sincerely,
James A. Michener

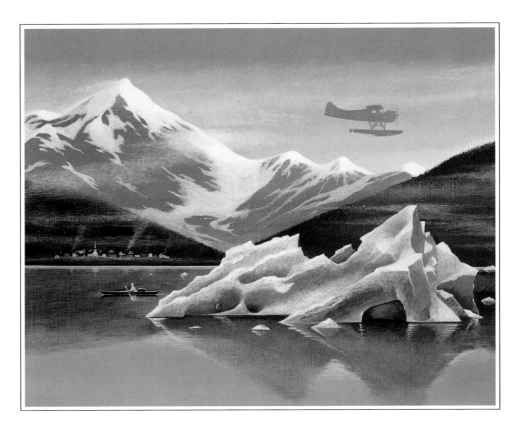

HOW TO LIVE ON ALMOST NOTHING AND HAVE PLENTY
by Janet Chadwick

The cover of my book, *How to Live on Almost Nothing and Have Plenty,* delighted my readers. People who strive for self-sufficiency do so partly for economic and health reasons and partly because of their dreams of those seemingly better times in the past. The colorful folk art of this cover captured those dreams and brought them to life.

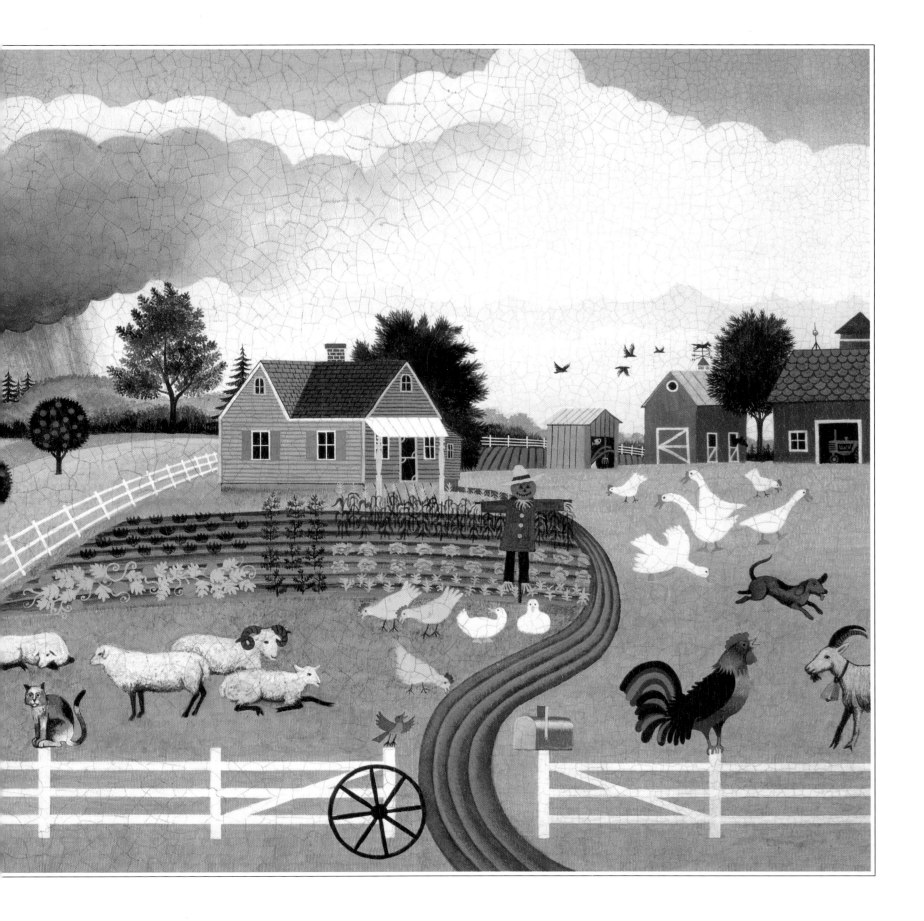

Throughout most of her life, Eleanor Roosevelt hated to be photographed. Occasionally an alert photographer would catch her off guard and come away with an excellent candid shot. But when she had to pose for a picture, she became self-conscious and embarrassed. Meeting her for the first time, a *New Yorker* correspondent was startled by how "unjustly" the camera treated her. Photographs had not prepared him for "her immaculate freshness of appearance, her graciousness, and the charm of a highly intelligent, forceful, and directed personality."

To illustrate my biography of Eleanor Roosevelt, I selected 140 photographs showing her at every stage of her life. Dorothy Briley, my editor at Clarion Books, went over these photos with me many times, but no single image seemed to capture the spirit of Eleanor Roosevelt, the essential Eleanor that we wanted to portray on the book's dust jacket. Dorothy suggested that we turn the task over to Wendell Minor. She asked him to design and illustrate the jacket. His artistry reveals the radiant Eleanor Roosevelt so admired by her friends and yet so often concealed from the camera's prying lens.

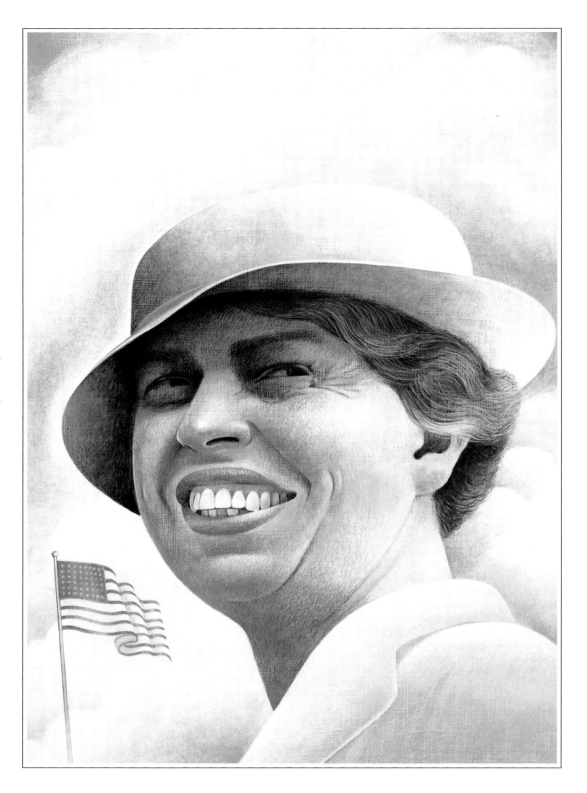

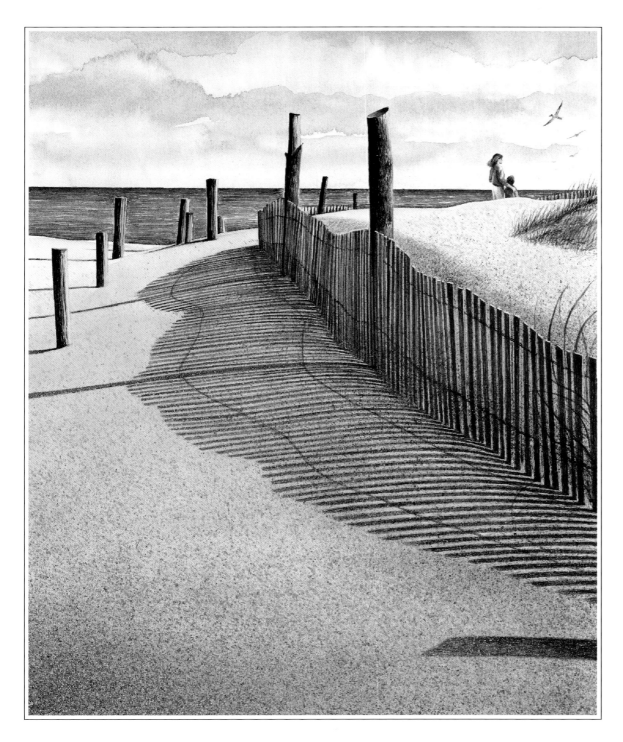

The sense of space and nature that Wendell captures in his artwork is magnificent. But when I heard he wanted to do *The Seashore Book,* I did worry, because so far as I knew, Wendell had not done people in his beautiful paintings. I need not have worried. The little dummy he sent for the story was precisely and exquisitely executed. Mother and child were just right for the story. There is an encompassing quality to what Wendell perceives and has caught in his art, which makes me happy when I look at *The Seashore Book.*

For someone who sees and paints vastness so evocatively, his lovely skill with the detail of close things—shells, dune grass, a child—is extraordinary. What I hoped to do with the sounds and smells and light and feel of seashores, he has interpreted so that it all reaches up from the page to child and adult alike. The words and the pictures are one.

Wendell Minor's lovely, muted, dream-like cover art for my book does not represent the place whose natural history I trace through a year in it. It doesn't look like my farm at all. Nor could it, for Minor has never seen my farm. Yet he has seen something else; he has seen into the book itself and has created, through his art, the subtlety of balance, composure, and peace that I always find when I return there. And readers sense those qualities, too, for they often mention the cover to me.

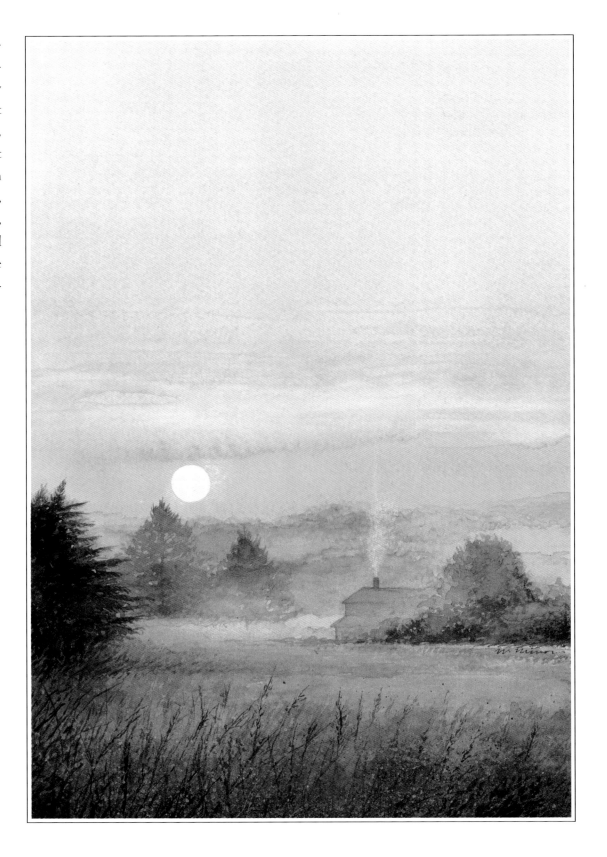

REFLECTIONS FROM THE NORTH COUNTRY *and* OF TIME AND PLACE *by Sigurd F. Olson*

January 14, 1977

Dear Wendell Minor:

Since my book, Reflections from the North Country, *came out, I have received hundreds of letters, many of them speaking of the beauty of the jacket and how much they were drawn to it. This morning I received a letter from an old friend with a lifetime of experience as a magazine editor. Here is what he said:*

My copy of this book has a jacket painting by Wendell Minor. A cloud-covered north country lake is shown. A canoe propelled by a lone paddler rounds a spruce-decorated point, and across the lake rise the mystery-steeped hills of the back country. It is reminiscent of some of the exquisite portrayals of America's magnificent wilderness painted a hundred or more years ago.

As a superb artist, that should warm the cockles of your heart, and I want to add to it my own accolade for good measure and the feeling that your cover has contributed much to the book's success. Kindest regards and thanks for your sensitive portrayal.

Sincerely,
Sigurd F. Olson

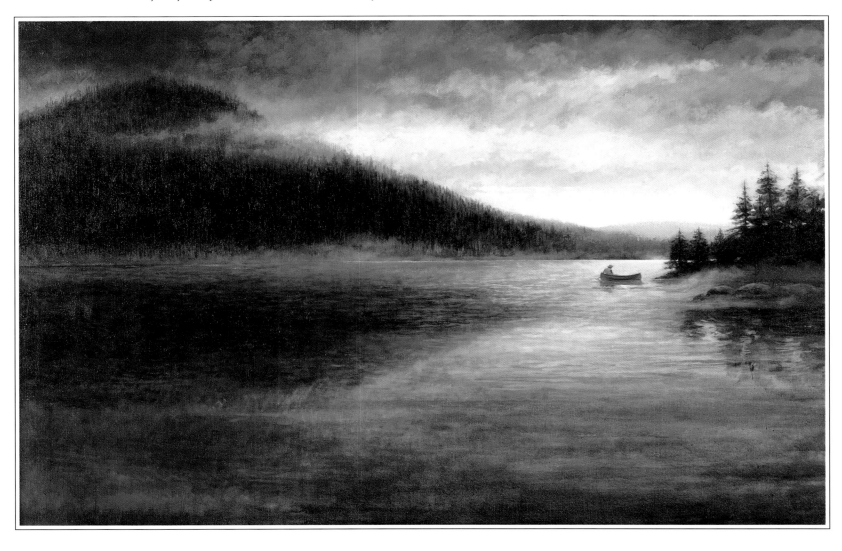

OF TIME AND PLACE *by Sigurd F. Olson*

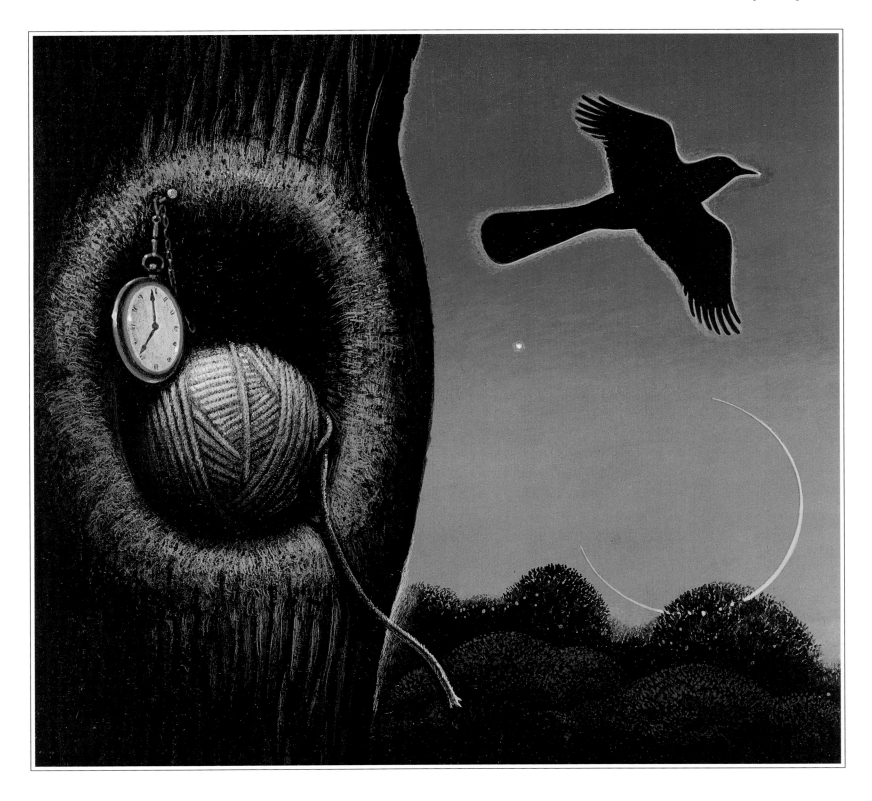

Commenting on the jackets created by Wendell Minor for the world-famous mystery writer Georges Simenon and his equally famous character, Chief Inspector Maigret, immediately raises the question: How important is the jacket for the perception and success of a book?

Let the answer be Simenon's. He had no agent and selected, supervised, and occasionally discarded his publishers himself, not by whim but by practical evaluation. As an excellent businessman, he applied the comparative yardstick. When his Dutch publisher, for instance, showed satisfactory sales but his Scandinavian publisher, with a similar potential market, fell far below, he would, so he told me (as a cautionary tale, perhaps), look closely at the books and think of possible causes. In a specific case he found them obvious—obsolete jacket styling. The delinquent publisher found himself summoned, accused of inertia, lack of enterprise and of vision, and admonished to shape up or cease a profitable relationship.

What Wendell Minor brought to Simenon's "packaging" would have pleased this shrewd, demanding, but never unreasonable author. Since the Maigrets are a chain of mysteries, each varying in milieu and plot yet sharing the same viewpoint and method, the visual presentation had to be one of unity in diversity. In being suggestive rather than explicit and blatant, Minor mirrors the way Simenon's mind works; he distills visually the essence of a writer whose primary object is psychology translat-ed into criminology, or vice versa. Minor is uniquely responsive to this scheme. His lines and colors are sometimes enchantingly delicate, sometimes assertively forceful, but never coarse. A close look at each design reveals its individual artistry—the curving lines of the only partially visible car with a corpse as fragmentary for *Maigret and the Gangsters,* or the exquisite evocation of the French Riviera which Minor created for *Maigret on the Riviera,* a composition that incorporates plants, architecture, the sea, and a skull-like moon in sinister beauty.

Outstanding for its compression of plot motifs in arresting starkness is Minor's visual interpretation of one of Simenon's psychological novels, *The Iron Staircase.* There is no staircase in the artwork, no obvious solution. Rather, we see the instrument of a man's slow physical destruction, a gigantic fork behind which the protagonist is kept prisoner.

Along with his graphic virtuosity, Minor manages to express himself, his acute and nimble intelligence. He is fully conscious of his primary task: to catch the eye and single out what will be shown in crowded competition. He knows that he has no control over the company his jackets will have to keep once they are on commercial display. To meet this by suggestion and subtlety, by swirling smoke rather than garish fire, is very specifically his seduction.

—Helen Wolff, Helen and Kurt Wolff Books

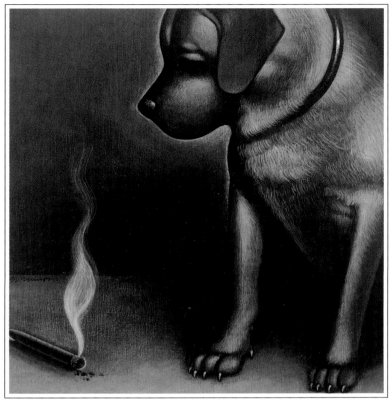

Maigret and the Yellow Dog

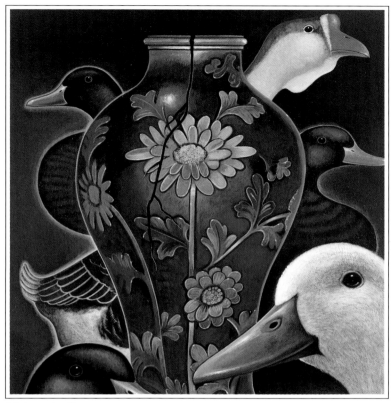

Maigret in Court

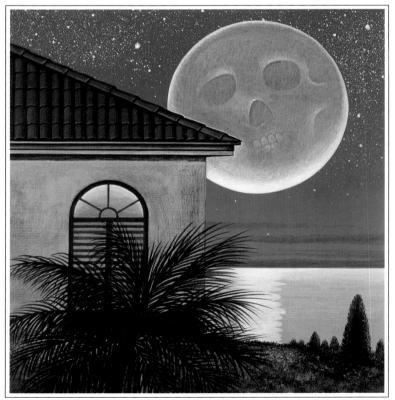

Maigret on the Riviera

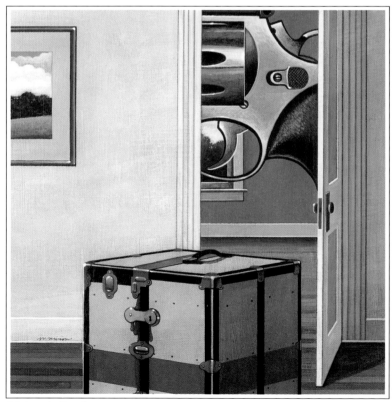

Maigret's Revolver

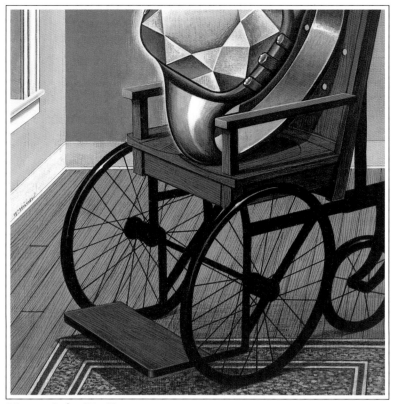

Maigret Bides His Time

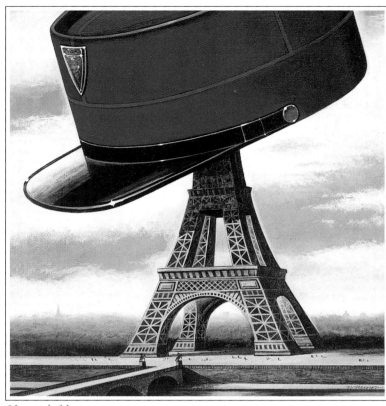

Maigret's Memoirs

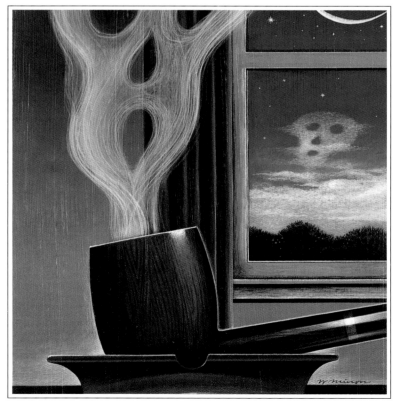

Maigret's War of Nerves

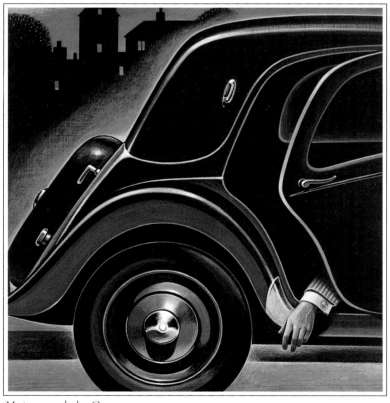

Maigret and the Gangsters

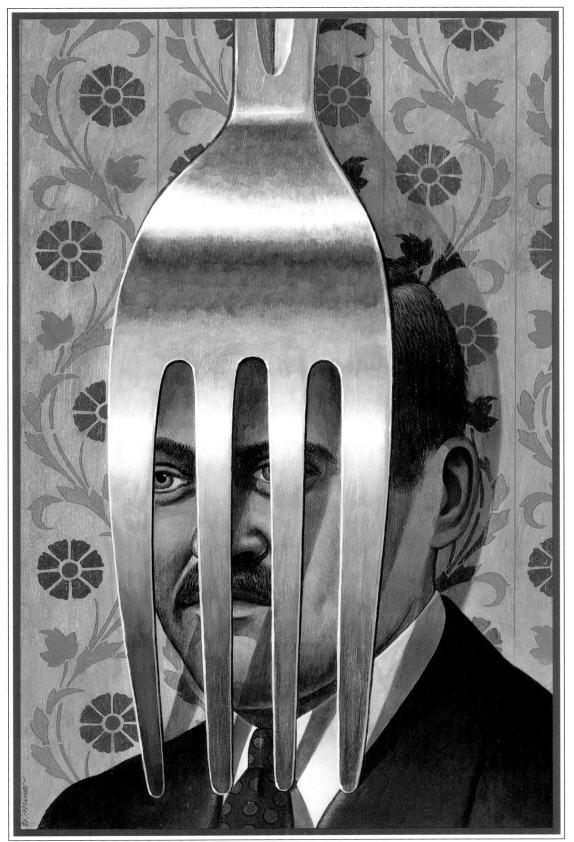

The Iron Staircase

61

THE BEAR FLAG *by Cecelia Holland*

Wendell Minor's jacket for *The Bear Flag* is one of my favorites, capturing as it does the dreamy, almost mythic quality of a California that I wanted to convey in the book. I love the colors, and the figure of the girl in the middle manages to express the heroine's resolute, almost defiant individuality in a single sweep of streaming pink skirt and windblown hair. The whole scene seems alive and moving— vigorous and romantic, exactly the tone I wanted for the novel.

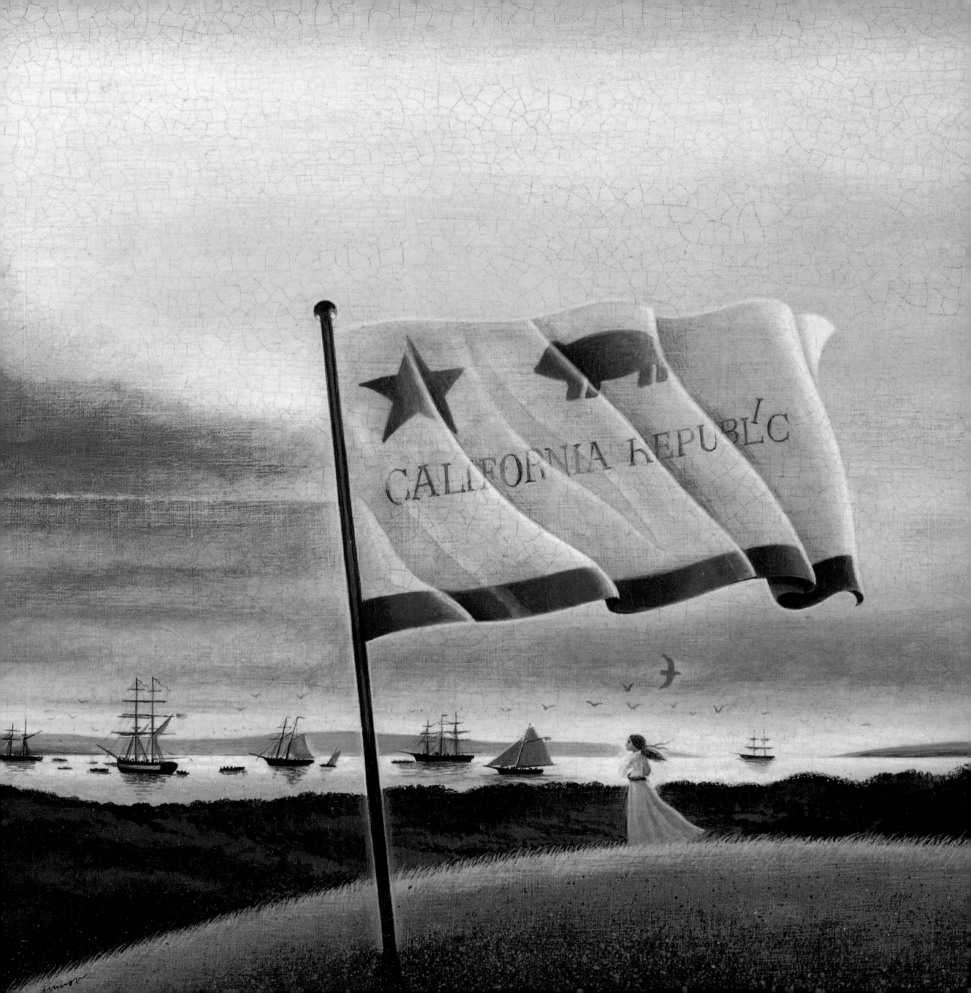

When I was a child, I learned my family history through stories. From as far back as I can remember, my father, my uncles, grandparents, and other members of the family would recount their lives and the lives of those long since dead through storytelling. In the South where I was born and in the North where I grew up, there were always the stories; therefore, by the time I began to write the Logan books, which are based upon these stories, I had very definite images in my mind about how family members and settings looked. Some of those images were etched because of old photographs; some were etched because I had seen the people and places myself; most, however, were etched because of the repeated telling of the stories, stories that were not only filled with dialogue, but colorful descriptions of the people and their ways, as well as the land and its beauty. However, I soon learned that artists meeting for the first time the people and settings described in my books had different impressions of how those beloved people and settings of my history should look.

For me, this was difficult.

As my first major book, *Roll of Thunder, Hear My Cry*, was published in countries outside of the United States and I had no input about the cover art, I began to feel a growing frustration that the people of my books were not as I described them. I remember the cover of one particular edition of my book was so distasteful to me, so unlike anything I had described, that I tore all the covers from those editions, then sat down and cried. It was obvious to me that the artist had not even read my book.

Then came Wendell Minor. He was to be the artist for my third book about the Logan family, *Let the Circle Be Unbroken*. In this book, set in the mid-1930s, the Logans face much strife in their family. Because this factor dominates the book, my publishers and I wanted a family portrait that reflected the unity and love of the family. Wendell Minor's painting of the Logans imparted just such a family feeling. Cassie, in particular, appealed to me. Sitting within the midst of her family wearing a red hat

adorned by a sunflower, she was the essence of the spirited Cassie I had created with the writing of my first book, *Song of the Trees*.

In 1990, nine years after *Let the Circle Be Unbroken* was published, *The Road to Memphis* was ready for publication and again Wendell agreed to do the artwork. In this book Cassie was seventeen, and I wanted a teenage portrait of the Cassie seen on the cover of *Circle*. My editors persuaded me, however, that we should focus on the car in which Cassie and her older brother Stacey and friends ride north during their perilous journey from

Jackson to Memphis. Although I agreed this should be the focus, once again I had a specific image in mind for the cover: my father's first car. From my childhood, I remembered seeing a photograph of my father as a young man standing beside the car. It was shiny and black, and looking at my father beside it, I could feel his pride. It was definitely the car that had to be on the cover of *The Road to Memphis.*

There was a problem, however. No one could identify the make of the car. My father had died in 1976 and my mother, who had never thought much of cars except as a means of get-

ting from one place to another, couldn't remember the make. Meanwhile, the publication date was nearing and Wendell had to get started on the artwork.

One day as I rode into town from my Colorado mountain home, I saw a vintage Ford parked in a driveway. I was bold enough to ask the owners about the Ford, and soon after, decided to make it the car that Cassie, Stacey, and their friends were driving. So instead of my father's car shown in the photograph—which we later learned was a 1940 Chevrolet—the 1938 Ford would grace the cover of *The Road to Memphis.*

Wendell Minor portrayed the car—burgundy with white-walled tires, lights beaming into the night—on a Mississippi highway with the full moon shining upon it. That painting exemplified for me the terrifying trek north to Memphis. It was a splendid painting, and quite memorable to me. Even though the car was not the same as the one my father had owned, seeing that painting gave me the same sense of pride I had felt when looking at the photograph.

To me, the role of the artist when portraying a writer's work for a book cover is to give the intended reader some essence of the book to come. It can mean the difference between picking up a book or leaving it on the bookstore shelf. A cover can be misleading or it can be a true barometer. For me, the jackets Wendell Minor painted for my books are true barometers. They show the essence of the Logan family, the essence of my family, and they are true to the stories told.

A few years ago, when I was new enough to the publishing game not to know that an author ceases to have any real usefulness to anyone once he has delivered his manuscript, I was asked by my publisher if I had any suggestions for the cover art for *The Lost Continent.* He was only being polite, of course, and almost certainly didn't expect to hear any more of the matter. But not knowing any better, I gave the matter a good deal of earnest thought and sent him a lengthy memo containing many complex and no doubt impractical suggestions.

He binned the letter (or possibly circulated it for amusement among his colleagues) and wisely turned the matter over to Wendell Minor.

On the face of it, *The Lost Continent* was not a straightforward book to illustrate. It is about how I grew up in Iowa and, after living abroad for many years, returned to the land of my birth

and made a thirty-thousand-mile odyssey by car to see how things had changed in this huge and complicated country.

Minor came up with a cover design—a billboard in the shape of a cow on a quiet, empty, yet somehow appealing landscape—that was simple and engaging and perfectly captured the spirit of the book. More than that—and I presume this is the key to any good jacket—it was intriguing. It made you want to pick up the book and left you with the impression that maybe there was something interesting going on inside.

Perhaps because he grew up in such an environment himself, Minor was able to concoct a fictional landscape that conveyed not just the look but the very feel of the Midwest: flat but not

without interest, empty of people and yet without question a friendly place. His painting is of an Iowa that never really existed, and yet paradoxically, it is precisely the Iowa I grew up in and was writing about.

It was the finest cover I'd ever seen and would have remained so, except that Minor's jacket for *Neither Here nor There* was even better.

This book, about traveling across Europe, was unashamedly going for belly laughs, so it required a comic illustration. Minor provided it in spades by taking a real painting—Piero della Francesca's portrait of the Duke of Urbino from the Uffizi Gallery in Florence—and with the simple, inspired stroke of turning his

hat into a valise and tucking a pencil behind his ear, created an illustration that was at once witty, surreal, ingeniously apt, and quite unforgettable.

Tens of thousands of bookstore browsers all across America must have been brought up short by the sight of such a wonderfully clever and arresting jacket and paused to look at it with an admiring smile. If only a few of them had actually bought it.

LOOKING FOR MR. GOODBAR *by Judith Rossner*

Of the nine novels I've published, two have been best-sellers, and the covers of those two—*Looking for Mr. Goodbar* is the one by Wendell Minor—were surely among the reasons for their commercial success. I suppose you could say that the covers of books are like the outsides of people: Beauty might or might not be the draw, but a draw there has to be.

The painting on *Goodbar*'s cover is both delicate and scary, and was doubtless even more of the latter in 1975, when murders hadn't become America's breakfast, lunch, and dinner fare. I'm proud of that title—which came to me full-blown, laden with its double and triple meanings, as I sat reflecting on the fact that my best friend adored the candy bar, although her taste in food was otherwise sophisticated. It seemed to me that in making the title as bold as he did, the artist acknowledged the title's draw, even as he made the observer curious about the connection between it and the girl—is she really dead? and how did her search lead to this?—beneath it.

The publisher recognized the cover's power by using it on the early paperback editions of *Looking for Mr. Goodbar*, changing it only later to use a photograph from the movie of the same name.

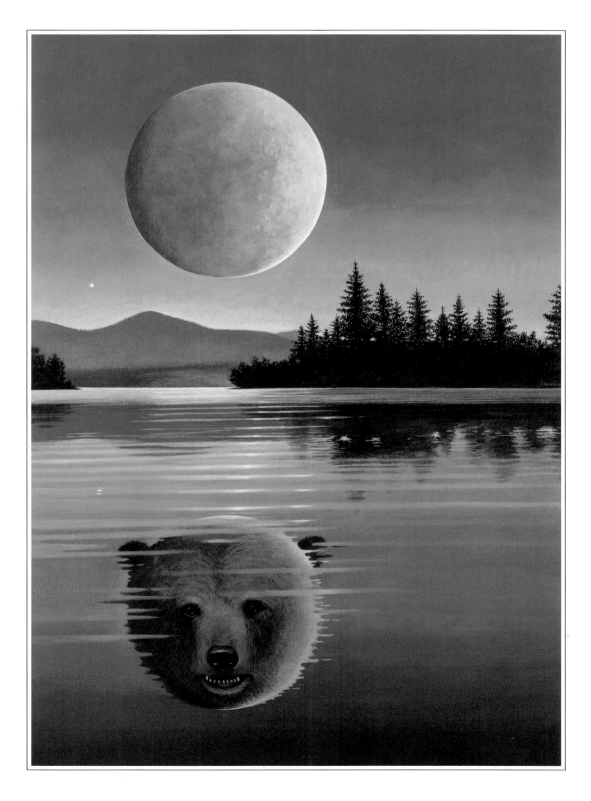

I love everything about the design of books. I love the shape and heft and smell of books and have always held the belief that a room without books is lifeless, by definition, and the homeplace of an idiot. Books, like paintings, are the things that are left when the fires of creation burn out. They are the footprints an artist leaves in a passage through time. Books make silence bearable. They are as beautiful as fruit or jade or roses when they lie about a house. They require the making of ink, the death of trees, the discipline of editors, the attention of printers, a common cause with manufacturers, and the peacock's eye of an art director.

In my life as a novelist, my books have also required the quiet genius of Wendell Minor. He has become a talisman for me, a good luck piece I have gathered along the way through wonderful art directors who knew that Minor's talent was uncommonly fine. The paintings he has done for my books honor them with their elegance and simplicity. He does more than jacket art. By his artistry, he interprets each of my books with a single stunning image that always surprises me. Wendell Minor has shown me corners of my work where I myself was not allowed to go. Where I write a scene, he builds a bonfire and shows me all the gargoyles and angels who inhabit the shadows. I write for a thousand pages and Wendell shows me what I mean in a single image.

When I wrote *The Prince of Tides,* I did not know where the book was leading until I saw the secret Wendell had gleaned from it. It was about a damaged and magnificent family living in a small white house beside a breathtaking tidal marsh. Neither the family nor the novelist could see the black, roiled storm clouds forming in the Atlantic. In that invisible, gathering storm, in the loveliest island country in the world, in that threatened house, three children were trying to make sense and art out of their broken lives. That storm would follow them always.

Throughout our career together, Wendell Minor has not only given me clues and passwords to my own books, he has often handed me the key to the front door. I build the church; he makes the stained glass windows.

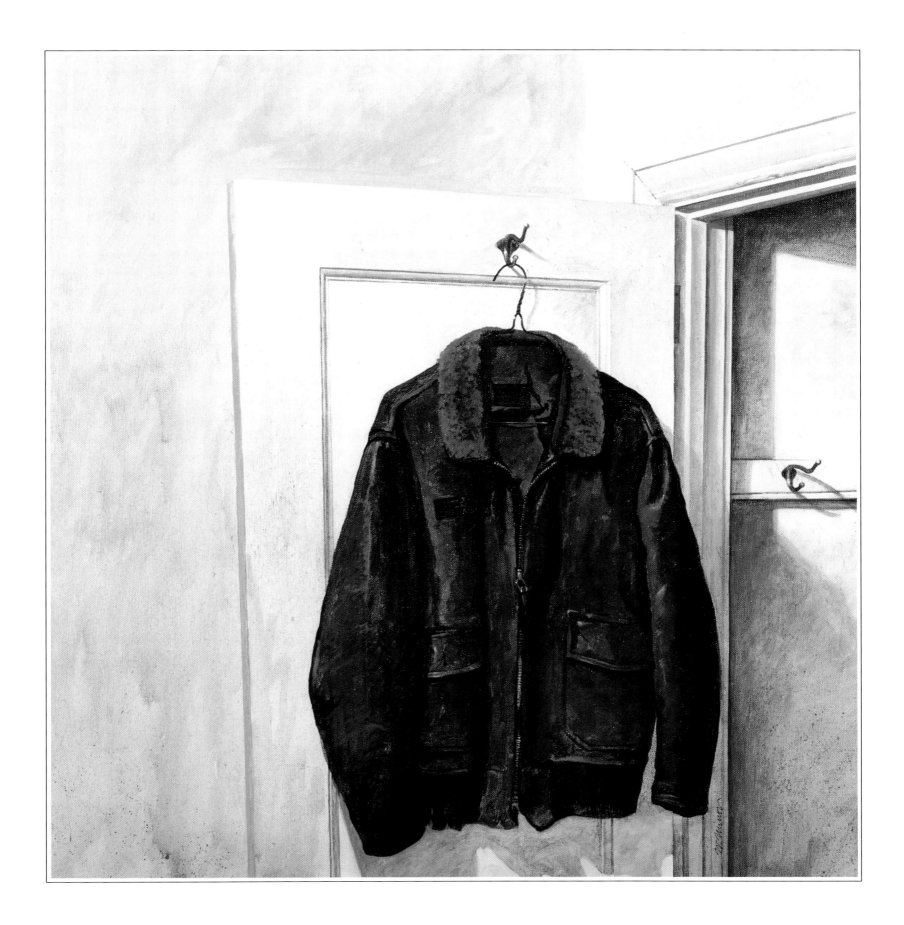

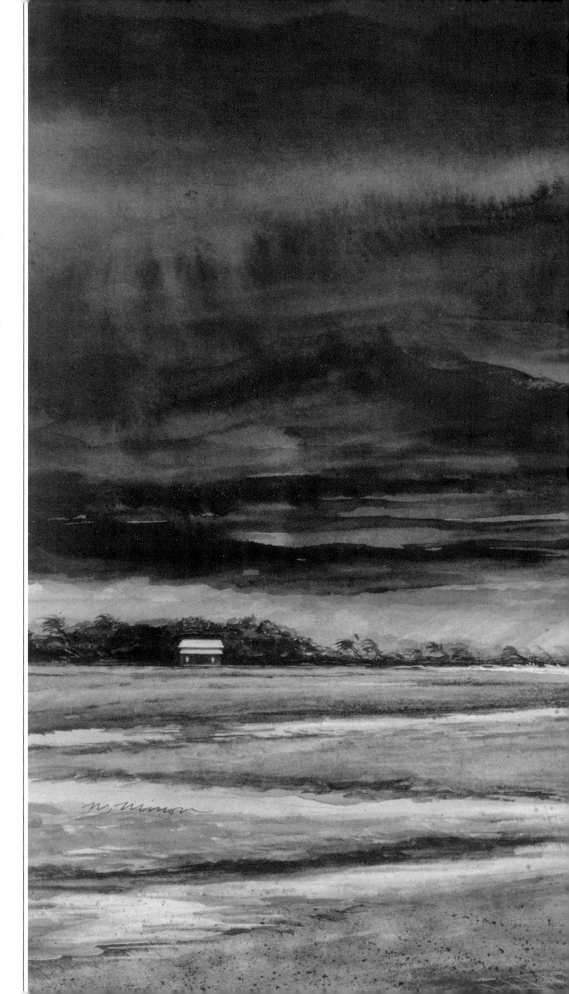

THE PRINCE OF TIDES *by Pat Conroy*

August 20, 1993

Dear Wendell,

To me, a jacket artist has an almost impossible assignment: to project in one image what has taken a writer years and often 100,000 words to explain. He/she is asked by the publisher to give the casual bookstore browser an idea of what the book is about—its style, its content, and that almost inexplicable but most important quality, its emotional impact on the reader. There are very few artists today who have the affinity for language to be able to do that, but you are certainly among those treasured few.

I remember when I first saw the artwork for The Prince of Tides, *that beautiful, dark, brooding painting. There was nothing more to say, just "Yes!" Thank you for that work, and for the many other jackets that have brought me to works that I've discovered and loved.*

My very best wishes,

Nan A. Talese
Publisher & Editorial Director
Nan A. Talese/Doubleday

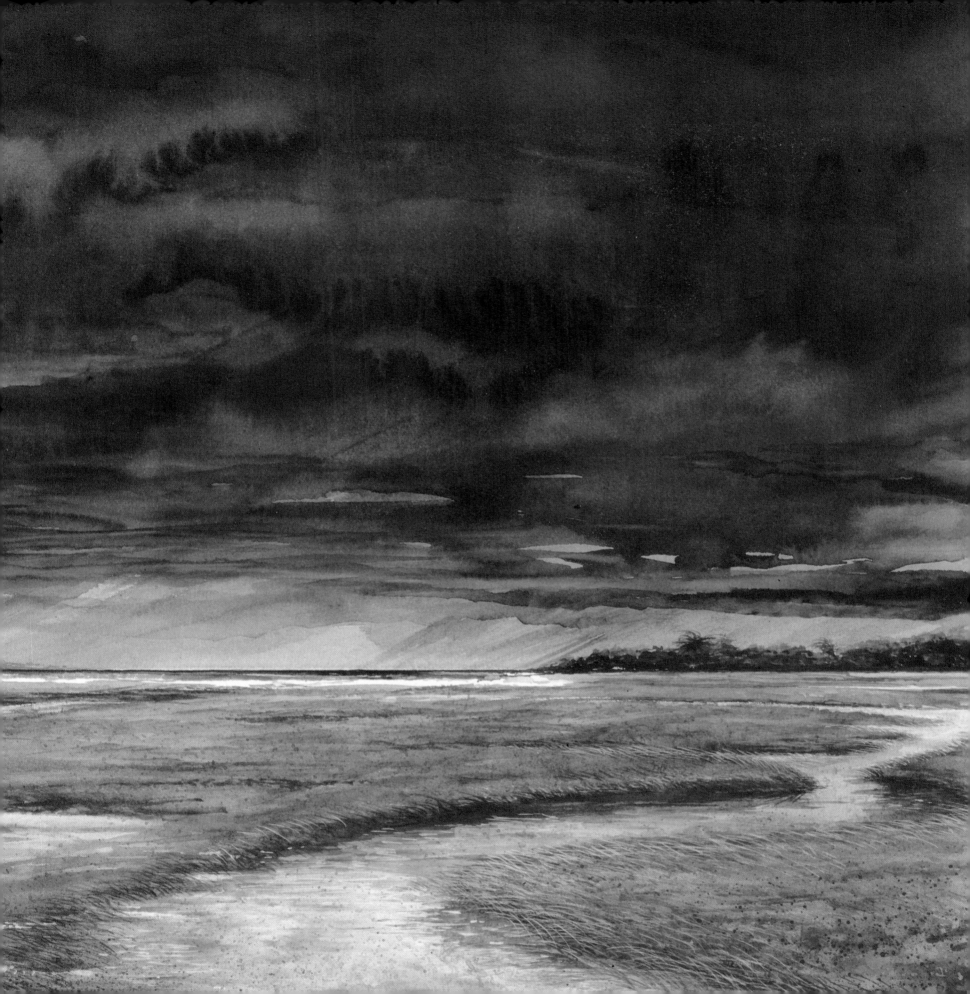

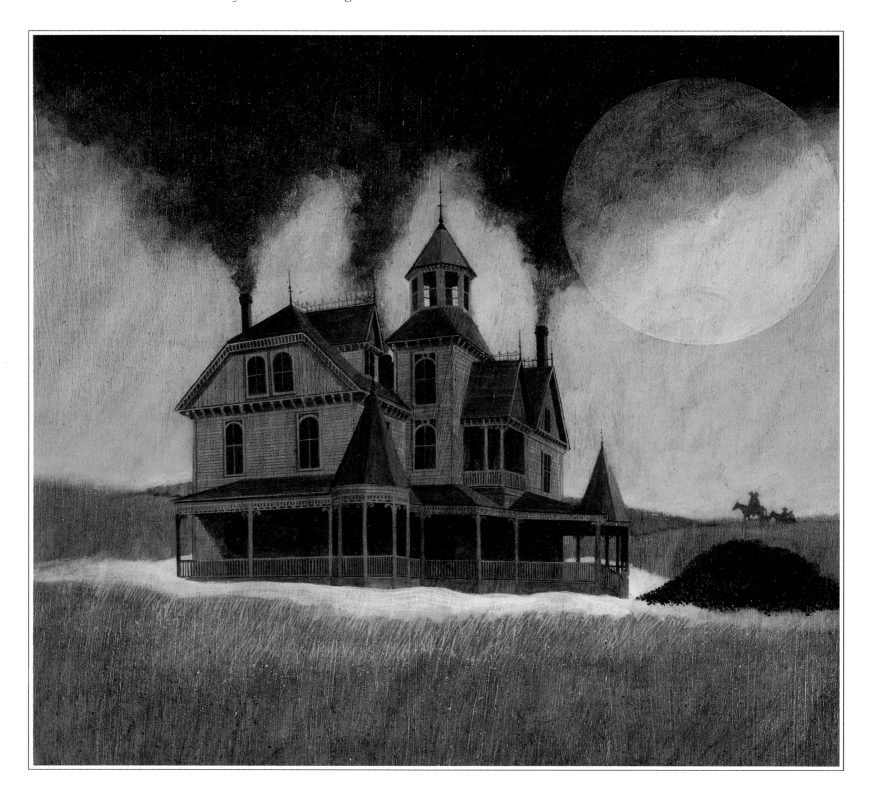

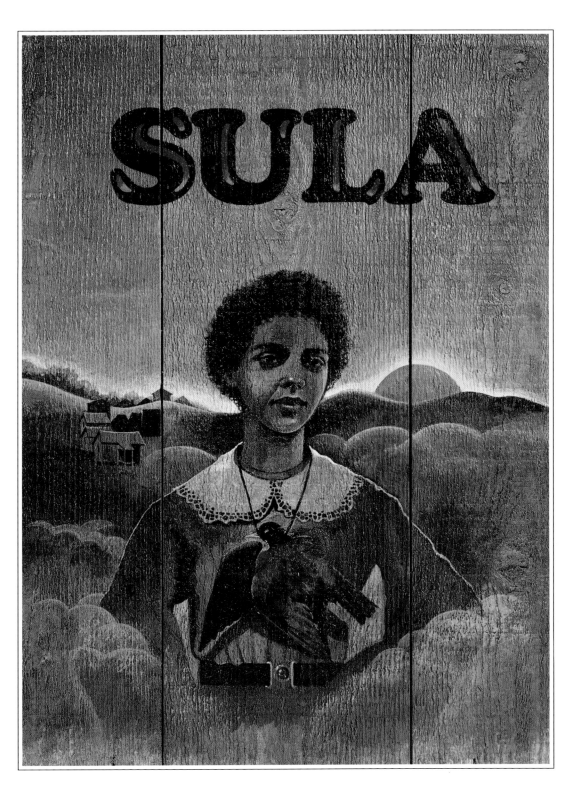

Sula, Toni Morrison's second novel, published by Alfred A. Knopf in 1973, established the author's reputation as something more than a "black woman writer." The book jacket, created by Wendell Minor during the early stages of his own graphic arts career, established the artist as something more than a cover designer.

Sula concerns the effect of American society on black women and is written in Toni Morrison's poetic yet spare and visionary language. Toni provides a gripping portrait of *Sula* using metaphors (of flight), folklore, symbolism, and her amazing talent for dialogue. Wendell's portrait captures many of the same literary qualities of the novel's presentation of Sula as a prototypical black American woman.

Eventually *Sula* was nominated for a National Book Award in fiction. Wendell Minor's *Sula* helped establish him as one of the leading American book jacket artists.

R. D. Scudellari
Former Vice President of Graphic Arts
Random House, Inc.

THE FEAST OF SANTA FE *by Huntley Dent*

Any book set in Santa Fe—even a cookbook like mine—winds up being *about* Santa Fe. A chile *ristra* hanging against an adobe wall, a lone hawk circling in the fierce desert sky, piñon hills haunting the horizon like blue ghosts: these are the images Wendell Minor caught, and in doing so, he caught the spirit of the place. Most illustrators would have missed that. The grit of the Southwest would have been airbrushed out in favor of glossy tastiness. So I count myself lucky, and whenever I look at *The Feast of Santa Fe*, I am impressed that its jacket is a landscape painting in its own right. If you didn't suspect that this was meant to be a cookbook, you'd know intuitively that it was about dust, heat, and sky. Santa Fe was captured truly and well.

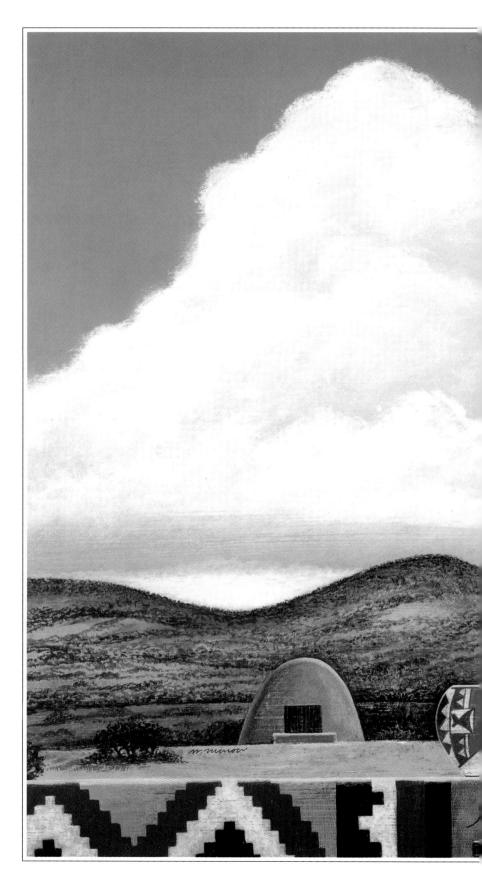

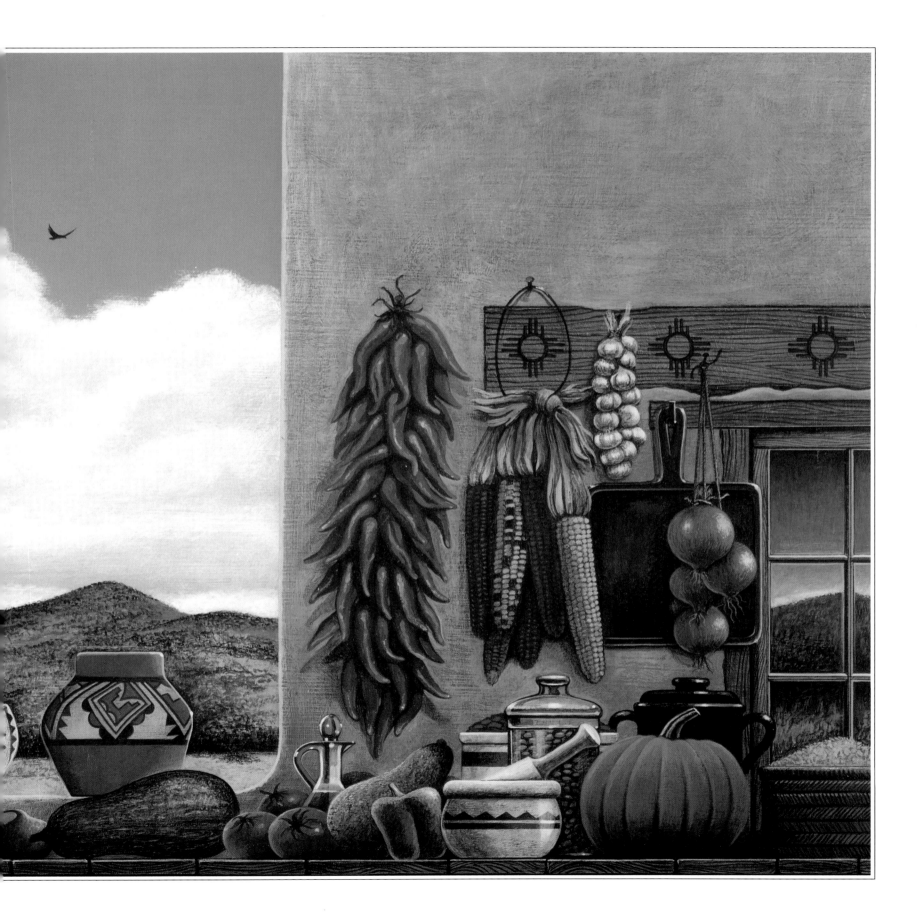

For my book on Poe, Wendell Minor caught a remarkable feeling of period and interpretation, capturing perfectly the essence of the book and much contributing, I feel, to its success. I was most favorably impressed by his work at the time, and whenever I have occasion to refer to *The Extraordinary Mr. Poe,* I am freshly impressed.

When one of my books is coming out, like most writers, I get as nervous as a baby duck about the cover. Among seven covers, I've had three mediocre ones and only a couple of distinguished ones.

Although obvious, it's hard to keep in mind that book covers and stand-alone art are distinct genres. Covers are artwork with an openly known purpose—to get a potential buyer to pick up

the book. They are halfway between advertising and "art." A great work of contemplative art might be a mediocre cover because it lacks magnetism or is not plainly enough related to the work inside the book or does not design well with letters or is the wrong scale for shrinking onto the relatively small space of a cover or has been poorly framed, or heaven knows how many other reasons.

But covers share one key feature with stand-alone art: the best ones become better as time passes. Rather than losing their strength, they grow on you as you realize how fitting and effective they are.

Wendell Minor's cover for my first novel had that effect on me. By personal taste and preference, I am not generally drawn to "primitive" styles, and therefore did not love it at first. From the start, though, there were some easy things to like: the white bandanna and pearl-handled revolver, the wonderful carmine feather, the lettering, and the colors. Later, I came to appreciate the portrait itself—the fact that while it is in the primitive style, it is actually drawn from a photograph of the historical Belle Starr.

When one compares Minor's cover to the South American edition of the novel, there is a world of difference. That cover was placed in a yearly advertising journal as the best example of that particular agency's work, and one can see the easy attractiveness of it: a beautiful, somewhat mysterious woman, face shadowed by her hat, walks directly toward you on a luminous, dusty street, rifle held casually by the barrel over her shoulder, wearing a radically décolleté blouse of a sort that was not seen in the American West, even in whorehouses, in the 1880s. Yes, I can easily enjoy that cover—it is technically well executed—but Wendell Minor's less obviously come-hither Belle is clearly of a different class because she better conveys the book's subject and mood. That's what makes the best covers grow on you—they refer to the book itself. They let the book show through. Wendell Minor is a master at paying attention to what's inside.

TRUMAN *by David McCullough*

November 13, 1991

Dear Mr. Minor:

This is just a note to tell you that I think that your initial sketch of the cover for the Truman book is positively brilliant.

Every once in a while a really thoughtful artist captures in a cover drawing the essence of the book which it surrounds. Nothing more perfectly delineates, in my view, the character and quality of Harry Truman than this very different, nostalgic, and old-fashioned (in the best sense of that phrase) drawing.

If it is important to you, you should know that both the author and his agent love the cover and admire the artist.

Sincerely,

Morton L. Janklow
Janklow & Nesbit Associates

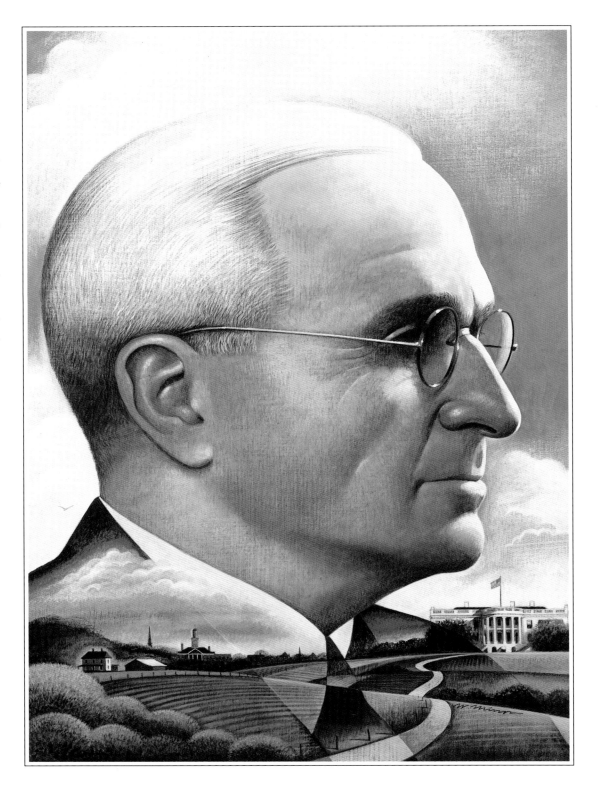

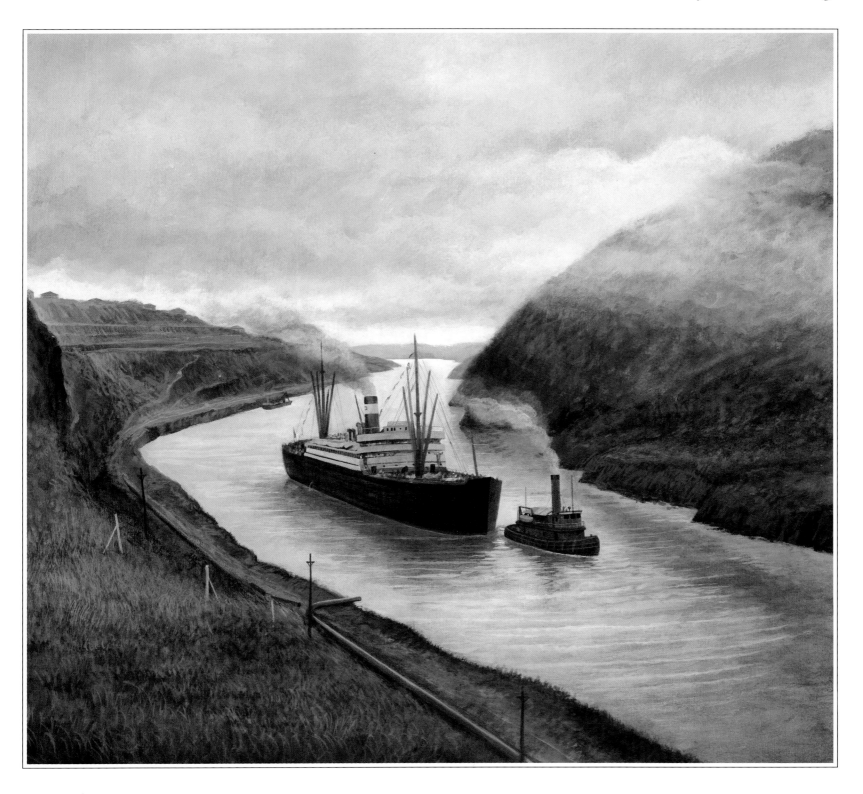

It all begins inside your head or floating in the vapors around you. Maybe it's a plot hook that grabs you while you're driving. Or a character situation. Or an historical event that seems ripe for a good game of *what-if?* Maybe you write down a snappy opening line and just follow your nose from there. Or maybe you spend months researching and outlining before you write a word.

But eventually, you write. You confront the blank piece of paper or the hollow-eyed computer screen, and you try to nail down those vapors with the sharpest words you can find. You try to turn all the chemistry inside your head into something as concrete as the desk you're sitting at.

And when you're done, you want people to read it and have the same chemical reactions inside *their* heads, while in the thin air around them, they see the faces you see.

But first, you have to get their attention. And for that, you have a lot of competition: eight thousand new fiction titles every year, magazines for every passion and pursuit, along with movies, home videos, network and cable TV, laser discs, compact discs, holograms, Game Boys, Walkmen, all kinds of computerized, digitized, modernized stuff, and all of it leading, in the not-too-distant future, to something called *virtual reality.*

You're working in a medium that hasn't changed since Cervantes published *Don Quixote* in 1605. But you know what readers know and what everyone else suspects—a good novel offers the best virtual reality of all, because it unfolds within the invisible proscenium of the imagination.

So how do you get the word out? If you're very good and very lucky, your name on the book will be enough to win the reader's attention. But writers today live in a land where the image is often the reality and where the first impression may be the only one you get to make. Bookstore window one day, remainder bin the next. That's the way it can go if it goes badly.

To catch the eye of the reader who isn't anxiously waiting for your book, you need a lot of things. Chief among these are the

talent and the luck, then the commitment of a publisher and sales force, good word of mouth, and as the flower to attract the bee in the bookstore garden, a good cover for your book.

Now *good*, as it relates to cover art, is a relative term. For a romance paperback, *good* means billowing silk, slabs of male pectorals, a bare female leg, and above all, pretty faces. *Good* for a techno-thriller may be no more than an F-16 trailing red fire across a background of black, with silver lettering for the title.

When your cover proof arrives in the mail, you always hope that it will be a striking work of art, something you wouldn't mind hanging on your wall. But that's not all that *good* is about. You also hope the artist has understood what you are trying to accomplish, knows how to attract the audience that forms the core of your readership, and at the same time, has found the

single image that will suggest the breadth of experience awaiting *any* reader who picks up the book.

In addition to skill with color, composition, and line, you're asking that the cover artist have the insight of a good editor, the savvy of a master marketer, and most importantly, taste—that ineffable sense of the look your book needs to develop an identity on the shelf. You're hoping for a lot.

When I completed *Cape Cod,* my publishers asked that I select two passages that would give the cover artist an idea of what was going on in my thousand-page, generation-spanning manuscript.

One passage included these lines: "Down on the Little Pamet Marsh, a blue heron was poking its bill into the grass. Geoff watched its slow and careful movement and marveled that such a delicate creature could be related to the gulls squawking above Pamet Harbor." And from another scene, set the morning after a storm, came this: "The crying of the gulls woke Serenity, the crying and the strange quiet. . . . The clouds were lifting off the horizon, like a ragged curtain, revealing a lurid band of red sky and a sea the color of slate."

Now, look at the cover of *Cape Cod:* a lonely heron and a lighthouse; a spectrum of colors—from sunrise gold through

lurid red to ragged strands of purple and blue—shimmering above a slate-colored sea.

It was my good fortune that those passages were sent to Wendell Minor. Though he reads in its entirety every book for which he creates a cover, in those passages, he found a key to *Cape Cod* and a way to symbolize it in a single arresting image.

The painting vibrates with the promise of an experience, the evocation of a place. The colors draw your eye. That lonely bird and the distant lighthouse intrigue you because they tell you so little. The whole image speaks without spelling anything out: here's a novel about nature and man and a colorful spectrum of events, a good read and maybe something more.

It's a cover that makes people want to pick up your book, not the one next to it. Once that happens, Wendell Minor has done his job.

And for me, he's done it more than once. Look at his cover for the paperback reissue of *Back Bay,* my first novel. The book is about a treasure that sinks into Boston's Back Bay and is buried when the bay is covered by landfill to create an exclusive neighborhood. The cover juxtaposes a timeless Boston bowfront with an old sloop and suggests that somehow sloop and bowfront, water and dry land, are related. In the foreground, a street lamp glows, adding the proper touch of intrigue: another cover that grabs your attention and makes you want to look inside.

Once word of mouth works its invisible magic, no good cover will sell a bad book. And a good book can often overcome the wrong cover. What begins inside your head or in the vapors around it will eventually succeed or fail based upon how well you create your virtual reality in print. But in an image-driven world, every author likes to know that there's a Wendell Minor reading his books and helping him to find his audience.

And when someone mentions *Cape Cod,* it's fine by me if they think of a blue heron standing by the sea at dawn, because that's what I think of, too.

MONTANA GOTHIC *by Dirck Van Sickle*

As we explore the painting's surface, a sexualized landscape strewn with Western icons, its meanings and feelings work into us by different means than decoding a half-mile string of words that key us to build our own images as we go along.

The eighty thousand words inside detail what we see and at some troubling level comprehend at a glance; for while the painting is a separate work of art from the book, it's also a cerebral cellophane that gives a glimpse of the world inside as seen by an early explorer, Wendell Minor.

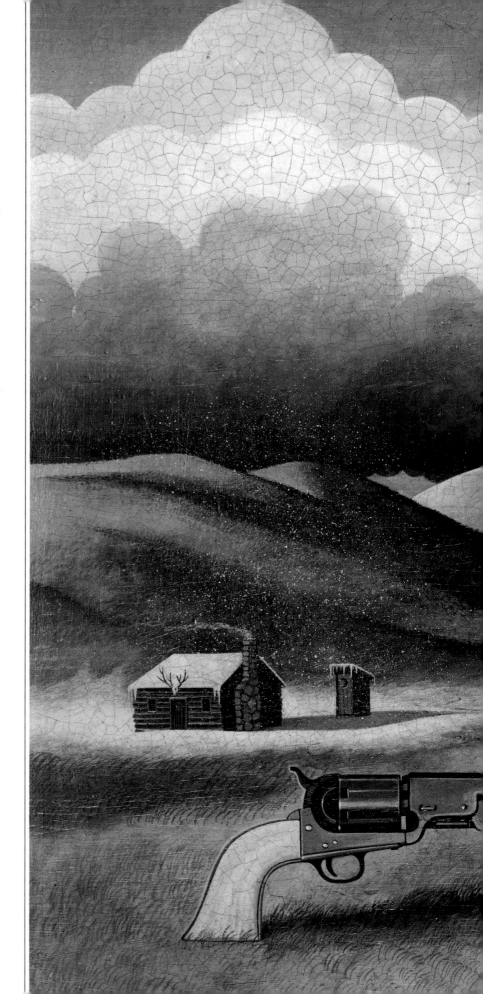

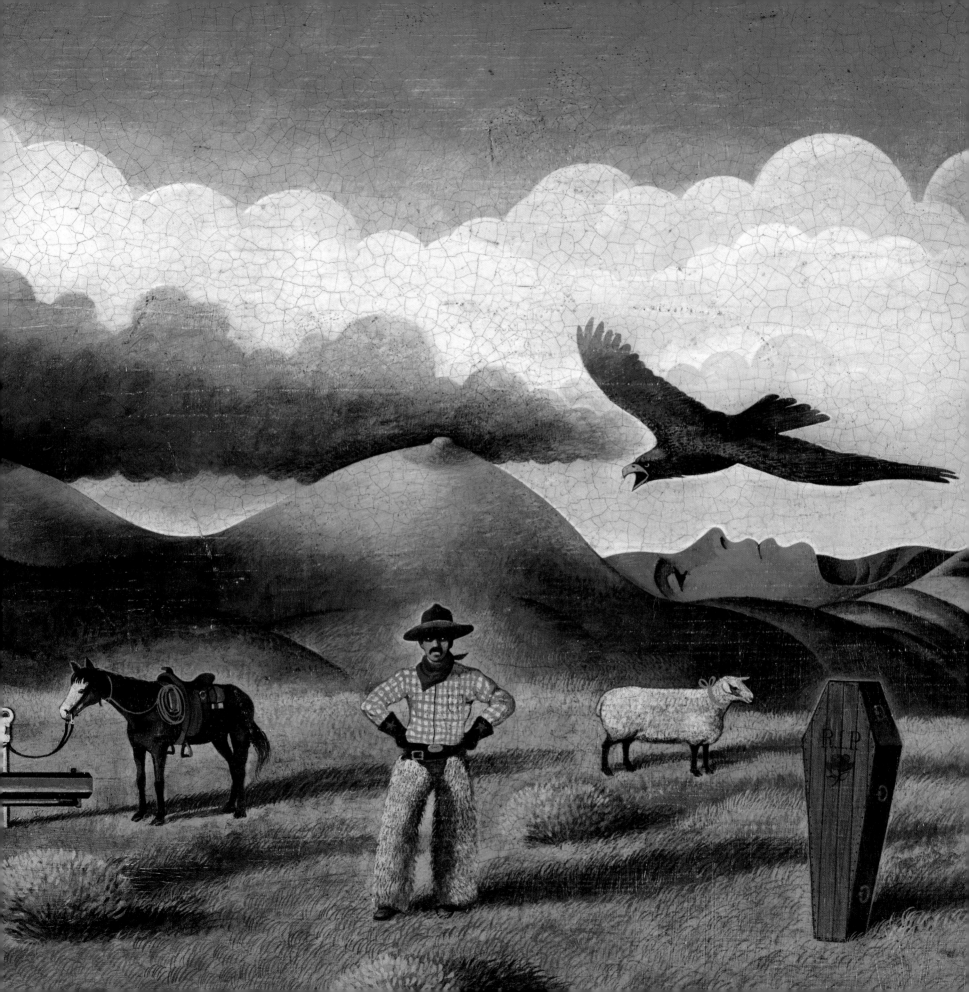

I avoid reading my old books because all I can see in them is the gap between shining intent and leaden performance.

Thank God the same is not true of their covers. I remember how for *Polar Star* I wanted a cover full of more stars and less ship, but over time, I have come to appreciate the still, massive quality of Wendell's factory ship and the shadow that spreads forward toward the viewer. For a writer, it is disorienting to see the jacket art because for the first time he or she is literally seeing the novel through someone else's eyes. Worse, the impression of the public will always wed the book to that art.

So it's interesting how the art for *Polar Star* has, for me, improved over time. The novel happens to have a particularly solid quality that is reflected by the art: a ship that looms like a black iceberg in the night. The painting even seems to pick up the structure of the writing, which divided the story into three sections titled Water, Earth, and Ice. Wendell has altered them into Water, Steel, and Air. And now that's the image of the book that I carry.

Wendell did just the opposite for *Stallion Gate*, a novel about the creation of the first atomic bomb in New Mexico during World War II. A lesser artist might have painted Indians dancing under a mushroom cloud. Instead, Wendell produced a graceful ballet of the usually invisible: Awanyu, the Plumed Serpent of Pueblo belief, sinuously coiled around the symbol of the atom. There is even the Minor solidity to the art, like a good Pueblo pot.

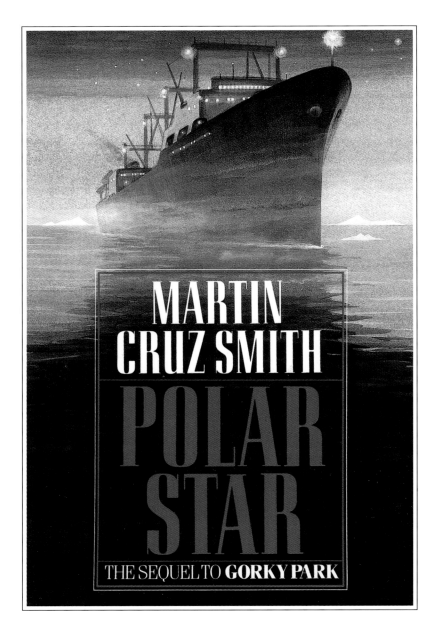

HIROSHIMA, THE WALL, and BLUES *by John Hersey*

January 31, 1993

Dear Wendell Minor:

The first book of mine that was favored by your cover art was Blues, *a rumination on the joys and the deep thoughts of angling for bluefish off the shores of Martha's Vineyard. Your painting folded around the book, on front and back covers, just as the sea folds around the Vineyard. And it had what seemed to me a thrilling ambiguity, for it was partly exact and true to life—picturing my boat heading out between the island's Chops, with the fisherman (perhaps me) at the wheel, wearing a white sun hat, and the East Chop lighthouse visible in the distance—but also partly, in a way, surreal, for besides the blue water going round the book, a huge bluefish, dwarfing all else, was also wrapped around the words within the cover.*

And so, again, with The Wall, *a book about the ghetto in Warsaw, tightly ringed with bricks and mortar by the Germans, you managed to build with your brushes and pigments a wall that encircled the cover, ominously hemming in all the words in the book and giving a sense of the malign enclosure of the story's victims by the Nazis, whose swastika could be seen peeking in a surreal way over its impossibly high top.*

With each book, in similar ways, you were able to combine a sense of three-dimensional reality, derived from the book's words, with symbols that seemed to come somehow from dreams those words might have engendered.

I'm most grateful to you for those illuminations.

Sincerely yours,

John Hersey

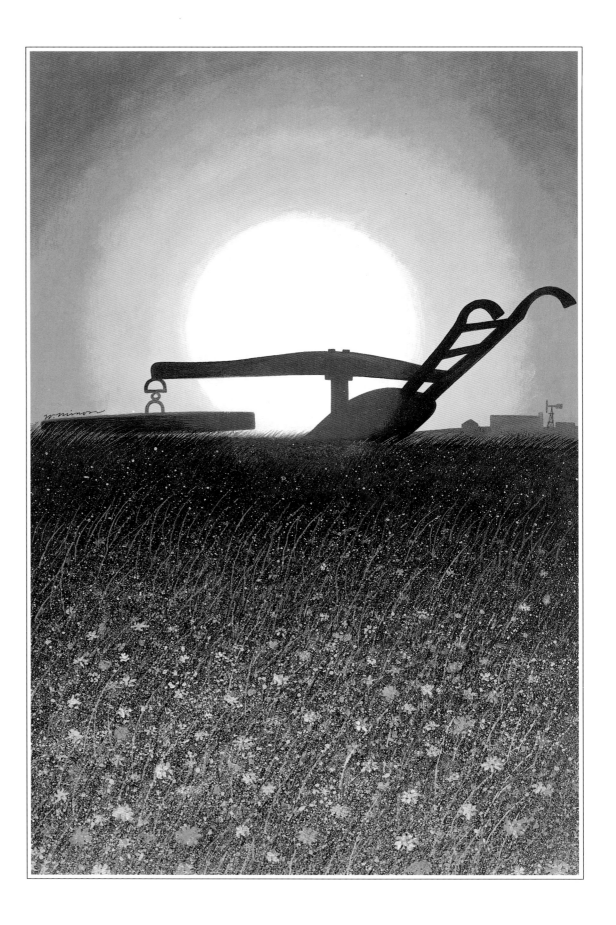

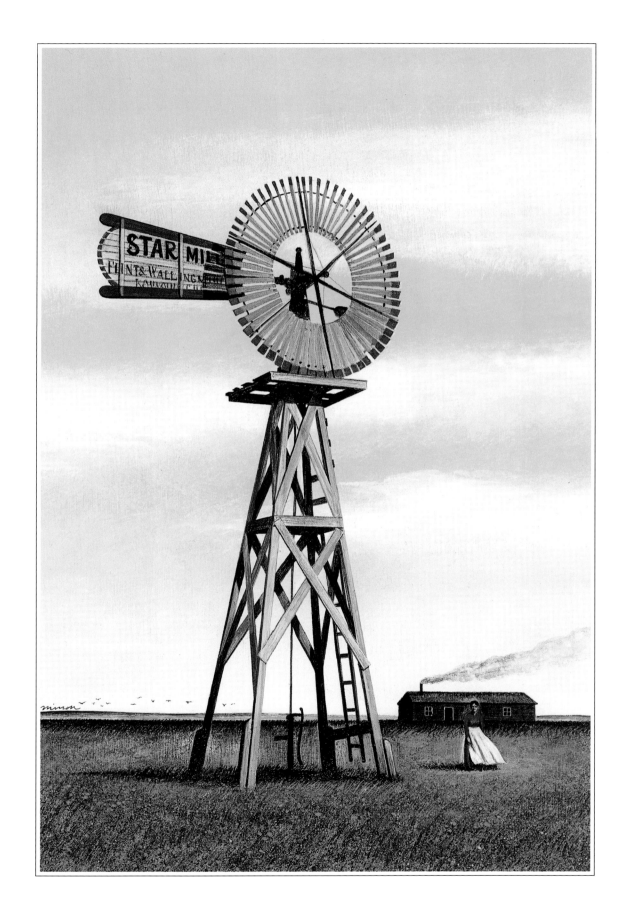

To achieve true book cover art, the publisher must be willing to commission an artist who will read the manuscript carefully and seek empathy with the author. Such cooperation will give added life to the words on paper. A picture may be worth a thousand words, but in this field of creativity, one hundred thousand words may be necessary to form the basis for the cover art.

King's Mountain concerns a little-known but decisive battle between "Backwater Men" and an army of Tories led by the remarkable Patrick Ferguson. Central to the book cover is Major Ferguson, falling dead from his white horse as he sought to flee a stricken field. This is all clear and dramatic, but what of the rising sun at the top? It is, of course, symbolic.

Deep in the book an incident is recounted in which an American prisoner hears news of the destruction of Ferguson's forces. He jumps upon a woodpile and crows like a rooster.

"Day is at hand," the prisoner proclaims.

The rising sun captures the prisoner's faith and marks Ferguson's death as the climactic moment of a decisive battle in a long war for freedom. In so doing, the artist enhances the word picture created by the author—an achievement every author and reader will applaud.

Cover art for a book presents the same challenge as title selection. The author composes maybe 150,000 words with varying degrees of pleasure and agony. But the last three or four, the title, are invariably the hardest, at least for this writer. Why? The challenge of distillation, of compressing complex ideas worked out over hundreds of pages into a single phrase, even a single word. Or, as in Wendell's case, into a single image.

I vividly recall going to the Viking Press as my book on Gettysburg neared publication and being greeted with the editor's surprise, a proof of Wendell's cover. I had tried to write about the GI, circa 1863, Yankee and Rebel, and what he must have undergone. And there it was, what I had taken 252 pages to say, the anomaly of young Americans, not all that different from each other, bearing no personal ill-will, poised to slaughter each other to such horrific effect. The faces possessed both strength and resignation, something that said, "This is a damn poor job I'm doing. I'm not sure why I'm doing it. But I'm told it must be done."

I liked the jacket well enough that my wife bought the original painting from Wendell for my birthday present, and it hangs in my office to this day.

The Dixon Cornbelt League *and* Shoeless Joe *by W. P. Kinsella*

March 9, 1993

Dear Wendell Minor:

I am very pleased with the cover art you have created for my books. My feeling is that cover art should cause the browsing book buyer to stop and take a second look, to pick up the book, admire the cover, say, "Oh, Kinsella. I've always wanted to read him." And then carry the book to the cashier.

 Cover art supplies that extra touch of beauty or mystery that turns a browser into a buyer. I feel your cover art has enhanced the sales of my books. I am particularly excited by The Dixon Cornbelt League.

Go the distance,

Bill Kinsella

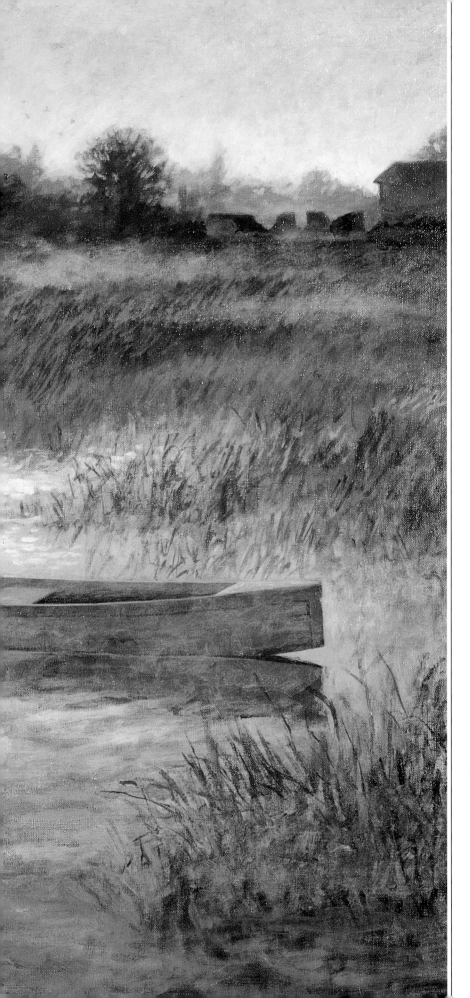

DARCOURT *by Isabelle Holland*

Wendell Minor's painting for the jacket of my novel *Darcourt* perfectly portrayed the lush and rather menacing swampland of the novel's fictitious island off the South Carolina coast. As a writer, I frequently tend to ignore physical background. *Darcourt* was an exception. Of all my books, *Darcourt* was the one where the physical surroundings most dominated the action and atmosphere of the story, providing a sense of the danger, mystery, and lurking menace that I tried to portray in the book—and that Wendell's jacket perfectly conveys. So many jackets today bear little connection to the contents of the novels they cover. But his was a wonderful union of art and words.

KILL DEVIL HILL *by Harry Combs*

The way Wendell demonstrated his exceptional artistic talents to conform with the story line in my book, *Kill Devil Hill,* was outstanding. The image of people standing in the foreground looking up at this strange contraption, a flying machine, relates so well to the book, which is the definitive work on the Wright Brothers and their discovery of flight.

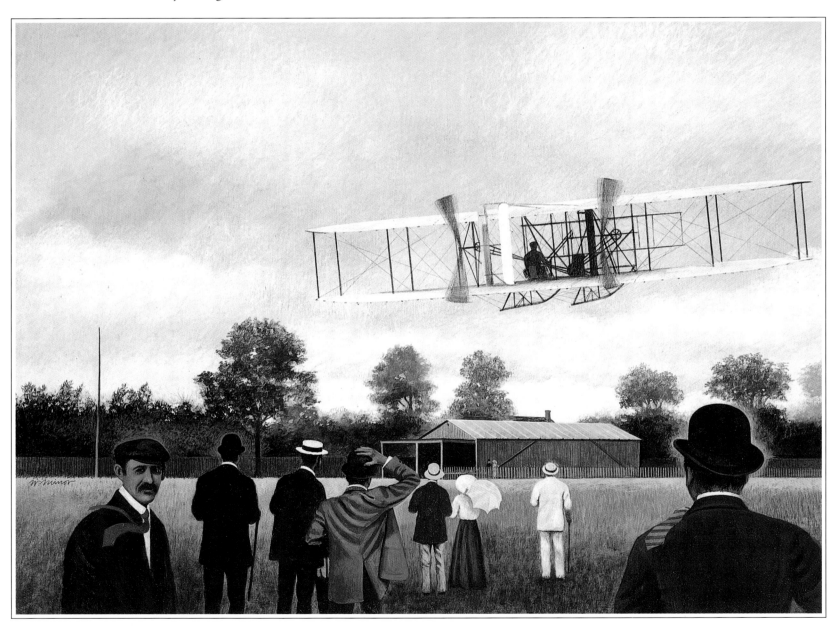

PAPER DOLL *by Jim Shepard*

Oh, are book covers important to fiction writers and poets. It's hard to make clear to people how important they are. To evoke what it's like during those months while you wait to see what the publisher has come up with, you have to go back to childhood to find analogous intensities of dread and anticipation. We keep how we feel to ourselves, because we know how petty and childish it will seem to the outside world. "It's only a *cover*, for god's sake," our loved ones will remind us. "Isn't what's important *inside?*"

Yes. And outside. A friend of mine was thrown into such despair by his publisher's choice of cover—which they regretfully refused to change, even when he offered to *pay* for the change, as if the decision had, alas, been taken out of their hands—that it ruined the entire experience for him. Compliment him on the book now, years later, and you'll still see him wince.

We fiction writers envy poets, at least poets at major publishing houses, their control over covers. It seems that the major houses, believing poetry to be beyond marketing anyway, leave the covers to the editors and authors themselves, and I'm forever being shown books of poems by poets who explain to me how much fun it was hunting down with their editors exactly the right painting by Franz Marc or Caspar David Friedrich. When it comes to fiction writers, some of us have veto power, and a few select others have a little more say than that.

Mostly we wait for that eight-by-ten envelope containing the color Xerox backed by cardboard, always accompanied by the same cover letter:

Here's the cover. We love it. What do you think? If you have any problems with it, make sure you call us by yesterday.

Such a letter accompanied Wendell Minor's cover for my second novel, *Paper Doll.* When I scrabbled the letter aside to view the image, imagine my relief when I saw that all of the disastrous strategies I had imagined had been avoided. The cover was *pleasing.* I liked looking at it. It was possible that other

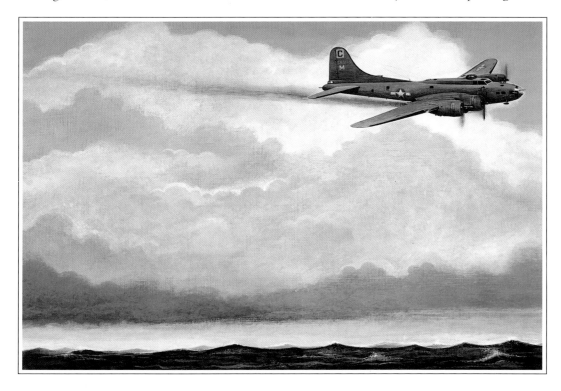

people, people who bought books, would like it too. It had a forlorn, faintly noble quality to it that seemed perfect. The understated jauntiness of the lettering, as well as the restraint involved in picturing just one seemingly only slightly damaged B-17 losing altitude in the gentlest manner, heading toward that gray stone ocean below, was exactly right.

Did I write Wendell Minor to thank him, or express my appreciation? I did not. I was young, and accepted my good luck without looking back. But I thank him now, and express my appreciation for his work—on my cover and other covers I admire as a book buyer—here, in this forum, where it seems most appropriate.

Anything for Billy *and* Terms of Endearment *by Larry McMurtry*

May 24, 1993

Dear Wendell:

Your work has always epitomized for me the visual leap ahead that defines a book in terms of cover art. Both with Anything for Billy *and* Truman, *the real art is to invent a look that is entirely original, and at the same time, beautiful, not what I could have imagined, but what I could never have imagined!*

As ever,
Michael

Michael Korda, Corporate Vice President, Editor-in-Chief
Trade Division, Simon & Schuster

August 23, 1993

Dear Mr. Minor:

I liked Terms of Endearment, *didn't much care for* Anything for Billy, *but really just have nothing to say that would be helpful.*

Best,

L. McMurtry

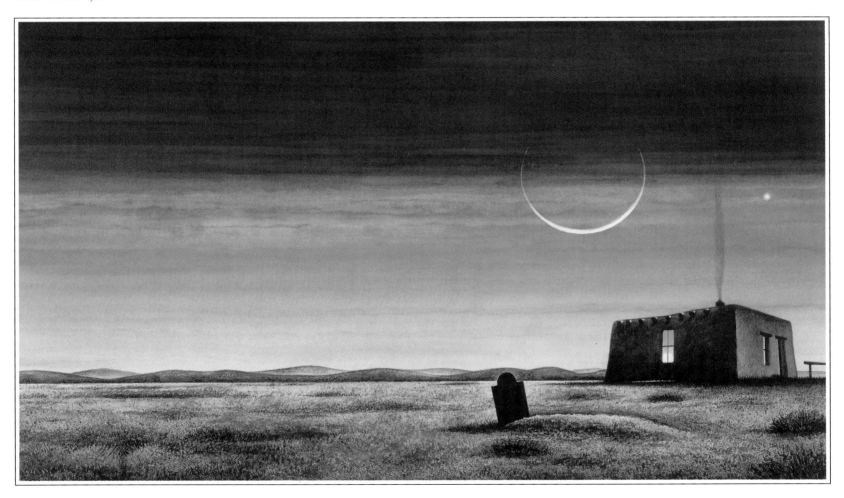

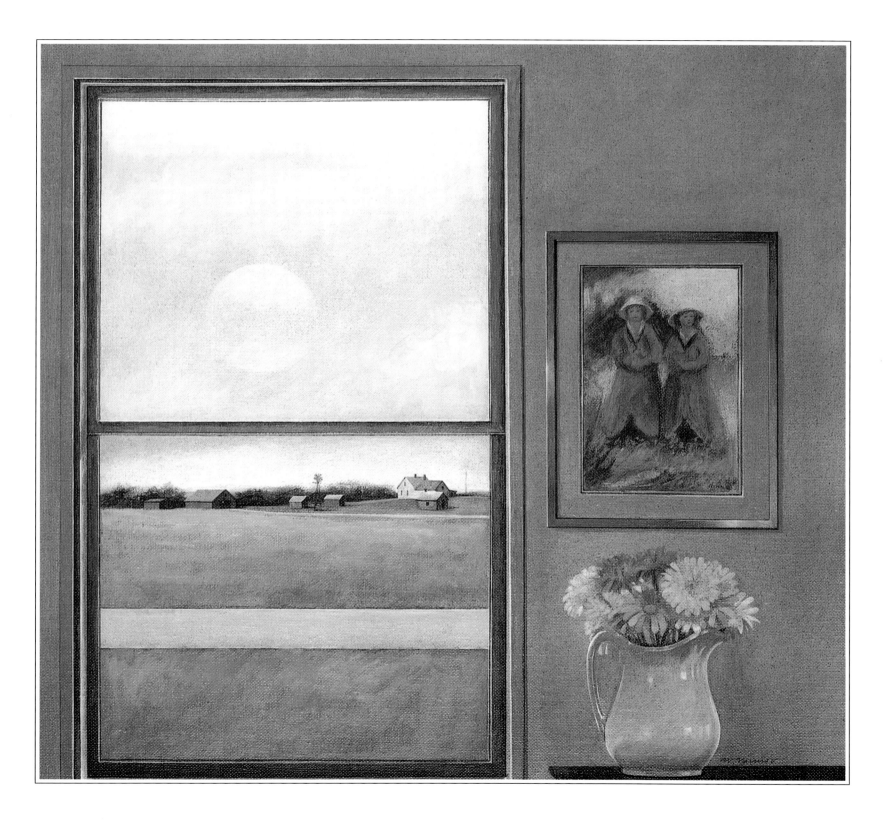

Truck *by John Jerome*

November 4, 1976

Dear Wendell,

You could've parked yourself by my barn for a month and you wouldn't have gotten any more accurate a likeness of Truck. My God, you even got the sag in the driver's-side door. And the rust spots are in the right place. Are you sure you haven't been snooping about these parts while my back was turned?

Needless to say, I'm pleased. I think the mood is precisely right, just somber enough. Shit, I'm just floored.

Regards,

John Jerome

July 16, 1993

Dear Wendell,

I was stunned when I first saw that Truck cover—and have never stopped being stunned for the succeeding sixteen years that the original painting has hung over my fireplace.

What stunned me was how many things about the book you'd gotten into the cover. You found an example of the very 1950 Dodge I was writing about, in the same color scheme, and captured the same stage of oxidization of its fading paint. The painting is technically accurate, in other words, which is especially fitting, since the book is a mock treatise on technical accuracy. Its setting—the silver-gray sky, the black-green spruce and firs—is bleak and gloomy, characteristic of the northern New Hampshire valley in which the book actually took place, and yet there is something basically cheerful about it, even about

that sagging old truck. And God knows I tried to make it a cheerful book. What you can't know is that the truck sat for years in just such a field of grass, with those firs in the background, so when my wife and I look at the painting, we also see the old barn just out of the frame to the right.

Sorry, I can't do anything but gush. The painting has been very important to me. Thanks for painting it.

Gratefully,

John Jerome

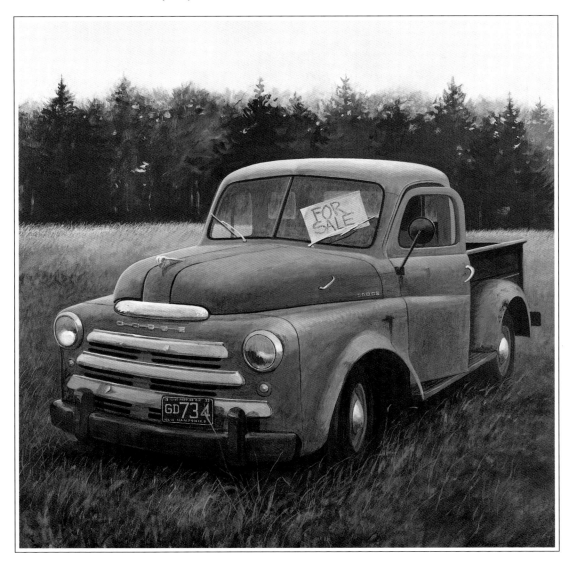

I must confess that when I write a book I never have a cover in mind. But if I did, I think it would resemble the covers that Wendell Minor has composed for my last three books. There's a fine moodiness about the scenes that his covers depict. All of them have caught the spirit of what I was trying to write.

THE DOUBLEMAN *by C. J. Koch*

The opening of my novel *The Doubleman* deals with a meeting between its central character—then a schoolboy—and a man called Broderick, who is a guitarist and an expert on the occult: in fact, a warlock. This meeting sets the course of the entire novel, whose themes are bondage to illusion, and the psychological effects on a group of musicians of obsession with the unseen.

The meeting at the opening is based on an old Scottish ballad called "The False Knight upon the Road." In that ballad, the false knight is actually the Devil. He questions the boy, who manages to get the better of him in regard to every question, never letting him have the last word. Wendell Minor took this meeting as the basis for his jacket design, and I am deeply impressed both with his choice of this scene—since it embodies the book's central theme—and with the way in which it is executed. Mr. Minor has captured the flavor and meaning of the meeting by his use of figures in a landscape that is apparently peaceful, yet ominous, and by the overlaid figure of the Devil as musician. He has invested the entire design with a quiet threat that is far more effective than anything more sensational would have been. A penetrating piece of work, which has understood the spirit of my story in a way few jacket artists ever do.

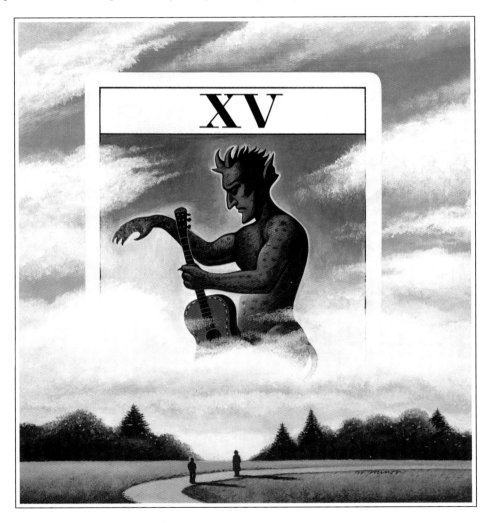

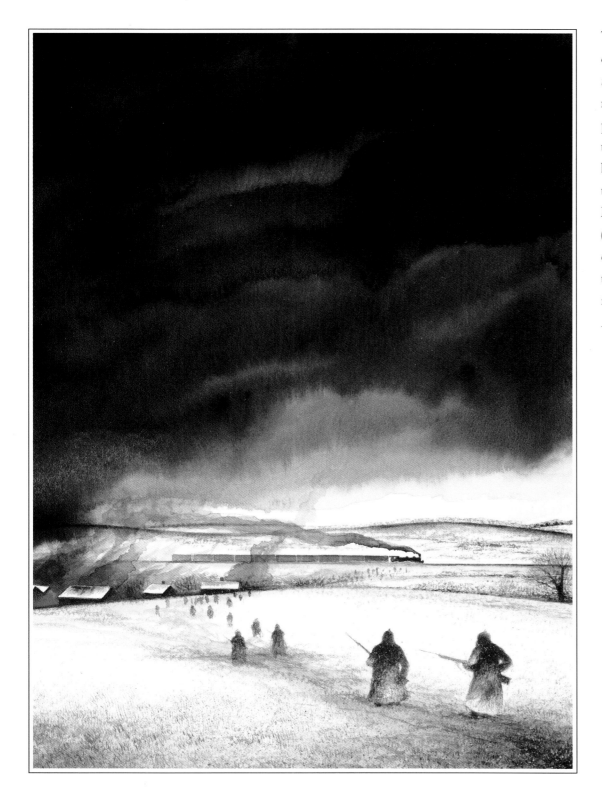

RED VICTORY *by W. Bruce Lincoln*

The dust jacket that Wendell Minor designed for *Red Victory: The History of the Russian Civil War* added an entirely new dimension to the book. What impressed me most was Minor's great talent for capturing the essence of the book and translating it into visual terms. The pain, pathos, and essential loneliness of the Russian Civil War (and all civil wars, for that matter) come through brilliantly in the illustration he did for the book's cover. I am indeed grateful for his effort to make *Red Victory* a very special book.

A Gathering of Old Men *by Ernest J. Gaines*

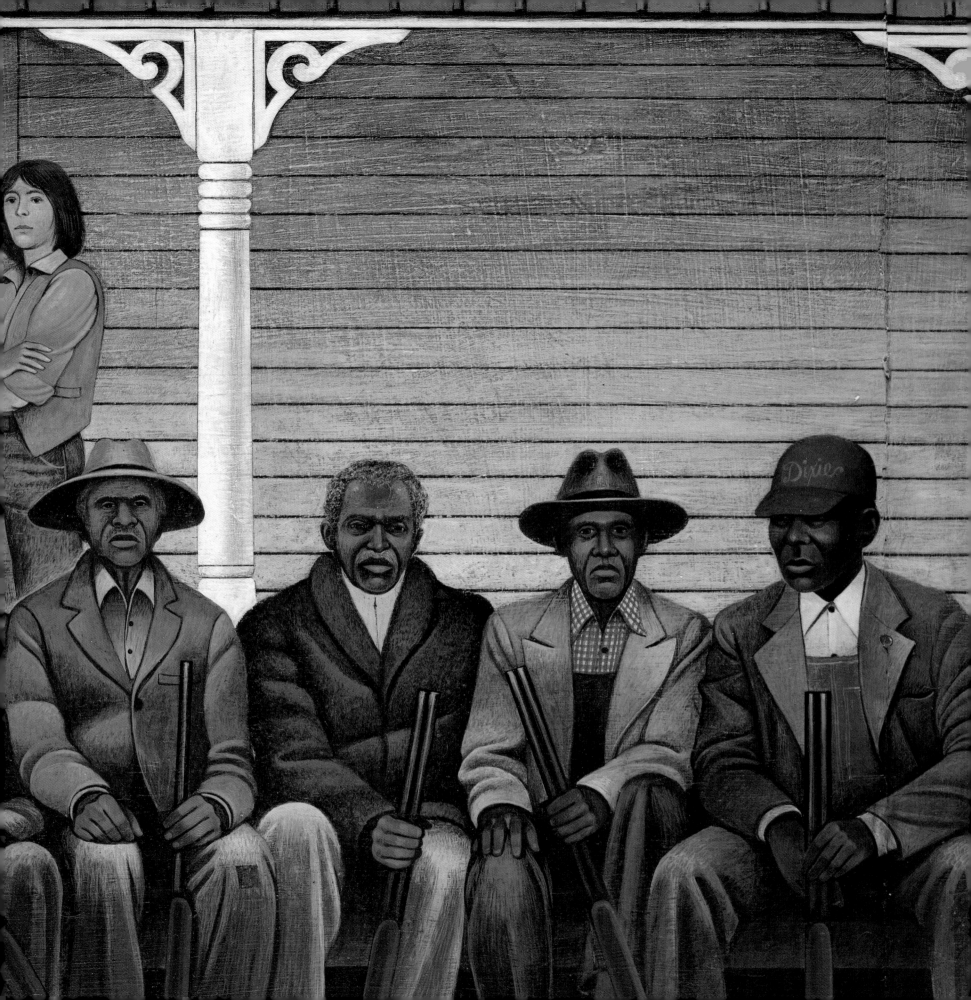

I've been a fan of Wendell Minor's work for years without being aware of it, admiring his book covers and never quite remembering the name. Then he did a cover for me and suddenly he became unforgettable. The book was a collection of pieces called *We Are Still Married,* not an easy assignment for an artist, what with the pieces being about everything and its cousin. But Wendell plowed through the manuscript and lit on a story called "Stinson Beach" about a place I used to know north of San Francisco. He painted an Underwood typewriter, a sheet of paper in the roller, sitting on a sandy knoll, with dune grass and a little beach house in the distance and the blue sea under a pinkish-blue early morning sky. I loved the picture right away. It arrested my attention to see a handsome old typewriter sitting on the ground, thinking of sand getting in the works, though Wendell had placed the typewriter lightly atop the sand, suggesting that someone had set it down only moments ago. My impulse on seeing the picture was to step forward, pick up the typewriter, haul it down to the house, and ask if they were missing one. The book's editor, Kathryn Court, and I looked at the picture, accepted it in an instant as is, and that was that.

The second cover, for a novel called *WLT: A Radio Romance,* was a little more complicated, which was my fault. I decided that Wendell should paint an image from the novel. On the wall of one of the WLT studios in the Hotel Ogden was a painting of a naked goddess dating back to when the room had been a ritzy bar called the Longue des Artistes, a painting that had been papered over when the radio station moved in, paper that WLT announcers over the years had peeled away to reveal the goddess once again. This was a complicated idea for a cover and one that wasn't especially relevant to the story, but it was my idea, and Wendell went ahead and painted a voluptuous and tremendously cheerful reclining woman attended by cherubs as a mural on a peeling wall with an announcer's felt-covered table and desk lamp and chair in the foreground. My editor and I both liked the

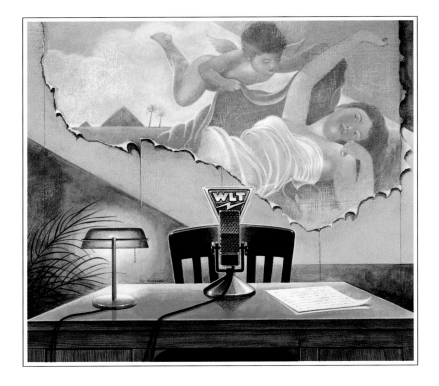

cover, which duly appeared in the publisher's catalog, and a few days later, a major book chain let it be known that they would not carry the book with the cover as shown. They objected to the woman's nipples and insisted that they be covered. So she was sent back to the artist for camouflage, and a winged cherub pulled a patch of gauze over the breasts, and the book was shipped.

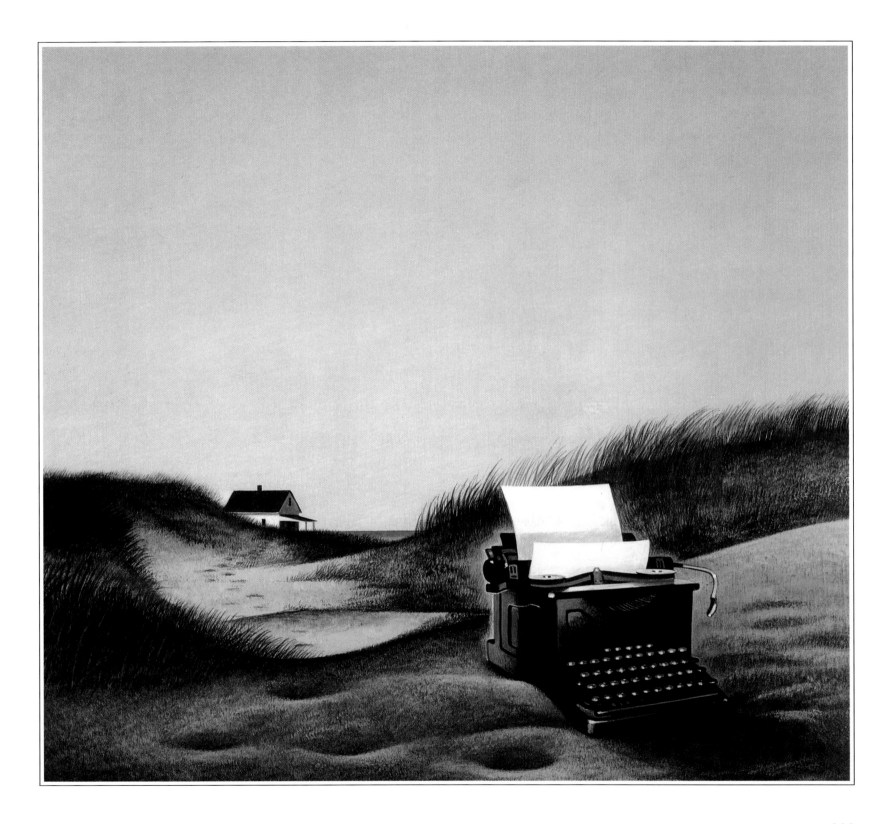

RUIN CREEK *by David Payne*

Mystery is a vapor that all too easily evaporates under the lights of too intense a scrutiny, and so it's probably wiser not to inquire how Wendell achieves his haunting effects in the painting for *Ruin Creek*. Throwing wisdom to the winds, let's ask anyway. . . .

A car barreling along a country road beneath an orange moon—what does this say, and more importantly, what does it suggest?

First of all, the car is a Chevy Bel Air, a 1950s icon quite distinct from the more familiar Corvette, Thunderbird, and other "cherry" cars that have come to represent the aspirations of rebel youth. By contrast, the Bel Air was the quintessential car of the American middle class, a steady, dependable family car, built for comfort, not for speed. It evokes for me—and, I expect, for others who remember the car and the time—a vague nostalgia for a vanished world.

In the painting, this car is traveling at a high rate of speed toward a destination that's not apparent, suggesting a past journey that's still unfinished. Beyond that, Wendell's image suggests the persistence of the past in the present, specifically the 1950s past: America in its post-war heyday, already accelerating toward the social fragmentation and malaise of the fin de siècle. The values that underlay the prosperity and well-being of that

time—attitudes concerning family, gender roles, work, personal fulfillment, love—have borne strange fruit that few could have predicted. What was it about that past that has led to this present and the condition in which we find ourselves today? Did the values somehow contain the seed of their own self-destruction, or did we merely betray them?

No answers are forthcoming, not in the painting, nor in the story that it introduces. Where all this is headed remains unclear; the only certainty is that the process is ongoing, the antique family vehicle is still hurtling along, carrying us toward an unknown future. Note, though, the black diamond of the caution sign in the foreground, and the direction of the motion: under the burning eye of the enormous harvest moon, everything is headed down and to the left.

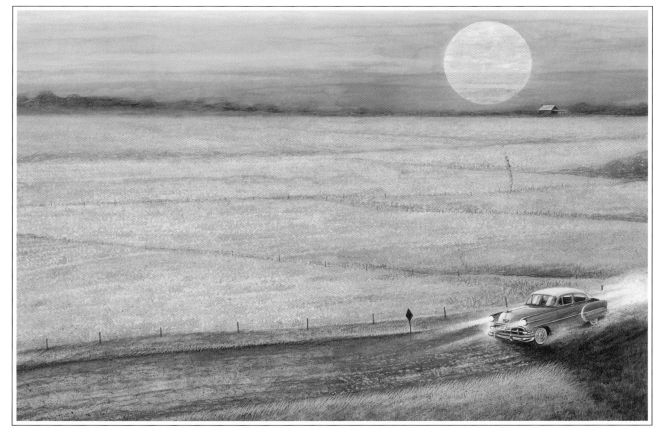

When I first saw Wendell Minor's cover for *Sleeping with the Enemy,* I said, "He's read the book." This was the first cover art done for a novel of mine: *A Natural Death* had a period watercolor for its

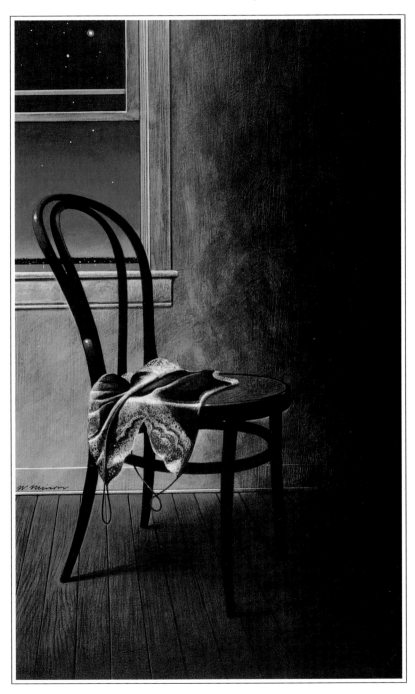

jacket, and *An Accomplished Woman* used only lettering. "He's read the book," I said, but if someone had asked me, "How do you know?" the answer would have been difficult. What did I see?

Wendell Minor's lettering on this cover is severe. There is nothing romantic about its thick verticals; from a distance they stripe their corner, coming toward the viewer, whiter than anything else. Off-center, they bar the darkness of half the cover where something we cannot see (but can guess at) is happening. The blue, gray, black, and rusty red join the lettering to say: Somber. Serious.

Far behind the words, Minor has drawn a rigid, bare fragment of a room. The lines of the quarter round, floor, and window form a barrier. Only the floorboards run toward their vanishing point in distant blue water, but they are stopped dead by that wall.

Something else wants to escape to stars, sea, and limpid night sky. The remaining objects are as rounded as the rest are angular. The abandoned chemise is gray like the wall, but its slithering satin is in stark contrast to the rough textures around it. Half of the intimate garment lies prostrate, flung down; the other half, closest to the window, echoes the rising curve of the chair. One chemise strap rounds on itself in a tear shape; the other strap is a noose.

Light falls on the rounded objects, glowing on the chair back as it would glow on a woman's shoulder. The chair stands in that light: a classic chair, which delights me. The rounds of its base circle under the load of satin, the chair's legs are half sunk in dark, but its back is in the light, and the long double curve of its bent wood seems ready to spring into night sky. Its legs are braced.

So Wendell Minor's cover says: somber, serious, subtle, and hidden. Someone may be shut in, but she can see that eloquent chair from where she lies. It holds her satin and is as strong as she is, waiting. The window is open.

A Relative Stranger *by Charles Baxter*

We are on the shadow side of a house, at twilight, in Wendell Minor's cover for my book of short stories, *A Relative Stranger.* The setting sun—I'm certain it's twilight and not sunrise—can almost be glimpsed through two downstairs windows. The light from an upstairs window and the light from the evening star provide something of a call-and-answer in the upper third of the picture. It's an unforgettable image of beauty and solitude of a particularly midwestern variety: there's a fire in the fireplace— you can see smoke rising almost invisibly from the chimney— and someone is upstairs, but no one is about to arrive, and probably no one is about to leave.

Why this sense of no one coming or going? It takes a moment of careful inspection before the observer notices that this house has no driveway and no sidewalk; its front and back steps lead down directly into overgrown grass, speckled green in the foreground, bright gold in the back. The image has a touch of surrealist loneliness, but also, I think, of strength—of someone who is out in the middle of nowhere and who likes it there and plans to stay.

Several friends from the Midwest have said that they know where this house is—they've seen it (in Iowa, or Michigan, or Minnesota; it's always in a different state). They know the house, and, more importantly, they know the feeling. It's a feeling I was attempting to capture in my stories that Wendell Minor captured perfectly in the art for the cover. It's that stubborn joyful loneliness we discover in Wendell's picture, seemingly a contradiction—how can anyone be joyfully lonely?—but which is, in fact, the source and being of so many lives out here.

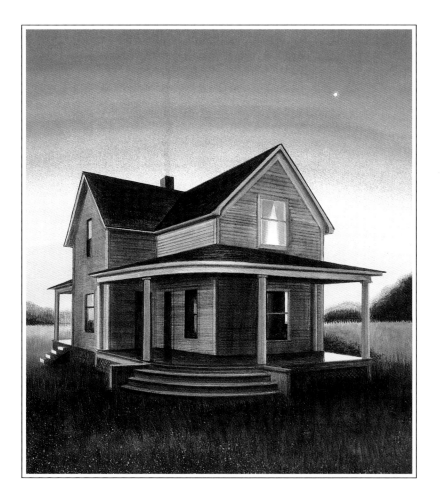

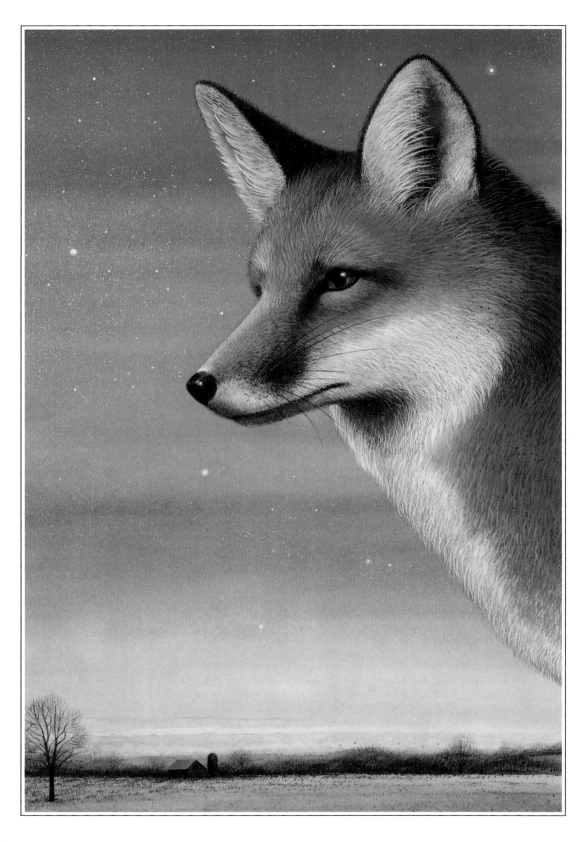

When I wrote the text for *Red Fox Running,* I had a vision of the cold, sweeping emptiness of snow country. The first four lines came almost instantly:

> *Red Fox running*
> *Running through the snow.*
> *White sky above*
> *And white earth below.*

Wendell's cover art captured that vision exactly as I had imagined it: the flat colors of earth and sky, the red streak that was our running fox. Seeing the first picture the way you imagined it doesn't always happen, and it is such a joy when it does.

The double-page spreads without words that come later show the quiet solitude of this world, where the fox moves on swift and silent feet. On pages where there is text, he still runs—ghost-like, invisible in his own natural habitat. To me, Wendell sees beyond the words and paints the mood.

As artist and writer, Wendell Minor and I have not met in person. But we meet on the pages. And there is unity.

THE GROTESQUE *by Patrick McGrath*

Of the several covers that Wendell Minor has designed for my books, my particular favorite is the work he did for *The Grotesque.* This is a book about uncertainty, about dark secrets and furtive nocturnal events, about a very English repression of sexuality and violence. A figure whose back is to the viewer, out on a marsh, in the rain, watching a flock of blackbirds: this is an image that not only illustrates a pivotal moment in the plot, but also catches the themes of obscurity, obliqueness, and mystery that dominate the novel. A watercolor wash is most apt for this damp story, and a blood-red that shades into greens, browns, grays, and blacks is precisely the right color scheme for a plot that revolves around a nasty eruption of murder most foul in the raw, autumnal English countryside. I still feel that no image could so effectively have evoked the spirit and setting of *The Grotesque* as this eerie picture of a strange, bulky figure out on a marsh at dusk.

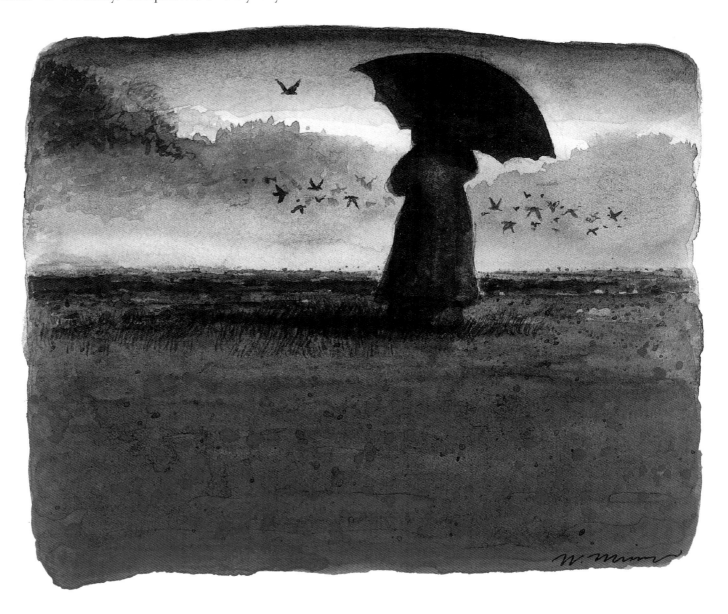

HEADHUNTER *by Timothy Findley*

Headhunter is a modern horror story, based very loosely on Joseph Conrad's *Heart of Darkness.* Consequently, one of the leading characters is Kurtz—the man portrayed in Wendell Minor's painting. My version of Kurtz has him as the head of a psychiatric research institute. His "river" is the human spirit, rising out of darkness and flowing through light. Kurtz, however, is not the least bit interested in light—he is mesmerized by darkness and what can be done in there with human ambition.

The setting is a high-powered, twentieth-century North American city—namely, Toronto—where a plague is raging in the streets. This plague has been caused by the fumbling of government-sponsored experiments from which a deadly virus has escaped. In order to mask this error, the government has claimed the disease is spread by lice-infested starlings. A public campaign has been started to eradicate the birds—and the sky above the city is filled with deadly yellow gases.

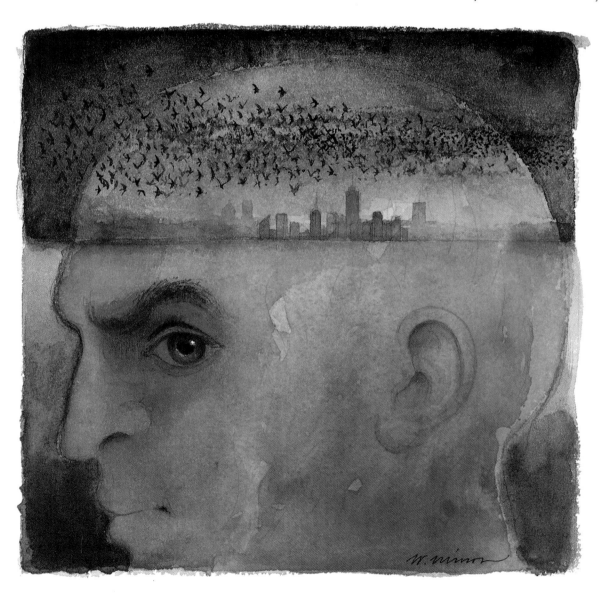

Out of these circumstances—and given the horrific influence of Kurtz—Wendell Minor has created a cover that perfectly sets the scene for the story that will unfold behind it. When I first saw the painting, I was "blown away," as they say. Minor had stepped inside my mind and come back out with the novel itself and all its complexities encapsulated in a single image: Kurtz and his madness, brooding over the death of everything green—the yellowing sky traversed by waves of doomed birds—the city seemingly about to drown in the fires of Kurtz's burning ambition.

I cannot describe how thrilling it was to receive this interpretation of what was in my mind. Wendell Minor is major, in my books, and I'm proud that he was asked to interpret *Headhunter.* Proud—and grateful.

THE BEET QUEEN *by Louise Erdrich*

I still long to repeat the kind of serendipitous experience that occurred when Wendell Minor agreed to do the book jacket for *The Beet Queen*. We all knew what we wanted, and it came out perfectly. Mr. Minor made Dot sturdy and her dress plantlike, so that she seems to grow from the very field, a tougher and more vigorous shoot than any pictured! His space, airplane, grain elevators, and thunderstorm precisely captured the combination of mood—plain longing, humor, and desire to escape and yet be home—that serves as ground for *The Beet Queen*'s characters. I have a framed copy of this cover hanging in our hallway, and we look at it all of the time. It is always fresh, there is always a *there* there, and looking at it, I always both miss and feel at home.

It is astonishing that there have not been many more studies or collections of book covers. In the past fifty years, the jacket round the book has become a work of art—and to collectors, literally the most desirable thing about a book; a first edition without its jacket becoming practically valueless in their eyes. This makes sense to collectors—the book to them is an object. To the buyer of a new book that is to be *read*, the jacket is rather more problematical. A different sort of choice prevails.

There was a fashion in the fifties to try and pass off classics as hot stuff: *Crime and Punishment* with a lime-faced sub–Anthony Perkins madman on the cover, *Moll Flanders* with a Ruth Roman-esque starlet straining out of a vaguely eighteenth-century bodice. I don't know if this sold any more copies, but it must certainly have led to great disappointment, and readers who already had an inkling as to what was in the books would not have been seen dead reading these editions in public. The genius of the recently reissued Everyman Classics has been to clothe them in a chaste, strictly typographic style that is emotionally neutral, uniform, and above all, cool. And it has always been the case with modern authors that the more well known they are, the simpler and less pictorial their cover may be—with their name, of course, the largest component.

It is with the unknowns and the obscure that the publishers must make the greatest effort; in targeting a book most nearly to its most likely reader, text becomes more important than author or critical provenance. With something like my own first novel, *The Good Republic,* the intention has to be to give as intriguing and accurate an idea of the book's contents as possible.

And Wendell Minor's cover does *intrigue.* It uses elements that I tried to convey strongly in the book: the Baltic coastline

and islands where the story takes place, the sense of the past in the shape of the swastika painted in blood on the cliff, the cold gray sea below, and my protagonist, standing alone on the edge of the cliff, casting a long shadow backward, as if he is dragging a dreadful past behind him, or that past is now reaching an accusing finger toward him. . . .

QUANAH PARKER *by Len Hilts*

One of the high (or low) points for an author in the preparation of a book is the first look at the proposed jacket. I remember slitting open the big envelope containing the design for *Quanah Parker* with a strong feeling of trepidation. All too often, books about Native Americans—especially books for younger readers—have been illustrated and jacketed with art that is a cartoony representation of the old American myths about savage Indians (the bad guys) and the blue-coated cavalry (the good guys). When you looked at them, you could hear the cavalry trumpets sounding "Charge!" and you knew the good guys would snatch victory from the bad guys at the last moment.

These stories were the modern morality plays we fed our children for perhaps a hundred years following 1875. Most of us educated in that century truly believed what we had been taught: The only good Indian was a dead one.

However, when I did the intense research needed to write the life of Quanah Parker, I discovered something I had never seen before: the viewpoint of the Indian. I found myself wondering what I would do if strangers drove up to my house, took over my land, and told me at gunpoint to go somewhere else—perhaps to a piece of ground hundreds of miles away that had been "reserved" for me.

In that frame of mind, I wrote the book. It was, I believed, a serious look at the situation in the West, circa 1860–75, told from the viewpoint of a Comanche chief. I didn't see these people as murdering marauders who savagely killed innocent ranchers. Instead, I saw them as proud people defending a land that had been theirs long before the white man knew it existed.

Little wonder, then, that I pulled the design from the envelope with trepidation. If I had succeeded in communicating my feelings, then the artist's work should reflect the fact. If I had failed, then God knows what I would see. In a way, the jacket design was the book's first review.

Now I saw the painting for the first time and, as the old cliché says, a wave of relief washed over me. I found myself looking at a beautiful, dignified, serious painting of Comanche country and the life in it. Wendell Minor had caught the spirit of the book and of the American Indian. The title was superimposed on the painting in a way that made the jacket say everything I had hoped to say in the book.

The wave of relief quickly turned to open admiration. I spent the next hour just looking at the design as one looks at a fine painting in an art museum. Just looking, soaking it up, feeling it. Minor's painting had made my day. In fact, it made my year.

The editors at Houghton Mifflin assured me that I would like the jacket. One of the best in the business was doing a painting, they told me, a fellow named Wendell Minor. They said he had a gift for getting to the meaning of a writer's work and then translating it to canvas. They did not call him an illustrator. He was an artist, and when they used the word they said it with reverence, as though it should be italicized for emphasis: *artist.* I was impressed by their enthusiasm. They promised to send a copy of the jacket as soon as they had one. They wanted my reaction.

A few weeks later the copy arrived. My wife was with me when I pulled it out of the envelope. We studied it in silence.

"I love it," she said after a moment. "What do you think?"

"He put grass in the front yard," I answered

My wife was astonished at such an absurd comment. She said, "What?"

"Southern farms didn't have grass in the front yards," I insisted. "The yards were dirt, or hard clay. We had to sweep them with brush brooms. I remember Mama making us—"

"I've heard the story," she said, taking the copy from me. "Too many times," she added. She stared curiously at the boy in Wendell Minor's painting. He was standing in front of a house, looking through a window at a bare electric light bulb that glowed in the dullness of a room. "Do you see what I see?" she asked.

"What are you talking about?" I said.

"The boy," she replied. "He looks like you did at that age. Exactly like you."

And he did.

I had had a checkerboard-patterned shirt like the boy was wearing. And jeans that fit on my hips in the same manner. The way the boy was standing was the way I had stood, one hand shoved into one back pocket, the thumb of the other hand hooked into the other back pocket.

My hair once had a reddish tint. I combed it to the right, as Wendell Minor's boy combed his hair. The crown was in the same place.

The boy's ears were my ears.

I had a feeling that if I could have tapped the boy on the shoulder, making him turn around in Wendell Minor's grass yard, I would have looked into a face of freckles and dimples.

"How did he do that?" my wife said in awe. "Did you send him any pictures, or anything?"

"Nothing," I told her.

"Well, he must have known something, or he did a great job of guessing," she said.

After the book was released, I would hear the same from siblings and from friends who had known me since childhood.

They asked the same question my wife had asked: "How?"

I don't have an answer, but I have a thought about it: the editors of Houghton Mifflin were right. Wendell Minor did more than sketch out a quick-impression idea and apply some snappy book-design color to catch the eye of browsers. He took the words of the book and he painted them. I believe he cared for the words or he would never have been able to put me there.

The original painting now hangs in my home, a surprise birthday gift from my wife a few years ago. It is my most prized possession, and not only because it was on the jacket of my first novel; it is my most prized possession because it is the work of an *artist.*

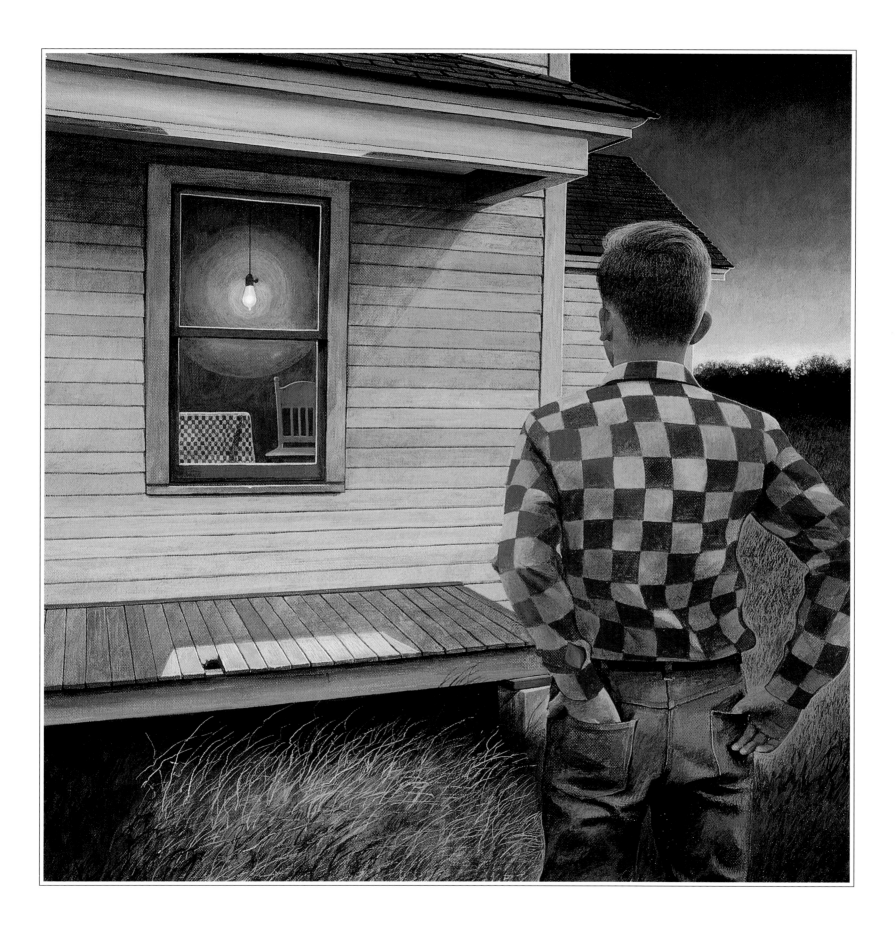

ARANSAS *by Stephen Harrigan*

Aransas was my first novel. It took me a year and a half to write, not counting the year or so of brooding that preceded the actual composition. I wrote it, if I recall, using an endless succession of roller-ball pens, filling up a half-dozen stiff-backed composition books whose covers announced the novel's title in Dymo label tape. Except for that one little flourish, the writing of the book was something of a secret act. Every day, I would guardedly fill up those notebook pages with my cryptic penmanship, striking out sentences and paragraphs and even whole chapters, telling a story to myself with agonizing slowness and indirection.

Wendell Minor's lovely cover painting was the first real evidence I had that the novel existed outside the hothouse of my own imagination. The illustration somehow validated the world I had so haphazardly created. I remember how surprised and pleased I was that the artist had gotten it right. There in the distance were my two main characters, piloting a boat exactly like the one I had imagined for them. There was a trio of dolphins leaping out of the water, their skin nearly the same shade of gray as the leaden sky. The deep water in the center of the picture was an opaque blue, shading to brown at the foreground mud-flats, and I liked this best of all. The painting's colors were subdued, like the colors in the book.

One of my prime objectives in writing this novel had been to get the mood of the Texas Gulf Coast right and to have that mood somehow ordain the action. I had wanted the story I told to rise up out of the humid air, the murky water, the somber land-and-seascape of tidal flats and spoil islands and littered shorelines. That Wendell Minor rendered all of this so exactly still seems like a miracle to me. I was lucky to have, my first time out, an artist who not only read my book, but read my mind.

126

THE JONAH MAN *by Henry Carlisle*

The text lies in wait between its covers, breathing glue and apprehension. Who will read it? How will the world discover the sinuous embrace of its story? How will it stand out amidst the silver- and gold-embossed candy-box packages proclaiming their publishers' tawdry greed?

If only there could be made a picture married with lettering that would in an instant project the text's uniqueness into the reader's consciousness so that, though dwarfed by the forklifted towers of its rivals, it would be truly and fairly known.

And so did it happen with Wendell Minor's beautiful jacket for *The Jonah Man*.

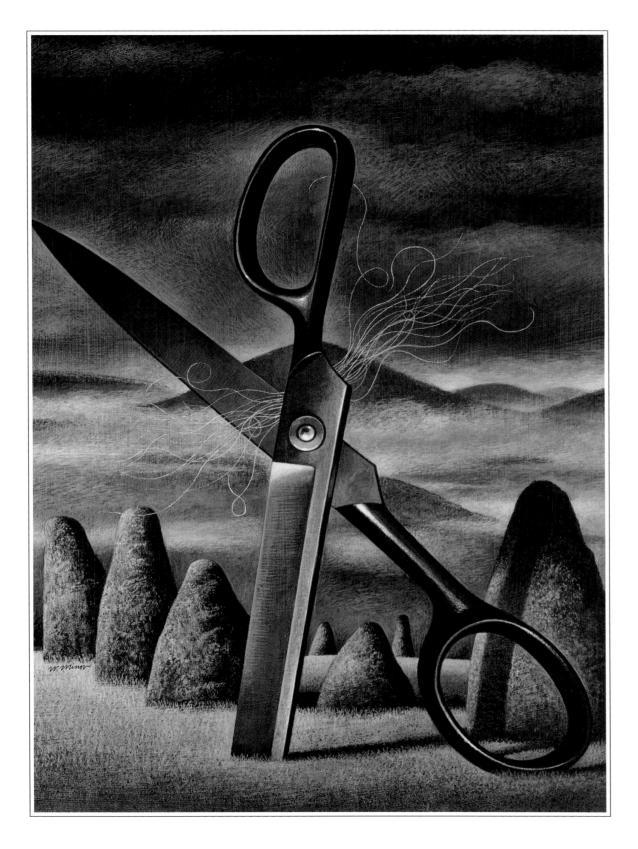

THE LAST CONVERTIBLE *by Anton Myrer*

In the demanding world of cover art, limitations of imagination and budget, as well as inevitable conflicts between author and publisher, must be swiftly resolved. There Wendell Minor is a master. No one else has created so many fresh and beautiful designs for the market while maintaining his own integrity as a painter. Elegance of line, a wonderful sense of color, and remarkably evocative brushwork distinguish his style. His jackets have helped writers reach an audience they might otherwise have lost, for he sees each book individually and gives it a dimension of his own.

I remember so well Wendell's cover for *The Last Convertible.*

His first rough was his usual fine drawing—a Packard car against sharply etched black lines of classical university gates. It was a good design, but Wendell was not satisfied. He threw out that sketch and began again, producing the memorable cover for *The Last Convertible,* capturing at once those young golden days with the softness of his particular brush. And he stamped it as always with the indelible touch: a small red kite floating high in the distance, carrying with it the memory of a period and evoking the mood of a novel. I've always felt that jacket helped the book's success in the stores. In pursuing his own vision with brilliance, Wendell Minor is unique in his field.

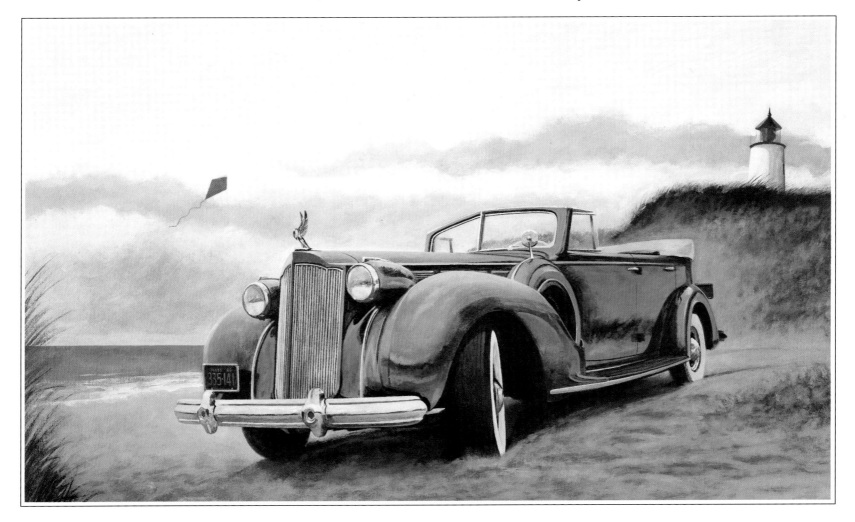

BABY *by Patricia MacLachlan*

I have always been jealous of artists who have space and color, form and design, while as a writer, I only have twenty-six little letters of the alphabet. In my head I have space and color, form and design, of course, that help me to know the character who tells my story, that show me the landscape that grounds me. But as one little boy once asked me, "Why is it always better in my head than on paper?" I am compelled to make the confession that words are limiting. This is so, I told the boy, because the art is internal and often cannot be translated into words.

Baby was written, like all of my books (another confession), out of a personal connection. When our children were grown, leaving for college or careers, the house was suddenly empty of young energy. I remembered suggesting to my husband that we get a monkey, an idea that he fully understood but found appalling after years of parenting. It is clear that what I really wanted more than anything was to have a baby left at my door. The book *Baby* is my literary wish fulfillment.

My great joy is that Wendell Minor's art matches my inner vision. There is a serenity about the baby, Sophie, that assures us that she will be loved for the short time she is there and for all the time after she leaves. She looks out to the place where she was born and where she will return. We do not see her face. This makes her all babies: your baby, your grandchild, your sister, your niece. Best of all, it makes her the baby, at long last, that has been left at my door.

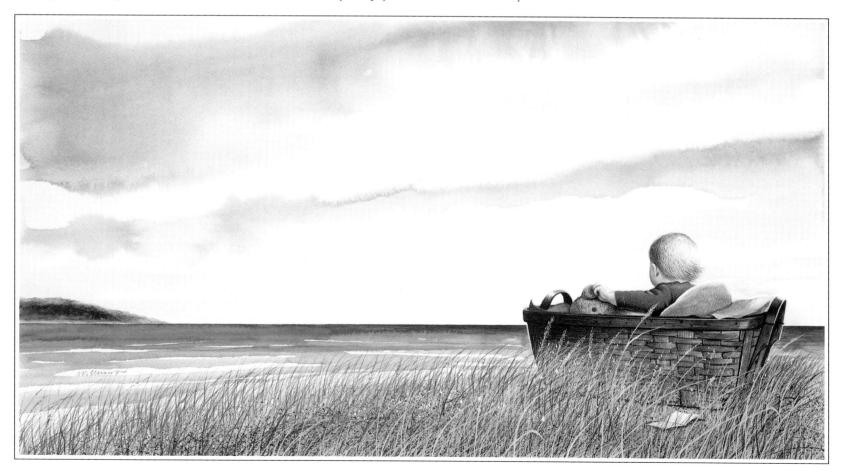

133

A dream: The Lone Ranger and Tonto were fistfighting in heaven. The loser had to go to hell. I was rooting for Tonto, of course, but woke up before the fight was over. I love my dreams. The entire history of Indian-white relationships might be contained in that one dream, although I'm not the only Indian who has ever dreamed it. If I close my eyes now, I can hear all of us Indians rooting for Tonto.

The dream became a story that did not work. The story was satire. I wanted more. I wrote a different story that had nothing to do with the Lone Ranger and Tonto. It was a love story about an Indian man and a white woman. It was a story about the love lost between them. It had everything to do with the Lone Ranger and Tonto. I called my new story *The Lone Ranger and Tonto Fistfight in Heaven.* Soon, I had written a whole book of short stories and decided to give it the same title.

It's a strong image. I can see the Lone Ranger and Tonto fistfighting in heaven. Everybody (my agent, editor, mother, and father) had the same general idea for the book cover. The Lone Ranger and Tonto would be trading blows in the sky above the reservation. Wendell Minor was chosen as the cover artist and he produced a sketch that was exactly what I had dreamed, except for a few minor details. I had dreamed that Tonto was punching the crap out of the Lone Ranger, but Wendell's sketch showed just the opposite, the way it's "supposed" to be, with the Lone Ranger as hero and Tonto as nothing but the sidekick. However, I didn't actually notice that the Lone Ranger was punching Tonto until it was almost too late to change the cover art. At first, I decided it was the result of Indian-white cultural differences, but I think it probably had more to do with the cultural expectations that Wendell and I shared, rather than with our differences. We all grew up with the Lone Ranger and Tonto.

Wendell changed the cover by switching heads. Tonto's head is now on the Lone Ranger's body, and vice versa. A beautiful and hidden metaphor. I loved the cover, although I would have liked to add an Indian grandmother smiling.

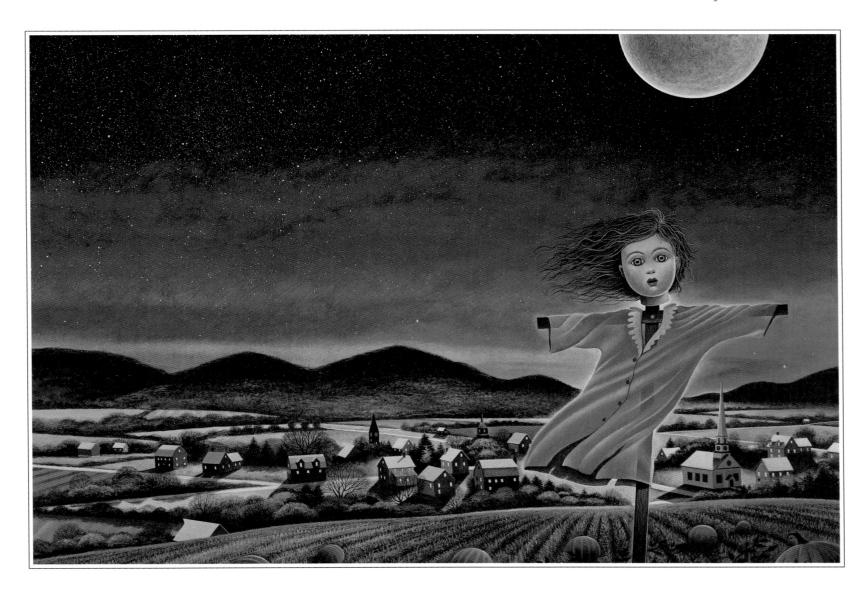

Think of some ideal text beyond the reach of authority, and beyond the grasp of anyone at any time, so that all those who work toward its symbolic manifestation in the physical book can be seen as collaborators. In this sense, a book's dust jacket reveals things about the text that the author could not have previously understood. I speak of some mystical, theoretical text that is at once both source and eventuation of all its expressions

This is not meant to disenfranchise the author. Quite the contrary, I rejoice in authorial authority. And yet, like the dust jacket artist, though less obviously, much of my own inspiration as an author turns out to be derivative insofar as I utilize old themes and work within the given networks and strictures of language and genre, and silently collaborate with countless others who have gone before. *Ex nihilo nihil fit.*

For example, part of the inspiration for my novel *Sassafras* was the story of Antigone, and how the burial rites she died for were in their intensity and devotion very much like those typical of Plains Indians, though reversed in detail, since they traditionally buried their dead in scaffolding *above* the ground, rather than interring them.

Then, after I had written my novel, Wendell Minor came along and found new meanings in the ghostly irreality of my story—which, like all novels, is an intersection of various hypothetical human destinies. His dust jacket impressed me wonderfully when I first gazed upon it, even though I found it bothered by small historical errors. And yet, these details are finally irrelevant, for the image that Minor presents is splendidly vivid, utilizing my narrative material in his own personally creative act—much as I used old themes and ideas to create the prototype and inspiration. All artists, even though we labor in "silence, exile, and cunning," belong, finally, to secret and silent devolutions of collaborators, uniquely expanding and enriching the tradition, even as we help perpetuate it.

So Minor's art is uninhibited by literal restrictions and true

in ways beyond a minimal historical precision. Though mistaken in details, it is colorful, solid, and "posed" in a manner felicitously suited to the time. Thaddeus Burke, the book's narrator, would have liked it, for it is his own happy fizz and breezy spirit that the novel celebrates, as its title proclaims. So what could be more appropriate than that the picture on the dust jacket should itself be endowed with its, and its creator's, own version of sassafras?

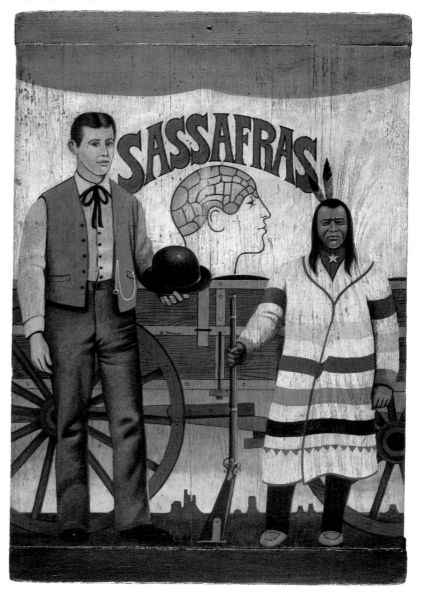

REINDEER MOON *by Elizabeth Marshall Thomas*

September 9, 1993

Dear Mr. Minor:

Discussing a book cover is a formidable task, at least for me. I could look at a painting and write about it, letting the visual images it stirs in me tell me what to say. Yet the cover of a book, especially if, like yours, it is excellent and successful, is the process in reverse.

Therefore, I believe that much of the success of Reindeer Moon *can be*

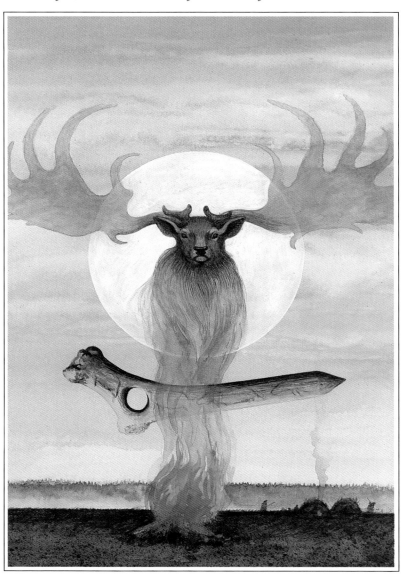

attributed to your cover—evening, a vast, featureless steppe in which human beings seem almost insignificant, a full, pale moon; and the image of an Irish Elk, at once spooky and majestic, rising in the smoke. Yes. This is exactly what the book is about. But best of all, you included a special mystery in the form of the engraved bone object, a rather common item that occurs throughout Paleolithic sites, but to which no function can be attributed, or not with our present state of knowledge. What was it for? The old people knew. We don't.

When I saw your drawing, I thought, "Ah! He's read this book!" And on a very personal note, when I realized you had included the mysterious bone thing, I wondered if it was a commentary on my style, since I had hoped to create a sense of mystery out of hard, pragmatic bits and pieces of reality.

Yours truly,

Elizabeth Marshall Thomas

The cover of a book is an invitation into that book. It catches the eye, intrigues the imagination, hints at the contents, and makes the potential reader want to know what is inside. A book is an unfolding story. The cover is, in essence, the first line of that story.

Wendell Minor has always created magnificent cover art for my books. From the very first one, *Where Are the Children?*, he captured the mood I wanted to convey. That lonely house, the hint of foreboding, the sense of a bleak, cold day, the child's red mitten on the lawn . . . all of the elements appearing in that painting embodied the essence of the events that would take place within the pages.

I have been equally delighted with the other covers Wendell has created for my work. They include *A Cry in the Night, Still-Watch, The Anastasia Syndrome and Other Stories,* and *All Around the Town.*

When *Where Are the Children?* was published, a friend told me that the really chic thing to do was to see if the artist was willing to sell the original painting. When I contacted Wendell, he said he would sell it, but with the proviso that he could borrow it occasionally for exhibitions. He said, "There'll be a plaque under it that says, 'From the collection of Mary Higgins Clark.'"

I offered one correction. "Take out the 'From.' This *is* the collection of Mary Higgins Clark."

Since that time, I have happily acquired other Wendell Minor paintings. It is a joy to have them.

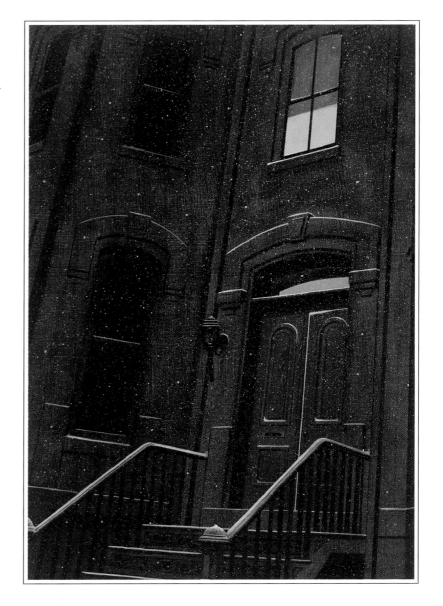

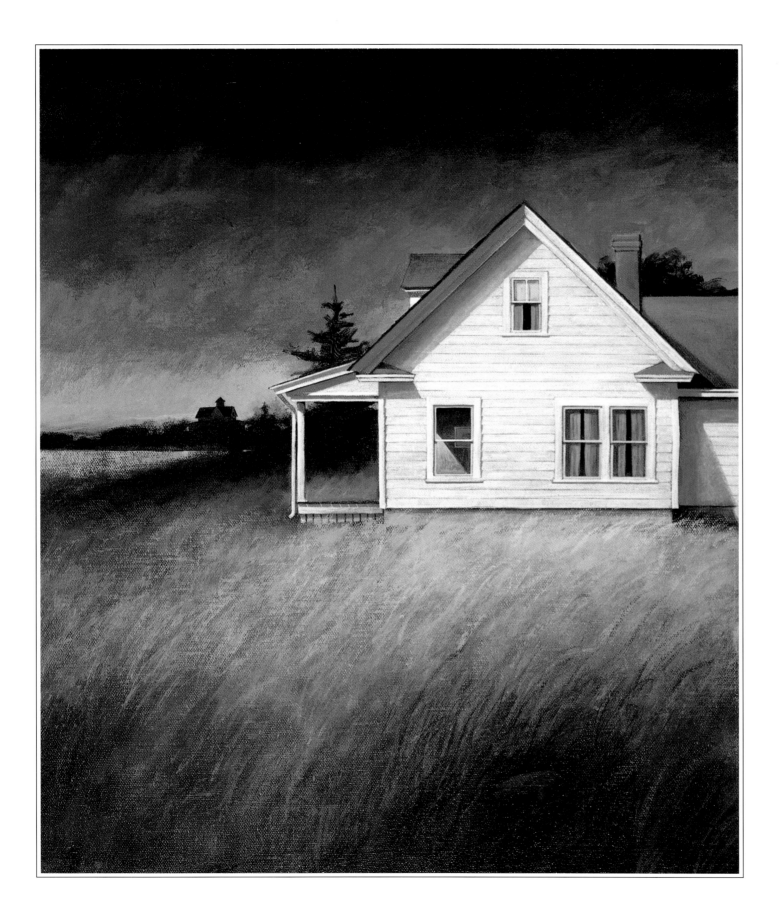

139

THESE LATTER DAYS *by Laura Kalpakian*

These Latter Days is a landscape novel. It is a tale of the American West. Two people ride a train eastward over the California mountains in the beginning, and at the end, a single character rides a train eastward out of Idaho. In his reading of the novel, Wendell Minor correctly assessed its central struggle and rendered it in colors: the female figure foregrounded (severe expression, severely clad, hand defiantly on hip) is dwarfed, diminished by the landscape, but significantly, she does not stand in its shadow. Neither does she stand in the shadow of the church, denominationally neutral, but its splintery inflexibility suggested by the very clapboards.

These Latter Days is indeed the story of such a woman and such a landscape. The hills, rocks, the foregrounded plain here have colors native to the West (and let it be said, not to the East), colors with a vein of metal, traces of unsoftened mineral, the browns and greens and blues not at all tender, the whole at once shadowless and, by implication, harsh. The field is not a riot of colorful wildflowers, but those bleached and sturdy, scraggly western wildflowers that challenge your power to see them at all. These are evoked with pointillistic perfection: the artist suggests color, the eye concocts meaning. You can see the wind. You can all but feel it.

The writing of a book is a solitary undertaking and the writer is probably a solitary sort of creature. But the creation of a book is a collective effort with the artist (probably an equally solitary sort of creature) who is called into service. Artist and author are thus thrown into a sort of dance, a strange tango, the publisher urging them onto the dance floor, arms out, eyes straight ahead, to perform steps that will complement and enhance one another. It doesn't always work. But when it does—and it does in *These Latter Days*—these two solitary creatures, the artist and the author, unite to elicit the participation of a third solitary creature, the reader.

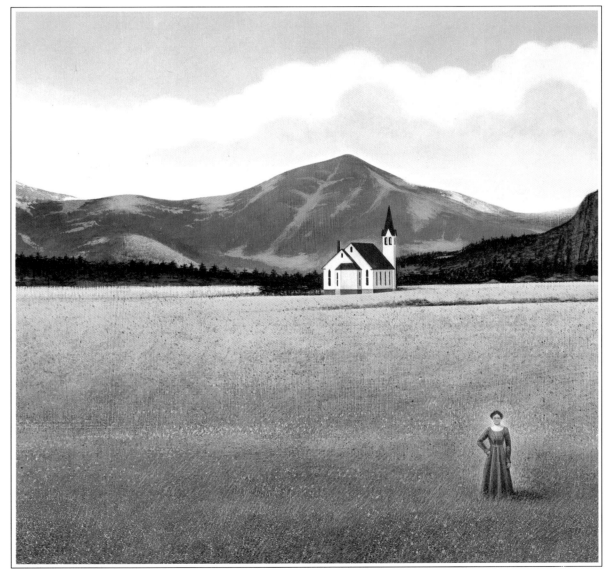

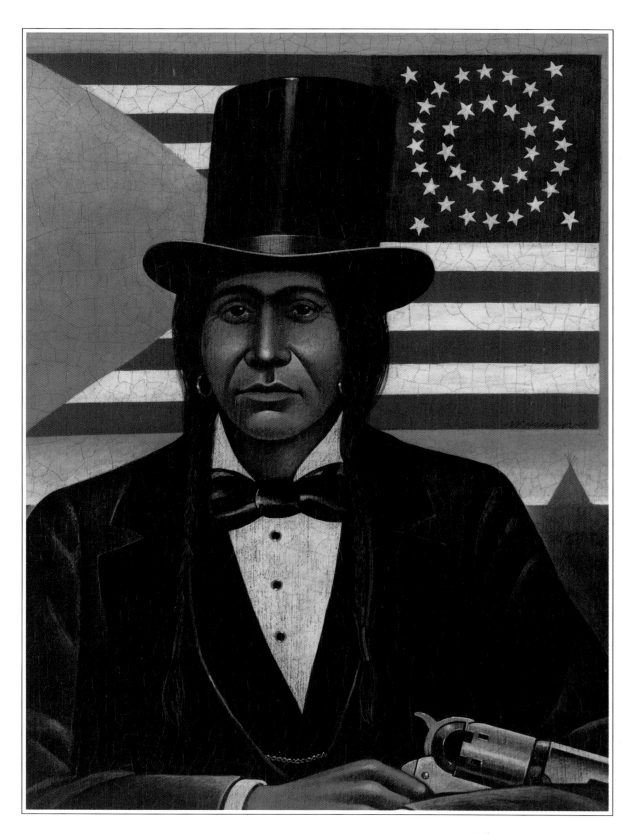

Somebody a long time ago, probably an old Greek or anyway an old college professor, said, "You can't judge a book by its cover." Okay. Sure. The cover art is one image, no matter how complex, and the text inside is about four hundred pages.

BUT. This isn't to say that the art on a book's front is supposed to do violence to sum and substance of what's inside. Which is often the case.

That's what I like and admire about Wendell Minor. On first glance at his cover art, you know he's read the book and understands what you're trying to say, and in a capsule tries to say the same thing with his painting. And almost always succeeds.

In my personal library, I have discarded many, many, many dust covers because the art does not come from the same world as the story inside. But listen, I've never, never, never discarded one of Wendell Minor's covers.

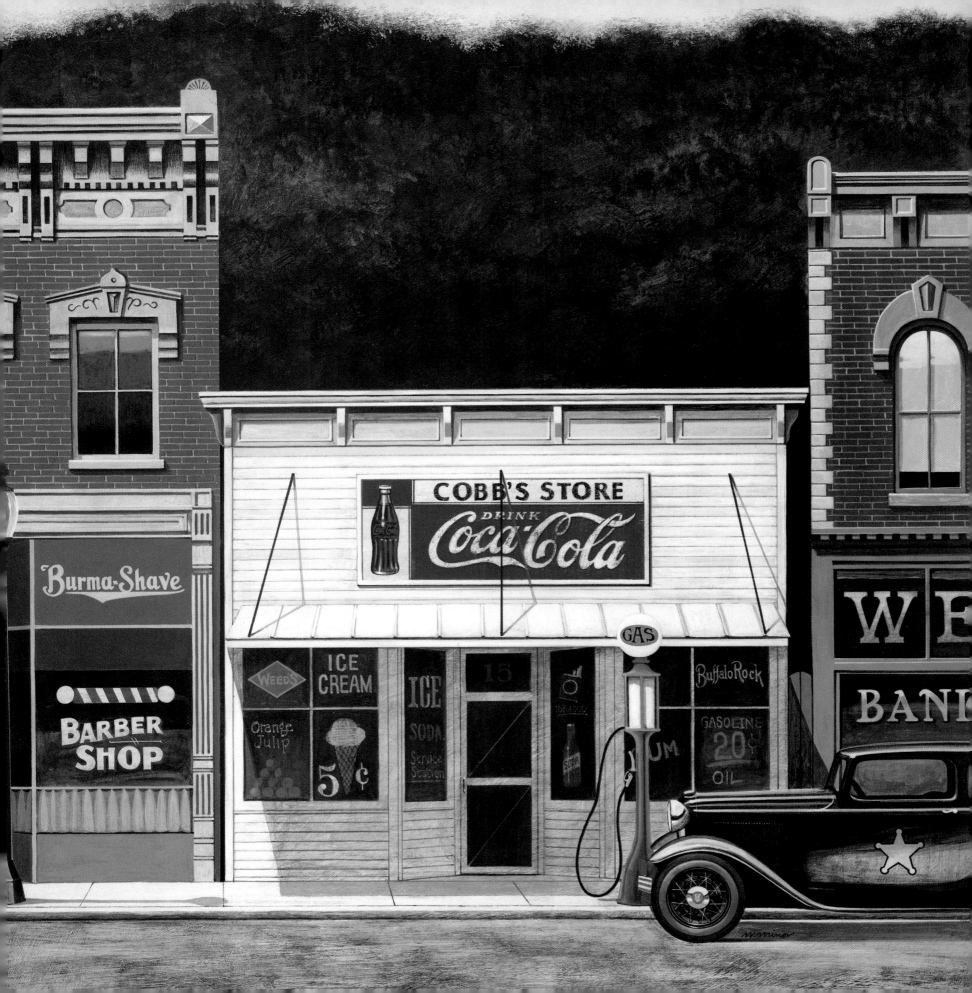

ACKNOWLEDGMENTS

THE REALIZATION of any book starts with an idea and someone who believes in that idea. I want to express my sincere gratitude to David McCullough for giving me the idea to do *Wendell Minor: Art for the Written Word*, and my deep appreciation to Rubin Pfeffer, President of the Trade Division of Harcourt Brace & Company, for his belief in this project and for making it, indeed, a reality.

A book is also more than the sum of its parts. And so, too, are the individuals who work behind the scenes to make it happen. Without my wife Florence's dedication and hard work, this book would still be just an idea. She diligently organized and coordinated all the elements to achieve perfect cohesion.

Vaughn Andrews deserves great credit for the book's design. I felt that I was much too close to the subject to be truly objective in undertaking such a task. Thanks, Vaughn, for a beautiful package.

A special note of thanks to Ruth Greenstein for her expertise, understanding, and patience during the editing process.

To the best production team in publishing, Warren Waller-stein and David Hough, I owe my gratitude for their pursuit of excellence.

I am very honored that so many authors and others were willing to take the time to contribute commentary about the cover images included in this volume. Their contributions add a dimension to the book that reinforces the connective tissue between words and art.

Thanks to Paul Bacon and Frank Metz for their insights and historical perspectives on book cover art and design in America in recent times.

To all my collectors who generously lent the originals of the cover art or arranged for transparencies to be made, I thank you.

There are so many publishers, art directors, editors, and authors with whom I have worked over the past twenty-five years that it would be impossible to name them all. Nevertheless, that in no way diminishes my heartfelt appreciation for their belief in my work. I sincerely thank each and every one of them.

And finally, a special thanks to my mother, Marjorie Minor, for fostering the talent of a fledgling artist.

ILLUSTRATED INDEX

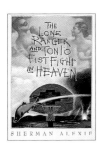
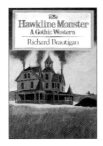
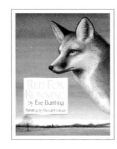

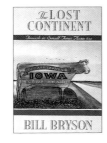
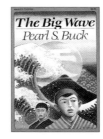

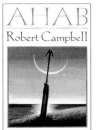

p. ii Campbell, Robert
Ahab
Leviathan Press, 1989
Watercolor on cold press board
9″h x 8″w
Toni Mendel, A.D.
Awards: Desi Award, *Graphic Design:
USA*, 1990; Society of Illustrators 32nd
Annual National Exhibition, 1990
Collection of Toni Mendel

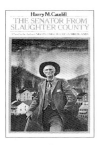

p. 37 Caudill, Harry M.
The Senator from Slaughter County
Little, Brown and Company, 1973
Gouache on wood
12″h x 8 3/4″w
Char Lappan, A.D.
Collection of the artist

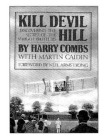

p. 100 Combs, Harry
*Kill Devil Hill: Discovering the Secret of the
Wright Brothers*
Houghton Mifflin Company, 1979
Acrylic on masonite panel
18 1/2″h x 16 1/2″w
Louise Noble, A.D.
United States Air Force art collection

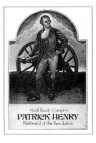

p. 40 Campion, Nardi Reeder
Patrick Henry: Firebrand of the Revolution
Little, Brown and Company, 1976
Acrylic on wood
14 1/2″h x 11 1/2″w
Char Lappan, A.D.
Awards: The Bicentennial in Print,
The Art Directors Club of
Washington, D.C., 1976
Collection of the artist

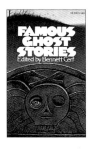

p. 41 Cerf, Bennett, editor
Famous Ghost Stories
Vintage Books, 1974
Acrylic on masonite panel
19 1/2″h x 12″w
Judy Loeser, A.D.
Featured in *Print*, 1975
Collection of the artist

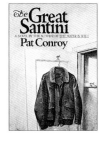

p. 71 Conroy, Pat
The Great Santini
Houghton Mifflin Company, 1976
Acrylic on canvas
17″h x 12″w
Louise Noble, A.D.
Collection of Pat Conroy

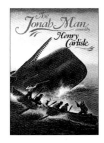

p. 128 Carlisle, Henry
The Jonah Man
Alfred A. Knopf, Inc., 1984
Acrylic on wood panel
14″h x 20″w
Sara Eisenman, A.D.
Awards: Desi Award, *Graphic Design:
USA*, 1985; Society of Illustrators 27th
Annual National Exhibition, 1985
Collection of the Society of Illustrators
Museum of American Illustration

p. 48 Chadwick, Janet
*How to Live on Almost Nothing and Have Plenty:
A Practical Introduction to Small-Scale Sufficient
Country Living*
Alfred A. Knopf, Inc., 1979
Acrylic on wood 14 1/2″h x 24 1/4″w
Lidia Ferrara, A.D.
Awards: Desi Award, *Graphics: USA &
Graphics: NY*, 1980; *Graphis* Annual 1980
Collection of the artist

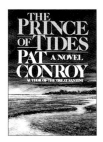

p. 72 Conroy, Pat
The Prince of Tides
Houghton Mifflin Company, 1986
Watercolor on cold press board
9 3/4″h x 15 1/4″w
Louise Noble, A.D.
Collection of Pat Conroy

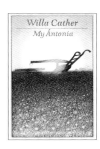

p. 92 Cather, Willa
My Ántonia
Houghton Mifflin Company, 1987
Acrylic on masonite panel
11 1/4″h x 7 1/2″w
Louise Noble, A.D.
Collection of the artist

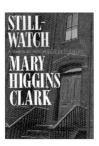

p. 138 Clark, Mary Higgins
StillWatch
Simon & Schuster, Inc., 1984
Acrylic on masonite panel
13 1/2″h x 8 1/2″w
Frank Metz, A.D.
Collection of Mary Higgins Clark

p. 36 Dary, David A.
The Buffalo Book: The Saga of an American Symbol
Avon Books, 1976
Acrylic on masonite panel
21 1/2″h x 12 1/2″w
Barbara Bertolli, A.D.
Featured in *Contemporary Western Artists*, 1980
Collection of the artist

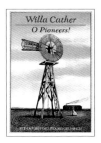

p. 93 Cather, Willa
O Pioneers!
Houghton Mifflin Company, 1987
Acrylic on masonite panel
11 1/4″h x 7 1/2″w
Louise Noble, A.D.
Featured in *Idea*, 1993
Collection of David and Rosalee
McCullough

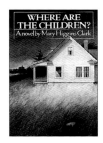

p. 139 Clark, Mary Higgins
Where Are the Children?
Simon & Schuster, Inc., 1974
Acrylic on canvas
18″h x 12″w
Frank Metz, A.D.
Collection of Mary Higgins Clark

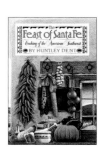

pp. 29 and 76 Dent, Huntley
*The Feast of Santa Fe:
Cooking of the American Southwest*
Simon & Schuster, Inc., 1985
Acrylic on masonite panel
13 1/2″h x 20 1/2″w
Frank Metz, A.D.
Collection of the artist

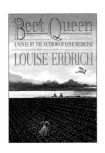

p. 118 Erdrich, Louise
The Beet Queen
Henry Holt and Company, 1986
Acrylic on masonite panel
13″h x 19 1/2″w
Bob Reed, A.D.
Collection of Dale and Nancy Wickum

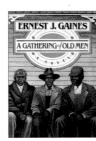

p. 108 Gaines, Ernest J.
A Gathering of Old Men
Alfred A. Knopf, Inc., 1983
Acrylic on wood panel
12 3/4″h x 18 1/4″w
Lidia Ferrara/Sara Eisenman, A.D.s
Awards: Society of Illustrators 26th
Annual National Exhibition, 1984;
Desi Award, *Graphic Design: USA*, 1984;
Featured in *Idea*, 1993
Collection of the artist

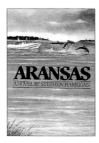

p. 126 Harrigan, Stephen
Aransas
Alfred A. Knopf, Inc., 1980
Acrylic on canvas
14 1/4″h x 20″w
Lidia Ferrara, A.D.
Collection of the artist

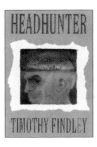

p. 117 Findley, Timothy
Headhunter
Harper Collins Publishers Ltd.,
Toronto, 1993
Watercolor on cold press paper
6″h x 6″w
Neil Erickson, A.D.
Awards: *Art Direction*
Creativity 93
Collection of Timothy Findley and
William Whitehead

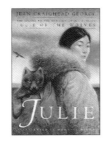

p. 130 George, Jean Craighead
Julie
HarperCollins Publishers, 1994
Acrylic on masonite panel
14″h x 11″w
Al Cetta, A.D.
Awards: *Art Direction* Creativity 94
Collection of the artist

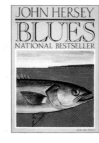

p. 90 Hersey, John
Blues
Alfred A. Knopf, Inc., 1987
Watercolor on cold press board
6 1/2″h x 14″w
Sara Eisenman, A.D.
Awards: *Print* Regional Design Annual,
1987; AIGA Exhibition, 1987
Collection of the artist

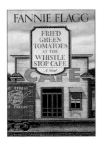

p. 31 Flagg, Fannie
Fried Green Tomatoes at the Whistle Stop Cafe
Random House, 1987
Acrylic on masonite panel
14″h x 9 1/2″w
Bob Aulicino, A.D.
Collection of the artist

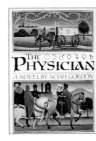

p. 27 Gordon, Noah
The Physician
Simon & Schuster, Inc., 1986
Acrylic on masonite panel
14″h x 12″w
Frank Metz, A.D.
Collection of the artist

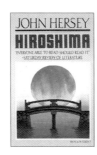

p. 88 Hersey, John
Hiroshima
Vintage Books, 1988
Watercolor on cold press board
4″h x 3 3/4″w
Susan Mitchell, A.D.
Collection of the artist

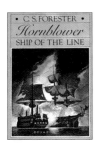

p. 121 Forester, C. S.
Hornblower: Ship of the Line
Little, Brown and Company, 1986
Acrylic on masonite panel
8″h x 6 1/2″w
Steve Snider, A.D.
Collection of the artist

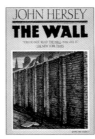

p. 35 Harington, Donald
The Architecture of the Arkansas Ozarks
Little, Brown and Company, 1975
Acrylic on wood
12 1/2″h x 11 1/2″w
Char Lappan, A.D.
Awards: *Graphis* Annual, 1982; Society
of Illustrators 18th Annual National
Exhibition, 1976
Collection of Donald and Kim
Harington

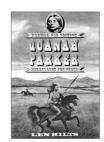

p. 89 Hersey, John
The Wall
Vintage Books, 1987
Watercolor on cold press board
6 3/4″h x 12 1/2″w
Susan Mitchell, A.D.
Collection of the artist

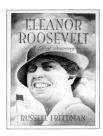

p. 50 Freedman, Russell
Eleanor Roosevelt: A Life of Discovery
Clarion Books, 1993
Acrylic on masonite panel
12″h x 8 3/4″w
Anne Diebel, A.D.
Awards: *Print* Regional Design Annual,
1994; *Art Direction* Creativity 93
Collection of the artist

p. 34 Harington, Donald
Some Other Place. The Right Place.
Little, Brown and Company, 1972
Gouache on canvas
9 3/4″h x 6 3/4″w
Char Lappan, A.D.
Collection of Donald and Kim
Harington

p. 122 Hilts, Len
*Quanah Parker: Warrior for Freedom,
Ambassador for Peace*
Harcourt Brace Jovanovich, 1987
Watercolor on cold press board
9″h x 17″w
Joy Chu, A.D.
Collection of the artist

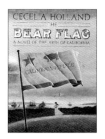

p. 62 Holland, Cecelia
The Bear Flag: A Novel of the Birth of California
Houghton Mifflin Company, 1990
Acrylic on masonite panel
12″ h x 18″ w
Sara Eisenman, A.D.
Collection of the artist

p. 142 Jones, Douglas C.
Weedy Rough
Holt, Rinehart & Winston, 1981
Acrylic on masonite panel
15″h x 21 1/2″w
Bob Reed, A.D.
Awards: Society of Illustrators 24th
Annual National Exhibition, 1982;
The Art Directors Club 61st Annual
Exhibition, 1982; *Graphis* Annual, 1985
Private collection

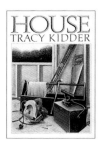

p. 105 Kidder, Tracy
House
Houghton Mifflin Company, 1986
Acrylic on masonite panel
12 1/2″h x 10 1/2″w
Louise Noble, A.D.
Awards: Desi Award, *Graphic Design: USA*,
1987; Society of Illustrators 29th Annual
National Exhibition, 1987;
Featured in *Idea*, 1993
Collection of the artist

p. 98 Holland, Isabelle
Darcourt
Weybright & Talley, Publisher, 1976
Acrylic on canvas
27″h x 38″w
Carolyn T. Anthony, A.D.
Collection of the artist

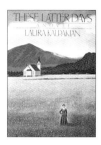

p. 140 Kalpakian, Laura
These Latter Days
Times Books, 1985
Acrylic on masonite panel
15″h x 22″w
Marge Anderson, A.D.
Awards: *Graphis* Annual, 1985
Collection of the artist

p. 96 Kinsella, W. P.
The Dixon Cornbelt League: and Other Baseball Stories
Harper Collins Publishers Ltd.,
Toronto, 1993
Watercolor on cold press board
9 3/4″h x 6 1/2″w Neil Erickson, A.D.
Awards: *Print* Regional Design Annual,
1994; Society of Illustrators L.A.,
Illustration West Exhibition, 1994
Collection of the artist

p. 52 Hubbell, Sue
A Country Year: Living the Questions
Random House, 1986
Watercolor on cold press paper
9 1/2″h x 6 1/2″w
Bob Aulicino, A.D.
Awards: *Art Direction* Creativity 86
Collection of the artist

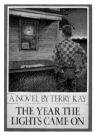

p. 125 Kay, Terry
The Year the Lights Came On
Houghton Mifflin Company, 1976
Acrylic on canvas
17″h x 16″w
Louise Noble, A.D.
Awards: *Communication Arts*, 1976;
Society of Illustrators 19th Annual
National Exhibition, 1977
Collection of Terry and Tommie Kay

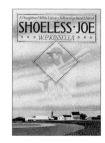

p. 97 Kinsella, W. P.
Shoeless Joe
Houghton Mifflin Company, 1982
Acrylic on masonite panel
14″h x 24″w
Louise Noble, A.D.
Private collection

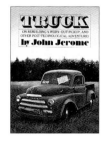

pp. vi and 104 Jerome, John
Truck: On Rebuilding a Worn-Out Pickup, and Other Post-Technological Adventures
Houghton Mifflin Company, 1976
Acrylic on canvas
28″h x 22″w
Louise Noble, A.D.
Collection of John Jerome

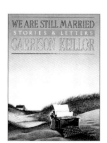

p. 111 Keillor, Garrison
We Are Still Married: Stories & Letters
Penguin USA (Viking), 1989
Acrylic on masonite panel
13 1/2″h x 10 1/2″w
Neil Stuart, A.D.
Awards: Desi Award, *Graphic Design: USA*,
1990; Society of Illustrators 32nd
Annual National Exhibition, 1990
Collection of the artist

p. 32 Knowlton, Winthrop
False Premises
Random House, 1983
Acrylic on masonite panel
8 3/4″h x 21 3/4″w
Bob Aulicino, A.D.
Awards: *Art Direction* Creativity 83
Collection of the artist

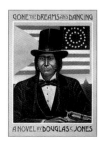

p. 141 Jones, Douglas C.
Gone the Dreams and Dancing
Holt, Rinehart & Winston, 1984
Acrylic on masonite panel
14″h x 10″w
Bob Reed, A.D.
Awards: Society of Illustrators 27th
Annual National Exhibition, 1985;
Featured in *Idea* 1993
Collection of David and Rosalee
McCullough

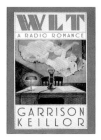

p. 110 Keillor, Garrison
WLT: A Radio Romance
Penguin USA (Viking), 1991
Acrylic on masonite panel
11 1/2″h x 12″w
Neil Stuart, A.D.
Collection of the artist

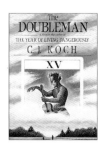

p. 106 Koch, C. J.
The Doubleman
McGraw-Hill, Inc., 1985
Acrylic on masonite panel
14″h x 10″w
Bob Mitchell, A.D.
Awards: *Print* Regional Design Annual,
1986
Collection of the artist

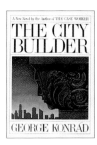

p. 56 Konrád, George
The City Builder
Harcourt Brace Jovanovich, 1977
Acrylic on canvas
17″h x 20″w
Harris Lewine, A.D.
Awards: Society of Illustrators 20th
Annual National Exhibition, 1978
Collection of the artist

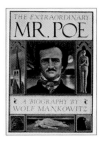

p. 78 Mankowitz, Wolf
The Extraordinary Mr. Poe
Simon & Schuster, Inc.
(Summit Books), 1978
Acrylic on masonite panel
18″h x 11 3/4″w
Frank Metz, A.D.
Awards: *Graphis* Annual, 1979
Collection of the artist

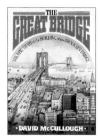

p. 24 McCullough, David
*The Great Bridge: The Epic Story of the
Building of the Brooklyn Bridge*
Simon & Schuster, Inc., 1972
Hand-tinted engraving
12″h x 9″w
Frank Metz, A.D.
Awards: AIGA Cover Show, 1973
Collection: Whereabouts unknown

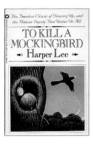

pp. 6 and 57 Lee, Harper
To Kill a Mockingbird
Warner Books, Inc., 1987
Acrylic on masonite panel
7″h x 7″w
Jackie Meyer, A.D.
Awards: Society of Illustrators 31st
Annual National Exhibition, 1989
Collection of the artist

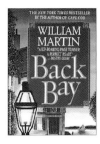

p. 82 Martin, William
Back Bay
Warner Books, Inc., 1992
Watercolor on cold press board
10 1/2″h x 6 3/4″w
Diane Luger, A.D.
Collection of the artist

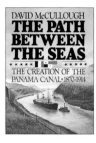

p. 81 McCullough, David
*The Path Between the Seas: The Creation of
the Panama Canal, 1870-1914*
Simon & Schuster, Inc., 1977
Acrylic on canvas
28″h x 20″w
Frank Metz, A.D.
Collection of David and Rosalee
McCullough

p. 28 Lieberman, Herbert
City of the Dead
Simon & Schuster, Inc., 1976
Acrylic on canvas
36″h x 24″w
Frank Metz, A.D.
Awards: *Print Casebooks Annual*, 1977;
Society of Illustrators 19th Annual
National Exhibition, 1977
Collection of the artist

p. 83 Martin, William
Cape Cod
Warner Books, Inc., 1992
Watercolor on cold press board
14″h x 14″w
Jackie Meyer, A.D.
Collection of the artist

pp. 26 and 80 McCullough, David
Truman
Simon & Schuster, Inc., 1992
Acrylic on masonite panel
14 1/2″h x 9 3/4″w
Frank Metz, A.D.
Awards: *Print* Regional Design Annual,
1993
Collection of David and Rosalee
McCullough

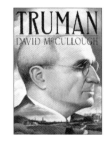

p. 107 Lincoln, W. Bruce
*Red Victory: A History of the
Russian Civil War*
Simon & Schuster, Inc., 1989
Watercolor on cold press board
12″h x 8″w
Frank Metz, A.D.
Collection of the artist

p. 136 Matthews, Jack
Sassafras
Houghton Mifflin Company, 1983
Acrylic on wood
15″h x 10″w
Louise Noble, A.D.
Awards: Desi Award, *Graphic Design: USA*,
1984
Collection of the artist

p. 116 McGrath, Patrick
The Grotesque
Simon & Schuster, Inc. (Poseidon Press),
1989
Watercolor on cold press paper
4″h x 5″w
Frank Metz, A.D.
Awards: Desi Award, *Graphic Design: USA*,
1990
Collection of the artist

p. 133 MacLachlan, Patricia
Baby
Delacorte Press, 1993
Watercolor on cold press board
11″h x 15 1/4″w
Marietta Anastassatos, A.D.
Awards: Society of Illustrators L.A.,
Illustration West 33, 1994
Collection of Susan Sauber

p. iv Maybury, Anne
Ride a White Dolphin
Random House, 1971
Gouache on wood
10 1/4″h x 17 1/2″w
Bob Giusti, A.D.
Featured in *Art Direction*, 1974
Collection of Bernardo and Wana
Hajdenberg

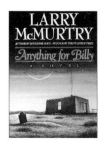

p. 102 McMurtry, Larry
Anything for Billy
Simon & Schuster, Inc., 1988
Watercolor on cold press board
12″h x 17″w
Frank Metz, A.D.
Collection of Katherine Monahan

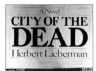

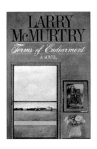

p. 103 McMurtry, Larry
Terms of Endearment
Simon & Schuster, Inc., 1975
Acrylic on canvas
23″h x 15″w
Frank Metz, A.D.
Collection of Katherine Monahan

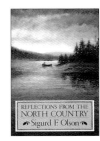

p. 79 Morgan, Speer
Belle Starr
Little, Brown and Company, 1979
Acrylic on canvas
17 1/2″h x 11″w
Char Lappan, A.D.
Private collection

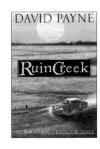

p. 53 Olson, Sigurd F.
Reflections from the North Country
Alfred A. Knopf, Inc., 1976
Oil on canvas
26″h x 37″w
Lidia Ferrara, A.D.
Collection of Gail and Elaine Tennant

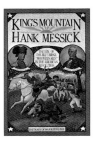

p. 94 Messick, Hank
King's Mountain: The Epic of the Blue Ridge
"Mountain Men" in the American Revolution
Little, Brown and Company, 1976
Acrylic on wood 19″h x 13″w
Char Lappan, A.D. Awards: *Communication Arts*, 1976; *The Bicentennial in Print*, The Art Directors Club of Washington, D.C., 1976; Society of Illustrators 19th Annual National Exhibition, 1977
Collection of Braldt and Charlotte Bralds

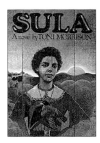

p. 75 Morrison, Toni
Sula
Alfred A. Knopf, Inc., 1973
Acrylic on wood
17 1/2″h x 14 1/2″w
R. D. Scudellari, A.D.
Awards: British Design Annual, 1974
Collection of Toni Morrison
(destroyed by fire 12/93)

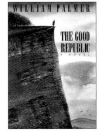

p. 120 Palmer, William
The Good Republic
Penguin USA (Viking), 1991
Watercolor on cold press board
8 3/4″h x 5 3/4″w
Neil Stuart, A.D.
Awards: *Art Direction* Creativity 91
Collection of the artist

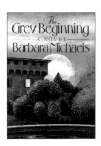

p. 10 Michaels, Barbara
The Grey Beginning
Congdon & Weed, 1984
Acrylic on masonite panel
12 1/2″h x 9 1/2″w
Krystyna Skalski, A.D.
Collection of Donna and Arthur Berman

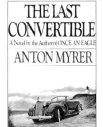

p. 132 Myrer, Anton
The Last Convertible
G. P. Putnam's Sons, 1977
Acrylic on canvas
16″h x 22″w
Phyllis Grann, A.D.
Featured in *Packard* magazine, 1978
Collection of Anton Myrer

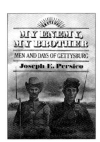

p. 112 Payne, David
Ruin Creek
Doubleday, 1993
Watercolor on cold press board
11 3/4″h x 17 3/4″w
Whitney Cookman, A.D.
Collection of the artist

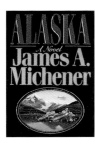

p. 46 Michener, James A.
Alaska
Random House, 1988
Acrylic on masonite panel
7 1/2″h x 11″w
Bob Aulicino, A.D.
Collection of the artist

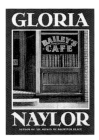

p. 45 Naylor, Gloria
Bailey's Cafe
Harcourt Brace & Company, 1992
Acrylic on masonite panel
8 3/4″h x 8″w
Vaughn Andrews, A.D.
Awards: *Print* Regional Design Annual, 1993
Collection of the artist

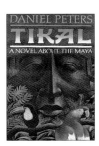

p. 95 Persico, Joseph E.
My Enemy, My Brother:
Men and Days of Gettysburg
Penguin USA (Viking), 1977
Acrylic on canvas
19″h x 13″w
Jessica Weber, A.D.
Awards: *Art Direction* Creativity 77
Collection of Mr. and Mrs. Joseph E. Persico

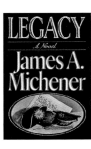

p. 46 Michener, James A.
Legacy
Random House, 1987
Acrylic on masonite panel
7″h x 12″w
Bob Aulicino, A.D.
Collection of the artist

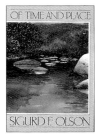

p. 54 Olson, Sigurd F.
Of Time and Place
Alfred A. Knopf, Inc., 1982
Watercolor on cold press paper
7 1/2″h x 11 1/4″w
Lidia Ferrara, A.D.
Awards: Society of Illustrators 25th Annual National Exhibition, 1983
Collection of Mr. & Mrs. Paul Bruning

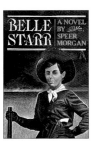

p. 38 Peters, Daniel
Tikal: A Novel About the Maya
Random House, 1983
Acrylic on masonite panel
16″h x 11 3/4″w
Bob Aulicino, A.D.
Featured in *Idea*, 1993
Collection of the artist

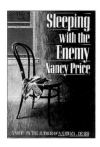

p. 113 Price, Nancy
Sleeping with the Enemy
Simon & Schuster, Inc., 1987
Acrylic on masonite panel
11 3/4″h x 7 3/4″w
Frank Metz, A.D.
Collection of the artist

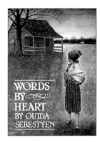

p. 44 Sebestyen, Ouida
Words by Heart
Little, Brown and Company, 1979
Acrylic on canvas
16″h x 23″w
Char Lappan, A.D.
Collection of the artist

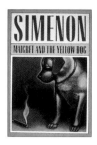

p. 59 Simenon, Georges
Maigret and the Yellow Dog
Harcourt Brace Jovanovich, 1987
Acrylic on masonite panel
12″h x 12″w
Vaughn Andrews, A.D.
Awards: *Print* Regional Design Annual,
1988; Society of Illustrators 30th
Annual National Exhibition, 1988
Private collection

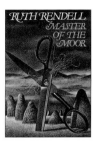

p. 131 Rendell, Ruth
Master of the Moor
Pantheon Books, 1982
Acrylic on masonite panel
13 1/2″h x 9″w
Louise Fili, A.D.
Awards: Desi Award, *Graphic Design:
USA*, 1983; Society of Illustrators 25th
Annual National Exhibition, 1983
Private collection

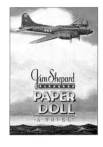

p. 101 Shepard, Jim
Paper Doll
Alfred A. Knopf, Inc., 1986
Acrylic on masonite panel
13″h x 19 1/2″w
Sara Eisenman, A.D.
Awards: Desi Award, *Graphic Design:
USA*, 1987
United States Air Force art collection

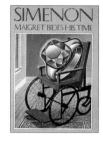

p. 60 Simenon, Georges
Maigret Bides His Time
Harcourt Brace Jovanovich, 1985
Acrylic on masonite panel
12″h x 8″w
Vaughn Andrews, A.D.
Awards: Society of Illustrators 28th
Annual National Exhibition, 1986
Collection of the artist

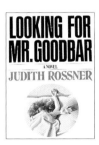

p. 69 Rogers, Michael
Do Not Worry About the Bear
Alfred A. Knopf, Inc., 1979
Acrylic on canvas
18″h x 12″w
Lidia Ferrara, A.D.
Featured in *Idea*, 1993
Collection of William Whitton

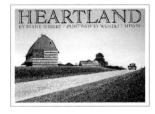

p. 3 Siebert, Diane
Heartland
HarperCollins Publishers,
1989
Acrylic on masonite panel
13″h x 17″w
Al Cetta, A.D.
Awards: *Print* Regional
Design Annual, 1989;
Society of Illustrators
31st and 32nd Annual National Exhibitions, 1989 and 1990
Collection of Richard and Lark Levine

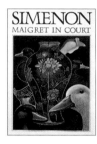

p. 59 Simenon, Georges
Maigret in Court
Harcourt Brace Jovanovich, 1983
Acrylic on masonite panel
15″h x 11 3/4″w
Rubin Pfeffer, A.D.
Awards: AIGA Exhibition, 1983
Featured in *Idea*, 1993
Private collection

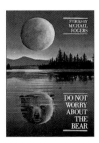

p. 68 Rossner, Judith
Looking for Mr. Goodbar
Simon & Schuster, Inc., 1975
Acrylic on canvas
11 1/4″h x 11 1/4″w
Frank Metz, A.D.
Featured in *Print*, 1975
Collection of
Bernardo and Wana Hajdenberg

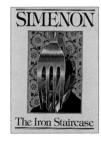

p. 61 Simenon, Georges
The Iron Staircase
Harcourt Brace Jovanovich, 1977
Acrylic on wood
16″h x 9 3/4″w
Harris Lewine, A.D.
Awards: *Art Direction* Creativity 78;
Print Casebooks Annual, 1979;
Society of Illustrators 21st Annual
National Exhibition, 1979
Collection of the artist

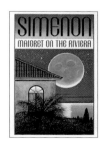

p. 59 Simenon, Georges
Maigret on the Riviera
Harcourt Brace Jovanovich, 1988
Acrylic on masonite panel
9″h x 8″w
Vaughn Andrews, A.D.
Featured in *Idea*, 1993
Collection of the artist

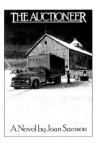

p. 42 Samson, Joan
The Auctioneer
Simon & Schuster, Inc., 1975
Acrylic on canvas
22″h x 28″w
Frank Metz, A.D.
Awards: *Art Direction* Creativity 87
Collection of Donna and Arthur
Berman

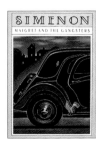

p. 60 Simenon, Georges
Maigret and the Gangsters
Harcourt Brace Jovanovich, 1986
Acrylic on masonite panel
10″h x 7 1/2″w
Vaughn Andrews, A.D.
Awards: Society of Illustrators 29th
Annual National Exhibition, 1987;
Featured in *Idea*, 1993
Collection of the artist

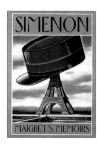

p. 60 Simenon, Georges
Maigret's Memoirs
Harcourt Brace Jovanovich, 1985
Acrylic on masonite panel
11″h x 9 1/2″w
Vaughn Andrews, A.D.
Collection of the artist

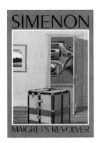

p. 59 Simenon, Georges
Maigret's Revolver
Harcourt Brace Jovanovich, 1984
Acrylic on masonite panel
12″h x 9 1/4″w
Vaughn Andrews, A.D.
Collection of the artist

p. 64 Taylor, Mildred D.
Let the Circle Be Unbroken
Dial Books, 1981
Acrylic on wood
12″h x 8 1/2″w
Atha Tehon, A.D.
Awards: Desi Award, *Graphic Design: USA*,
1982; Society of Illustrators 24th
Annual National Exhibition, 1982
Collection of Robert Sherman and
Amanda Tomalin

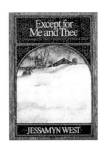

p. 5 West, Jessamyn
Except for Me and Thee: A Companion
to The Friendly Persuasion
Harcourt Brace and World, 1968
Gouache on wood
9″h x 6″w
Helen Mills, A.D.
Collection of Dr. Harry West

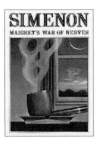

p. 60 Simenon, Georges
Maigret's War of Nerves
Harcourt Brace Jovanovich, 1986
Acrylic on masonite panel
10″h x 8″w
Vaughn Andrews, A.D.
Awards: *Print* Regional Design
Annual, 1986; *Graphis* Annual, 1983
Featured in *Idea*, 1993
Collection of the artist

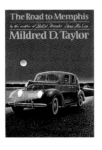

p. 65 Taylor, Mildred D.
The Road to Memphis
Dial Books, 1990
Acrylic on masonite panel
13″h x 8 3/4″w
Atha Tehon, A.D.
Collection of the artist

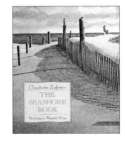

p. 51 Zolotow, Charlotte
The Seashore Book
HarperCollins Publishers, 1992
Watercolor on cold press board
12″h x 9 1/2″w Al Cetta, A.D.
Awards: *Print* Regional Design Annual,
1992; Society of Illustrators 34th
Annual National Exhibition, 1992;
Art Direction Creativity 93; New York
Art Directors Club Annual 1993
Collection of Anita M. Lamour

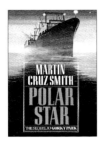

p. 86 Smith, Martin Cruz
Polar Star
Random House, 1989
Watercolor on cold press board
18″h x 12″w
Bob Aulicino, A.D.
Collection of the artist

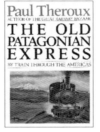

p. 47 Theroux, Paul
The Old Patagonian Express: By Train
Through the Americas
Houghton Mifflin Company, 1979
Acrylic on canvas
12″h x 16″w
Louise Noble, A.D.
Collection of Paul Theroux

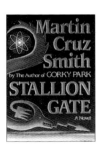

p. 87 Smith, Martin Cruz
Stallion Gate
Random House, 1986
Acrylic on masonite panel
14 1/2″h x 11 3/4″w
Bob Aulicino, A.D.
Collection of the artist

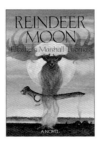

p. 137 Thomas, Elizabeth Marshall
Reindeer Moon
Houghton Mifflin Company, 1987
Watercolor on cold press board
11 1/2″h x 9 1/2″w
Louise Noble, A.D.
Collection of Illinois State Museum

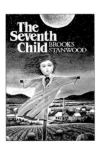

p. 135 Stanwood, Brooks
The Seventh Child
Simon & Schuster, Inc. (Linden Press),
1981
Acrylic on masonite panel
14 3/4″h x 22″w
Frank Metz, A.D.
Awards: Desi Award,
Graphic Design: USA, 1982
Collection of
Susan and Howard Kaminsky

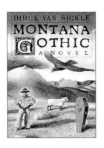

p. 84 Van Sickle, Dirck
Montana Gothic
Harcourt Brace Jovanovich, 1979
Acrylic on wood
17″h x 24 1/2″w
Harris Lewine, A.D.
Awards: AIGA Exhibition, 1979;
Nominated for the National Book
Award for Cover Design 1979
Collection of the artist

PERMISSIONS

Alexie, Sherman: *The Lone Ranger and Tonto Fistfight in Heaven*. Jacket art and design used by arrangement with Grove/Atlantic, Inc. Commentary by Sherman Alexie used by permission of the author.

Baxter, Charles: *A Relative Stranger*. Jacket art and design used courtesy of W. W. Norton & Company. Commentary by Charles Baxter used by permission of the author.

Bradbury, Ray: *The Illustrated Man*. Jacket art and design used by permission of Doubleday.

Brautigan, Richard: *The Hawkline Monster*. Jacket art and design used by permission of Simon & Schuster, Inc.

Bryson, Bill: *The Lost Continent*. Jacket art and design used by permission of HarperCollins Publishers. Commentary by Bill Bryson used by permission of the author.

Bryson, Bill: *Neither Here nor There*. Jacket art and design used by permission of William Morrow & Company, Inc. Jacket painting and design copyright © 1992 by Wendell Minor. Commentary by Bill Bryson used by permission of the author.

Buck, Pearl S. *The Big Wave*. Jacket art and design used courtesy of HarperCollins Publishers.

Bunting, Eve: *Red Fox Running* was published by Clarion Books. Text copyright © 1993 by Eve Bunting. Jacket art and interior paintings copyright © 1993 by Wendell Minor. Commentary by Eve Bunting used by permission of the author.

Burns, Olive Ann: *Cold Sassy Tree* was published by Ticknor & Fields. Copyright © 1984 by Olive Ann Burns. Jacket art and design used by permission of Ticknor & Fields.

Campbell, Robert: *Ahab*. Jacket art and design used by permission of Leviathan Press.

Campion, Nardi Reeder: *Patrick Henry* was published by Little, Brown and Company. Copyright © 1976 by Nardi Reeder Campion. Jacket art and design used by permission of the author.

Carlisle, Henry: *The Jonah Man*. Jacket art and design used by permission of Alfred A. Knopf, Inc. Commentary by Henry Carlisle used by permission of the author.

Cather, Willa: *My Ántonia* was published by Houghton Mifflin Company. Copyright 1918 by Willa Sibert Cather; copyright renewed 1946 by Willa Sibert Cather; copyright 1926 by Willa Sibert Cather; copyright renewed 1954 by Edith Lewis; copyright 1949 by Houghton Mifflin Company; copyright © renewed 1977 by Bertha Handlan. Jacket art and design used by permission of the publisher.

Cather, Willa: *O Pioneers!* was published by Houghton Mifflin Company. Copyright 1913 by Willa S. Cather; copyright renewed 1941 by Estate of Willa S. Cather. Foreword copyright © 1988 by Houghton Mifflin Company. Jacket art and design used by permission of the publisher.

Caudill, Harry M.: *The Senator from Slaughter County*. Copyright © 1973 by Harry M. Caudill. Jacket art and design used by permission of Little, Brown and Company.

Cerf, Bennett: *Famous Ghost Stories*. Jacket art and design used by permission of Vintage Books.

Chadwick, Janet: *How to Live on Almost Nothing and Have Plenty*. Jacket art and design used by permission of Alfred A. Knopf, Inc. Commentary by Janet Chadwick used by permission of the author.

Clark, Mary Higgins: *StillWatch* and *Where Are the Children?* Jacket art and design used by permission of Simon & Schuster, Inc. Commentary by Mary Higgins Clark used by permission of the author.

Combs, Harry: *Kill Devil Hill*. Copyright © 1979 by Harry Combs. Jacket art and design used by permission of Houghton Mifflin Company. Commentary by Harry Combs used by permission of the author.

Conroy, Pat: *The Great Santini* and *The Prince of Tides* were published by Houghton Mifflin Company. Copyright © 1976 and copyright © 1986 by Pat Conroy. Jacket art and design used by permission of the publisher. Commentary by Nan A. Talese used by permission of Nan A. Talese. Commentary by Pat Conroy used by permission of the author.

Dary, David A.: *The Buffalo Book*. Jacket art and design used by permission of Avon Books. Commentary by David A. Dary used by permission of the author.

Dent, Huntley: *The Feast of Santa Fe*. Jacket art and design used by permission of Simon & Schuster, Inc. Commentary by Huntley Dent used by permission of the author.

Doig, Ivan: *This House of Sky* was published by Harcourt Brace & Company in 1978. Jacket art reprinted by permission of Paul Bacon.

Erdrich, Louise: *The Beet Queen*. Jacket art and design reprinted by permission of Henry Holt and Company. Commentary by Louise Erdrich used by permission of the author.

Findley, Timothy: *Headhunter* was first published by Harper Collins Publishers Ltd., Toronto. Jacket art and design used by permission of the publisher. Commentary by Timothy Findley used by permission of the author.

Flagg, Fannie: *Fried Green Tomatoes at the Whistle Stop Cafe* was published by Random House in 1987. Jacket art and design used by permission of the publisher. Commentary by Fannie Flagg used by permission of the author.

Forester, C. S.: *Hornblower: Ship of the Line*. Jacket art and design used by permission of Little, Brown and Company. Copyright © 1966 by C. S. Forester; renewed 1981 by Dorothy E. Forester, John Forester, and George Forester.

Freedman, Russell: *Eleanor Roosevelt* was published by Clarion Books. Copyright © 1993 by Russell Freedman. Jacket art and design used by permission of the publisher. Commentary by Russell Freedman used by permission of the author.

Gaines, Ernest J.: *A Gathering of Old Men*. Jacket art and design used by permission of Alfred A. Knopf, Inc.

George, Jean Craighead: *Julie*. Text copyright © 1994 by Jean Craighead George. Jacket art and interior drawings copyright © 1994 by Wendell Minor. Jacket art and design used by permission of HarperCollins Publishers.

Gordon, Noah: *The Physician*. Jacket art and design used by permission of Simon & Schuster, Inc.

Harington, Donald: *The Architecture of the Arkansas Ozarks* and *Some Other Place. The Right Place.* were published by Little, Brown and Company. Jacket art and design used by permission of the author. Commentary by Donald Harington used by permission of the author.

Harrigan, Stephen: *Aransas*. Jacket art and design used by permission of Alfred A. Knopf. Commentary by Stephen Harrigan used by permission of the author.

Heller, Joseph: *Catch-22*. Jacket art and design copyright © 1970 by Paul Bacon. Jacket used by permission of Simon & Schuster, Inc.

Hersey, John: *Blues*. Jacket art and design used by permission of Alfred A. Knopf. Commentary by John Hersey used by permission of Brook Hersey.

Hersey, John: *Hiroshima* and *The Wall*. Jacket art and design used by permission of Vintage Books. Commentary by John Hersey used by permission of Brook Hersey.

Hilts, Len: *Quanah Parker*. Jacket art and design reprinted by permission of Harcourt Brace & Company. Copyright © 1987 by Len Hilts. Commentary by Len Hilts used by permission of the author.

Holland, Cecelia: *The Bear Flag*. Copyright © 1990 by Cecelia Holland. Jacket art and design used by permission of Houghton Mifflin Company. Commentary by Cecelia Holland used by permission of the author.

Holland, Isabelle: *Darcourt*. Jacket art and design used by permission of Weybright & Talley, Publisher. Commentary by Isabelle Holland used by permission of the author.

Hubbell, Sue: *A Country Year* was published by Random House in 1986. Jacket art and design used by permission of the publisher. Commentary by Sue Hubbell used by permission of the author.

Jerome, John: *Truck*. Copyright © 1976 by John Jerome. Jacket art and design used by permission of Houghton Mifflin Company. Commentary by John Jerome used by permission of the author.

Jones, Douglas C.: *Gone the Dreams and Dancing* and *Weedy Rough*. Jacket art and design reprinted by permission of Henry Holt and Company, Inc. Commentary by Douglas C. Jones used by permission of the author.

Kalpakian, Laura: *These Latter Days*. Jacket art and design used by permission of Times Books. Commentary by Laura Kalpakian used by permission of the author.

Kay, Terry: *The Year the Lights Came On*. Copyright © 1976 by Terry Kay. Jacket art and design used by permission of Houghton Mifflin Company. Commentary by Terry Kay used by permission of the author.

Keillor, Garrison: *We Are Still Married* and *WLT: A Radio Romance*. Jacket art and design used courtesy of Viking Penguin, a division of Penguin Books USA Inc. Commentary by Garrison Keillor used by permission of the author.

Kidder, Tracy: *House*. Copyright © 1986 by Tracy Kidder. Jacket art and design used by permission of Houghton Mifflin Company. Commentary by Tracy Kidder used by permission of the author.

Kinsella, W. P.: *The Dixon Cornbelt League* was first published by Harper Collins Publishers Ltd., Toronto. Jacket art and design used by permission of the publisher. Commentary by Bill Kinsella used by permission of the author.

Kinsella, W. P.: *Shoeless Joe* was published by Houghton Mifflin Company. Copyright © 1982 by W. P. Kinsella. Jacket art and design used by permission of the publisher. Commentary by Bill Kinsella used by permission of the author.

Knowlton, Winthrop: *False Premises* was published by Random House in 1983. Jacket art and design used by permission of the publisher.

Koch, C. J.: *The Doubleman* was published by McGraw-Hill, Inc. in 1986. Jacket art and design used courtesy of the publisher. Commentary by Christopher J. Koch used by permission of the author.

Konrád, George: *The City Builder*. Jacket art and design reprinted by permission of Harcourt Brace & Company. Copyright © 1987 by George Konrád.

Lee, Harper: *To Kill a Mockingbird*. Jacket art and design reprinted by permission of Warner Books, Inc.

Levin, Meyer. *Compulsion*. Jacket art and design copyright © 1956 by Paul Bacon. Jacket used by permission of Simon & Schuster, Inc.

Lieberman, Herbert: *City of the Dead*. Jacket art and design used courtesy of Simon & Schuster, Inc.

Lincoln, W. Bruce: *Red Victory*. Jacket art and design used by permission of Simon & Schuster, Inc. Commentary by W. Bruce Lincoln used by permission of the author.

MacLachlan, Patricia: *Baby*. Jacket art and design used by permission of Delacorte Press, a division of Bantam, Doubleday, Dell Publishing Group Inc.

Mankowitz, Wolf: *The Extraordinary Mr. Poe*. Jacket art and design used by permission of Simon & Schuster, Inc. (Summit Books). Commentary by Wolf Mankowitz used by permission of the author.

Martin, William: *Back Bay* and *Cape Cod*. Jacket art and design reprinted by permission of Warner Books, Inc. Commentary by William Martin used by permission of the author.

Matthews, Jack: *Sassafras*. Copyright © 1983 by Jack Matthews. Jacket art and design used by permission of Houghton Mifflin Company. Commentary by Jack Matthews used by permission of the author.

Maybury, Anne: *Ride a White Dolphin* was published by Random House in 1971. Jacket art and design used by permission of the publisher.

McCullough, David: *The Path Between the Seas*, *The Great Bridge*, and *Truman*. Jacket art and design used by permission of Simon & Schuster, Inc.

McGrath, Patrick: *The Grotesque*. Jacket art and design used by permission of Simon & Schuster, Inc. (Poseidon Press). Commentary by Patrick McGrath used by permission of the author.

McMurtry, Larry: *Anything for Billy* and *Terms of Endearment*. Jacket art and design used by permission of Simon & Schuster, Inc. Commentary by Larry McMurtry used by permission of the author. Commentary by Michael Korda used by permission of Michael Korda.

Messick, Hank: *King's Mountain* was published by Little, Brown and Company. Jacket art and design used by permission of the author. Commentary by Hank Messick used by permission of the author.

Michaels, Barbara: *The Grey Beginning*. Jacket art and design used by permission of Congdon & Weed, Inc.

Michener, James A.: *Alaska* and *Legacy* were published by Random House in 1971. Jacket art and design used by permission of the publisher. Commentary by James A. Michener used by permission of the author.

Morgan, Speer: *Belle Starr*. Jacket art and design used by permission of Little, Brown and Company. Copyright © 1979 by Speer Morgan. Commentary by Speer Morgan used by permission of the author.

Morrison, Toni: *Sula*. Jacket art and design used by permission of Alfred A. Knopf, Inc. Commentary by R. D. Scudellari used by permission of R. D. Scudellari.

Myrer, Anton: *The Last Convertible*. Jacket art and design used by permission of G. P. Putnam's Sons. Commentary by Anton Myrer used by permission of the author.

Naylor, Gloria: *Bailey's Cafe*. Jacket art and design reprinted by permission of Harcourt Brace & Company. Copyright © 1992 by Gloria Naylor. Commentary by Gloria Naylor used by permission of the author.

Olson, Sigurd F.: *Of Time and Place* and *Reflections from the North Country*. Jacket art and design used by permission of Alfred A. Knopf, Inc. Commentary by Sigurd Olson used by permission of Robert K. Olson.

Palmer, William: *The Good Republic*. Jacket art and design used courtesy of Viking Penguin, a division of Penguin Books USA Inc. Commentary by William Palmer used by permission of the author.

Payne, David: *Ruin Creek*. Jacket art and design used by permission of Doubleday. Commentary by David Payne used by permission of the author.

Persico, Joseph E.: *My Enemy, My Brother*. Jacket art and design used courtesy of Viking Penguin, a division of Penguin Books USA Inc. Commentary by Joseph E. Persico used by permission of the author.

Peters, Daniel: *Tikal* was published by Random House in 1983. Jacket art and design used by permission of the publisher. Commentary by Daniel Peters used by permission of the author.

Price, Nancy: *Sleeping with the Enemy*. Jacket art and design used by permission of Simon & Schuster, Inc. Commentary by Nancy Price used by permission of the author.

Rendell, Ruth: *Master of the Moor*. Jacket art and design used by permission of Pantheon Books.

Rogers, Michael: *Do Not Worry About the Bear*. Jacket art and design used by permission of Alfred A. Knopf, Inc.

Rossner, Judith: *Looking for Mr. Goodbar*. Jacket art and design used by permission of Simon & Schuster, Inc. Commentary by Judith Rossner used by permission of the author.

Samson, Joan: *The Auctioneer*. Jacket art and design used by permission of Simon & Schuster, Inc.

Sebestyen, Ouida: *Words by Heart*. Copyright © 1979 by Ouida Sebestyen. Jacket painting and design copyright © 1979 by Wendell Minor. Jacket art and design used by permission of Little, Brown and Company. Commentary by Ouida Sebestyen used by permission of the author.

Shepard, Jim: *Paper Doll*. Jacket art and design used by permission of Alfred A. Knopf, Inc. Commentary by Jim Shepard used by permission of the author.

Siebert, Diane: *Heartland*. Text copyright © 1989 by Diane Siebert. Jacket art and interior paintings copyright © 1989 by Wendell Minor. Jacket art and design used by permission of HarperCollins Publishers.

Simenon, Georges: Jacket art and design for the following books reprinted courtesy of Harcourt Brace & Company. *Maigret and the Gangsters*, copyright © 1986 by Georges Simenon; *Maigret and the Yellow Dog*, copyright © 1987 by Georges Simenon; *Maigret Bides His Time*, copyright © 1985 by Georges Simenon; *Maigret in Court*, copyright © 1983 by Georges Simenon; *Maigret on the Riviera*, copyright © 1988 by Georges Simenon; *Maigret's Memoirs*, copyright © 1985 by Georges Simenon; *Maigret's Revolver*, copyright © 1984 by Georges Simenon; *Maigret's War of Nerves*, copyright © 1986 by Georges Simenon; *The Iron Staircase*, copyright © 1977 by Georges Simenon. Commentary by Helen Wolff used by permission of Christian Wolff.

Smith, Martin Cruz: *Polar Star* and *Stallion Gate* were published by Random House in 1989 and 1986. Jacket art and design used by permission of the publisher. Commentary by Martin Cruz Smith used by permission of the author.

Stanwood, Brooks: *The Seventh Child*. Jacket art and design used by permission of Simon & Schuster, Inc. (Linden Press).

Taylor, Mildred D.: *Let the Circle Be Unbroken* and *The Road to Memphis* were published in 1981 and 1990 by Dial Books, a division of Penguin Books USA Inc. Jacket art and design used by permission of the publisher. Commentary by Mildred Taylor used by permission of the author.

Theroux, Paul: *The Old Patagonian Express*. Copyright © 1979 by Paul Theroux. Jacket art and design used by permission of Houghton Mifflin Company.

Thomas, Elizabeth Marshall: *Reindeer Moon*. Copyright © 1987 by Elizabeth Marshall Thomas. Jacket art and design used by permission of Houghton Mifflin Company. Commentary by Elizabeth Marshall Thomas used by permission of the author.

Van Sickle, Dirck: *Montana Gothic*. Copyright © 1979 by Dirck Van Sickle. Jacket art and design reprinted by permission of Harcourt Brace & Company. Commentary by Dirck Van Sickle used by permission of the author.

West, Jessamyn: *Except for Me and Thee*. Copyright © 1968 by Jessamyn West. Reprinted by permission of Harcourt Brace & Company.

Zolotow, Charlotte: *The Seashore Book*. Text copyright © 1992 by Charlotte Zolotow. Jacket art and interior paintings copyright © 1992 by Wendell Minor. Jacket art and design used by permission of HarperCollins Publishers. Commentary by Charlotte Zolotow used by permission of the author.